SCHOENBERG

Also by Harvey Sachs

Ten Masterpieces of Music

Toscanini: Musician of Conscience

The Ninth: Beethoven and the World in 1824

Rubinstein: A Life

Reflections on Toscanini

Music in Fascist Italy

Virtuoso

Toscanini

AS COMPILER, EDITOR, AND TRANSLATOR

The Letters of Arturo Toscanini

AS COAUTHOR

Solti on Solti (with Sir Georg Solti)

My First Forty Years (with Plácido Domingo)

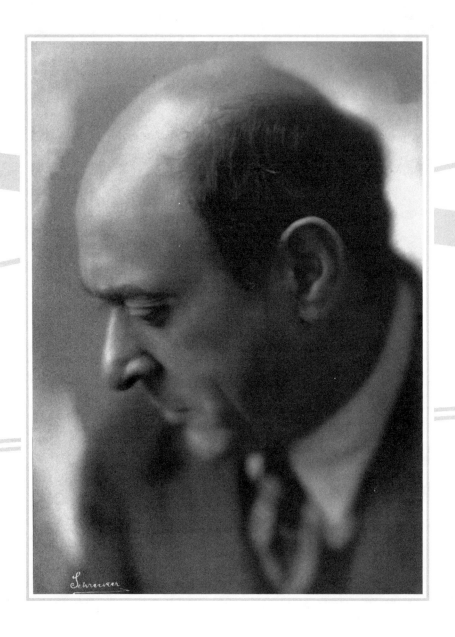

HARVEY SACHS

SCHOENBERG

WHY HE MATTERS

Liveright Publishing Corporation

*A Division of W. W. Norton & Company
Celebrating a Century of Independent Publishing*

Frontispiece: Arnold Schoenberg in Berlin, late 1920. Photograph by Karl Schrecker.

Copyright © 2023 by Harvey Sachs

All rights reserved
Printed in the United States of America
First Edition

The author gratefully thanks the Arnold Schönberg Center, Vienna, for making available all of the images reproduced in this book.

For information about permission to reproduce selections from this book, write to Permissions, Liveright Publishing Corporation, a division of W. W. Norton & Company, Inc., 500 Fifth Avenue, New York, NY 10110

For information about special discounts for bulk purchases, please contact W. W. Norton Special Sales atspecialsales@wwnorton.com or 800-233-4830

Manufacturing by Lakeside Book Company
Book design by Daniel Lagin
Production manager: Louise Mattarelliano

ISBN 978-1-63149-757-5

Liveright Publishing Corporation, 500 Fifth Avenue, New York, N.Y. 10110
www.wwnorton.com

W. W. Norton & Company Ltd., 15 Carlisle Street, London W1D 3BS

1 2 3 4 5 6 7 8 9 0

For Eve, who persuaded me to write it.

You can see it isn't easy to get on with me.
But don't lose heart because of that.

—Arnold Schoenberg,
LETTER TO A NEW ACQUAINTANCE, AUGUST 30, 1923

Contents

Prologue: A WARNING ... XIII

Author's Note ... XIX

I. A BOY FROM MATZAH ISLAND 1

II. FORMING THE BATTLE LINES 25

III. WAR, INTERNAL AND EXTERNAL 85

IV. BREAKTHROUGH AND BREAKAWAY 127

V. A CALIFORNIAN FINALE 163

Epilogue: WHAT NOW? 201

Acknowledgments ... 219

Notes ... 221

Bibliography ... 231

Index ... 235

Prologue

A WARNING

Arnold Schoenberg's place in posterity has yet to be determined. As I write these paragraphs, nearly a century and a half after Schoenberg's birth and more than seven decades after his death, I have no choice but to declare that his works, with few exceptions, have not been widely accepted even within the relatively small segment of the world's population that loves Western art music. Schoenberg's twelve-tone compositional technique or its offshoots were virtually obligatory among composers struggling for recognition in the third quarter of the twentieth century, but they have been either abandoned or drastically altered, often beyond recognition, by most younger composers, and few professional observers can imagine a major change in the situation. Gustav Mahler, one of Schoenberg's mentors, proved to be right when he said—in the face of widespread disinterest in or opposition to his own compositions—"My time will come." Of Schoenberg, on the other hand, many would say that his time has come and gone: his music and his musical experiments left an extremely strong imprint on the professional lives of several

generations of musicians and musicologists, and they continue to fascinate many people in the profession. But they also continue to meet with apathy, and often downright antipathy, on the part of most listeners.

A random glance at several major orchestras' last regular, pre–COVID pandemic season, 2018–19, provides the following statistics regarding the number of performances of Schoenberg's works:

Berlin Philharmonic—1 (the Violin Concerto)
Boston Symphony Orchestra—0
London Symphony Orchestra—0
New York Philharmonic—0
Philadelphia Orchestra—0
Vienna Philharmonic (Schoenberg's hometown orchestra)—0

Even the Los Angeles Philharmonic, known for performing more twentieth- and twenty-first-century music than most other first-class orchestras, performed nothing by Schoenberg that season. Two of these ensembles included some of his tonal, pre–First World War music *outside* their regular seasons: the ten-minute-long choral piece *Friede auf Erden* (Peace on Earth) was heard at the Boston Symphony's summer Tanglewood Festival, and the London Symphony performed the massive, hyper-Romantic *Gurrelieder* at one of the city's popular Proms concerts. But that was all—three pieces (only one of which—the Violin Concerto—makes use of the twelve-tone system) over an entire year, by seven world-famous orchestras, of works by the man who may well have been the most discussed and influential composer of the twentieth century.

The widespread hostility shown toward atonality and the twelve-tone system during the first few decades after those approaches to

composition had begun to make their way into Western music was often attributed to the public's need for adequate time to catch up with the products of creative minds, but now that atonality and the twelve-tone technique (and its offshoots) have been with us for a century we may safely say that they have proved to be dead ends for most listeners and for many—perhaps even most—professional performing musicians as well. (I'm not referring to atonal or twelve-tone music that is used in film soundtracks or in other media in which the audience's attention is mostly focused elsewhere, but only to concert pieces or other works in which music is the sole or primary focus.) Although I do not believe that a work's quality can be judged by the degree of its popularity, the cruel fact is that if hardly anyone wants to look at a given piece of visual art, read a given piece of literature, attend a given play or movie, or listen to a given musical composition, the work in question is likely headed for oblivion, no matter how brilliant it may be.

All musicians have likes and dislikes—often passionately held likes and dislikes. Some musicians are fascinated by Debussy's works; others find them too rarefied. Some adore Rossini; others consider him trivial. Wagner is one of the greatest of all composers for many and intolerably long-winded for others. Brahms's intense emotion speaks directly to some and leaves others untouched. I know of no musician, however, who would claim that Debussy, Rossini, Wagner, or Brahms destroyed music's future, whereas I have heard many make that claim, explicitly or implicitly, about Schoenberg. For the detractors, the serialist compositional techniques that Arnold Schoenberg and his followers created and promoted as part of Western music's natural evolutionary path ended up blocking that path by splitting the musical world into mutually destructive factions, and the wounds from those schisms have never healed and perhaps

can never be healed. Others find such opinions ridiculous: no single trend in music history can in itself destroy the art's onward flow.

Then there are the practical problems that Schoenberg's music presents—problems that a professional pianist of my acquaintance once summed up crudely but succinctly. He had, he said, successfully learned and thoroughly memorized several (I don't recall the exact number—maybe six or seven) Mozart piano concerti in about the same amount of time that he had needed to learn Schoenberg's sole Piano Concerto. But in studying Mozart, this pianist's love for every movement of every piece had deepened, whereas he had continued to find himself "in conflict" with Schoenberg, no matter how hard he had tried to penetrate the work's expressive essence. Why, he asked, should he be expected to devote substantial chunks of his professional life to learning music that he found impossible to love?

But some performers take a very different view. The outstanding American violinist Hilary Hahn has written, for instance, that although Schoenberg's Violin Concerto was "unlike any other piece I'd studied," and that she had had to train her hands "to adopt positions completely new to me," she was "excited by both the novelty of the writing and its musical possibilities." In the end, she had found that the composer's "grace, wit, lyricism, romanticism and drama came through with an impact that was almost visual," even though, she conceded, she had needed "a couple of years [. . .] to be able to play the piece comfortably up to Schoenberg's tempi—to the oft-ignored tempi printed in the score."[1] Her passion and determination are wholly admirable, and her recording of the concerto is stunning, but how many professional violinists are willing to devote that much time to mastering a work that many orchestras will hesitate or refuse outright to program?

For better or for worse, all of these issues form a backdrop to the

entire Schoenberg story, thus to everything that follows in this book. The controversy remains: Schoenberg still matters!

———

I HAVE KEPT TECHNICAL DETAILS TO A BARE MINIMUM IN THE FOL-
lowing pages and have focused on the musical sense and content—
as I hear them—of some of Schoenberg's works, rather than on
their internal and theoretical workings, so that nonmusicians who
are interested in the subject will not find themselves groping their
way through a seemingly impenetrable forest. There are no har-
monic analyses of Schoenberg's tonal works, no details of the ways
in which he diverged from traditional harmony in his early post-
tonal works, and no discussion of tone rows (except a brief attempt
to explain what they are) in his twelve-tone compositions. Besides,
although I take bizarre pleasure in doing those sorts of analyses for
my own purposes, I am by nature much more a storyteller than an
analytical musicologist.

I do believe that musicians, too, will find much to interest them
in this book, but in any case the project was meant from the start to
be a relatively brief, succinct interpretive study of Arnold Schoen-
berg's life and work, as opposed to either a full-length biography
based on fresh archival research or a thesis based on theoretical
analysis, fresh or otherwise. It is a book by a writer and music
historian who is Schoenberg-curious rather than a Schoenberg
expert. I have, however, tried to peer a little more closely than
some others have done into a few aspects of the story that piqued
my curiosity, and I have examined several of his works from my
own point of view, intentionally avoiding close contact with the
interpretations of Schoenberg specialists. This may prove to be an
exemplary case of a fool rushing in where experts fear to tread,

but I have wanted to use my own sensibilities in the process, with the hope—at least in part—that an understanding of Schoenberg's work will reach more people. For musicians, musicologists, and other readers who seek more detailed knowledge of the subject, I particularly recommend the books authored or edited by Joseph Auner, Juliane Brand et al., Sabine Feisst, Walter Frisch, Malcolm MacDonald, Willi Reich, Jennifer Shaw, Allen Shawn, and Erwin Stein—all listed, among others, in the Bibliography. As I have never been either a dyed-in-the-wool Schoenbergian or an anti-Schoenbergian, I don't doubt that some of my ideas about his music and his life will displease or even horrify members of one or the other camp, or both simultaneously. But in the course of preparing for and writing this book, I have come to believe that Schoenberg, a thorny character who composed thorny works, *must* be confronted by anyone interested in the past, the present, and the future of Western art music—where that music has been, where it is located today, and in which directions it may be heading.

Since the mid-1970s I have written extensively about music, music history, and musical performers and performance practices during Schoenberg's lifetime—the last decades of the nineteenth century and the first half of the twentieth—but this is the first time that I am writing at length about much of the music and most of the musical environments specifically covered in the following pages. As a matter of fact, had someone foretold, as recently as four or five years ago, that I would write a book about Schoenberg and his milieu, I would have reacted with shock. Yet I have found the whole process fascinating and have tried to cast some fresh light on certain aspects of the book's subject.

Author's Note

Until he moved to America in the 1930s, this book's protagonist spelled his surname Schönberg, in the normal German way. But since the umlaut was often left off in English-language publications, which made a name that means "beautiful mountain" into the nonsensical "already mountain" (Schonberg), the composer legally adopted the alternate German spelling, Schoenberg. Today, it usually appears as Schönberg in German-speaking countries, Schoenberg in English-speaking countries, and either way elsewhere. I am using the un-umlauted version, with a few exceptions.

In quoting or otherwise making use of material that was originally in German but had already been translated into English, I have generally used the translations. In the case of translated passages that seemed to me unclear or misleading, I returned to the original sources and made my own decisions. Concerning Schoenberg's writings in English: he became fluent—remarkably fluent—in the language only in his sixties, after his move to the United States, and he must surely be excused for some clumsy usage in his English-

xx | AUTHOR'S NOTE

language correspondence and other writings that date from his American years.

In supplying information about Schoenberg's earnings and other financial matters, I have refrained from providing contemporary equivalents in US dollars or other currencies, since those rates are constantly shifting. That information can be found on several Web sites.

SCHOENBERG

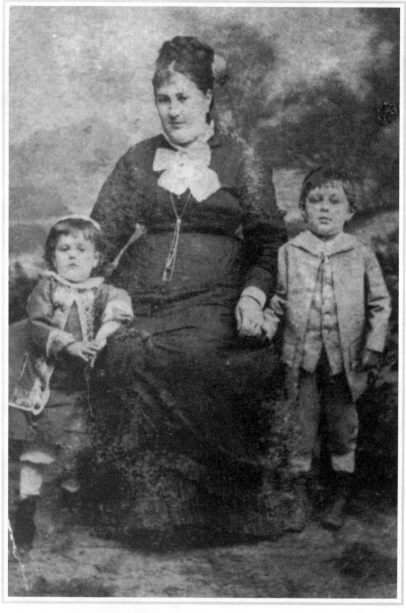

Vienna, 1879; Arnold Schoenberg (right), age four or five, in Vienna, with his little sister, Ottilie, and their mother, Pauline, *née* Nachod. Photograph by Karl Matzner.

I

A BOY FROM

MATZAH ISLAND

The Jews of Vienna, when they were many, produced two famous jokes about local attitudes toward themselves. "The Viennese definition of anti-Semitism"—begins the first joke—"is 'to dislike Jews more than is strictly necessary.'" The second one, even more biting than the first: "In Vienna, even the Jews are anti-Semites."

Jews had been living in the city since the late twelfth century, except during periods of expulsion. Most of them inhabited a district that was originally called Unteren Werd (Lower Island), sandwiched between the Danube River on the northeast and the Danube Canal on the southwest. When, in the late seventeenth century, the Holy Roman Emperor Leopold I expelled Vienna's Jews, his deed so pleased the majority Christian population that the area was renamed Leopoldstadt—Leopold Town. And yet, when Jews were eventually allowed back into the city, it was to Leopoldstadt that they returned.

In 1744–45, Empress Maria Theresa tried and partially succeeded in banishing Jews from the Austrian-ruled territories of Moravia and Bohemia, including the city of Prague. "I know of no

more troublesome pestilence for the state than this nation," she said, "which, through fraud, usury and financial manipulations, reduces people to beggary."[1] But a century later, in the wake of the revolutionary uprisings of 1848, Maria Theresa's great-grandson, Emperor Franz Joseph I, agreed to a constitution in which "civil and political rights" would no longer be "dependent on religion"—that is, on being Roman Catholic—and in 1867 yet another constitution granted complete religious and civil liberties to all creeds and ethnicities within what was now called the Austro-Hungarian Empire. Jews, whose access to intellectual professions had previously been restricted to the area of medicine, were now free to study any subject and to practice any legally recognized profession, and many Jews who had been living elsewhere in the empire began to flock to Vienna. Between 1860 and 1900 the city's Jewish population increased nearly twenty-five-fold, from 6,000 to 147,000,[2] and this happened despite the rise of the anti-Semitic Christian Social party under its leader Karl Lueger, who would be Vienna's mayor from 1897 to 1910. (Some of Lueger's policies probably inspired the young Adolf Hitler, who migrated to Vienna from the Austrian provinces during that period—which brings to mind yet another well-known joke: "The Viennese have tried to make the world believe that Beethoven was Austrian and Hitler German.")

During the seven decades between the promulgation of the 1867 constitution and the plebiscite that confirmed, by an overwhelming majority of votes, the Nazi takeover of Austria in 1938, many of Vienna's Jewish or part-Jewish natives or longtime residents made extraordinarily significant contributions to the city's intellectual and artistic life. A short list must include the philosophers Martin Buber, Theodor Gomperz, Karl Popper, and Ludwig Wittgenstein;

the pioneering medical doctors Emil and Otto Zuckerkandl (brothers) and, above all, the extraordinarily influential Sigmund Freud and Alfred Adler; the physicist Lise Meitner; the jurist and political and legal philosopher Hans Kelsen; the composers and/or performing musicians Karl Goldmark, Erich Wolfgang Korngold, Fritz Kreisler, Gustav Mahler, Franz Schreker, Johann Strauss II, Richard Tauber, Karl Weigl, Egon Wellesz, and Alexander Zemlinsky, in addition to Schoenberg himself; the music critics, theorists, and musicologists Guido Adler, Elsa Bienenfeld, Otto Erich Deutsch, Eduard Hanslick, Heinrich Jalowetz, Heinrich Schenker, Paul Stefan, and Erwin Stein; the painter Richard Gerstl; the stage director and impresario Max Reinhardt; the educator Eugenie Schwarzwald (*née* Nussbaum) and her banker husband Hermann Schwarzwald; and, in greatest abundance, writers—poets, playwrights, novelists, essayists, and journalists: Peter Altenberg, Hermann Broch, the future Nobel laureate Elias Canetti, Egon Friedell, Theodor Herzl (a journalist who would become the father of modern Zionism), Hugo von Hofmannsthal, Karl Kraus, Alfred Polgar, Joseph Roth, Felix Salten, Arthur Schnitzler, Jakob Wassermann, Franz Werfel, and Stefan Zweig.

In one or more ways, all of these individuals developed their careers and carried out their work despite the anti-Semitism, overt and hidden, that constantly confronted them. Schnitzler, a Leopoldstadt native a dozen years Schoenberg's senior, reported, in *My Youth in Vienna*, that he had faced appalling prejudice during his university years, and he quoted the notorious Waidhofen Manifesto of the 1880s, which banned Jews from student organizations in Austria: "Everyone of a Jewish mother, every human being in whose veins Jewish blood flows, is from the day of his

birth without honor and void of all the refined emotions. . . . He is ethically subhuman."[3] And yet, these "subhumans," more than the members of any other single ethnicity or religion, are the people whose names still crop up when one thinks about Vienna and its contribution to the humanities and the sciences between 1867 and 1938.

So many Jews continued to live in Leopoldstadt even after the 1867 constitution gave them the right to reside elsewhere that it was derogatorily nicknamed Mazzesinsel—Matzah Island—although the area also contained, and still contains, the Prater, the city's most famous and most frequented public park. Arnold Schoenberg was among Matzah Island's native sons, yet his roots were not Viennese. Both of his parents hailed from elsewhere within the empire—an empire that, although not as large as the American state of Texas, was massive by European standards and included all or parts of present-day Austria, Hungary, the Czech Republic, Slovakia, Poland, Romania, Ukraine, Italy, Slovenia, Croatia, and Bosnia-Herzegovina. Samuel Schoenberg, Arnold's freethinking Jewish father, was born in 1838 in Szécsény, a tiny town in Hungary, just across the border from Slovakia and culturally more Slovakian than Hungarian, but by the time he was fourteen he had moved with his family, first to Pressburg (now Bratislava) and then to Vienna, where he seems to have run a shoe store and, later, a pawnshop and payments agency. At the age of thirty-two, Samuel married twenty-two-year-old Prague-born Pauline Nachod, who came from an Orthodox Jewish family that had migrated to Vienna. Arnold, the Schoenbergs' second child and the first to survive infancy, was born on September 13, 1874, in an apartment at what is now No. 5 Obere Donaustrasse (Upper Danube Street),

near the Augarten—a small, Baroque park—about a half-hour's walk from Vienna's central Stephansplatz, the cathedral square. According to the complex Austrian imperial laws of the time, Arnold, as a result of his father's place of birth, was considered a Hungarian subject and culturally Slovakian, yet he spoke neither Hungarian nor Slovakian.[4]

Although neither of Arnold's parents was especially musical, they both "enjoyed music, particularly singing," he later recalled, but their musical abilities did not extend beyond "the musicality that the average Austrian possesses, provided that he is not hostile to music in the first place."[5] The Nachod family had produced several synagogue cantors, and Arnold's younger brother, Heinrich (1882–1941), and their first cousin, Hans Nachod (1883–1965), would become opera singers.

By 1880, the Schoenberg family was living in the Taborstrasse— still well within Leopoldstadt—and Arnold had begun to attend a public elementary school (*Volksschule*) in the nearby Kleine Pfarrgasse. When his parents had to decide on a post-elementary school for their eldest child, they opted for the *Realschule*, which focused on practical and scientific subjects and modern languages (young Arnold took classes in mathematics, zoology, chemistry, geometry, German, French, English, history, free drawing, and gymnastics), instead of the more prestigious *Gymnasium*, which emphasized humanistic studies, including classical Greek and Latin, and was attended mainly, although not exclusively, by scions of the upper and upper-middle classes. Bojan Bujić, one of Schoenberg's biographers, suggests convincingly that the lack of a *Gymnasium* education— combined, one should add, with Pauline Schoenberg's Orthodox Judaism—explains why Arnold Schoenberg, "in his musical career

6 | SCHOENBERG

[. . .] never drew any inspiration from Latin and Greek literature; the Bible remained for him the most powerful depiction of antiquity and the repository of symbolic imagery."[6]

In any case, the young Schoenberg's formal education was relatively short-lived: Samuel Schoenberg died late in 1889, and by the end of the 1889–1890 academic year the nearly sixteen-year-old Arnold had to leave school and find a job in order to help support the family.* He was taken on as a low-paid junior clerk at the Werner & Co. private bank, where he continued to work for five years.

Even before he had left school, however, music had become his passion and joy, and his greatest desire was to be a composer. He had begun violin lessons at the age of eight and had simultaneously started to compose, although he was familiar only with arrangements of opera excerpts and pieces played by military bands at public concerts on Sundays and holidays, as one of his friends later recalled:

> In front of the Erste Kaffeehaus, in the main alley of the Prater, there stood a group of young onlookers, one of whom was a young lad in a short overcoat of bright yellow, talking loudly about music and remarking, among other things, on the sounds that swept to us from the bandstand in the Café park. That is my earliest recollection of Arnold Schoenberg. . . . All of us, seventeen- and eighteen-year-olds, used to stand near

* His brother, Heinrich, was only eight years old at the time, and their sister, fourteen-year-old Ottilie (1876–1954), would not have been sent to work because her middle-class, Orthodox Jewish mother would not have considered it proper for a girl to work outside the home.

the dividing hedge, so as to hear music for nothing . . . [including] excerpts from Wagner. . . . For most of us, this was our only chance of hearing a little real music, and Schoenberg, too, made the most of the opportunity. . . .[7]

"All my compositions up to about my seventeenth year were nothing more than imitations of such music as I could become acquainted with,"[8] Schoenberg wrote, nearly six decades later. On the other hand, he felt that his originality was "the result of having immediately imitated everything that I saw that was good."[9] He eventually gave up the violin for the cello, which he began to play in mostly nonprofessional chamber ensembles and orchestras.

When we think of musical life in Vienna during the years of Schoenberg's adolescence—the late 1880s and early 1890s—we think of local residents Anton Bruckner, who completed his Eighth Symphony in 1890 and worked on the Ninth until his death, in 1896; Johannes Brahms, whose final orchestral work, the Double Concerto, received its first performance in 1887, and some of whose greatest chamber music appeared during the years immediately preceding his death, in 1897; and, perhaps above all, Johann Strauss II, who lived until 1899 and whose operettas and dance music enchanted the Hapsburg capital and much of the rest of the Western world. But Schoenberg, in his teens, did not have the wherewithal to attend performances at the Hofoper (Court Opera), where the repertoire was at last including generous doses of Wagner's previously suspect music dramas, or concerts by that ensemble's orchestra when it regrouped from time to time as the Vienna Philharmonic.

8 | SCHOENBERG

What happened in his seventeenth year, or thereabouts, that gradually began to expand his musical awareness? First, he got to know Oskar Adler, a boy nearly a year younger than himself but already an accomplished amateur violinist. Through Adler, "I learned that there exists a theory of music, and he directed my first steps therein," Schoenberg would later recall. "[A]ll my acquaintance with classical music derived from playing quartets with him."[10] Adler later became a physician and an astrologer; his older brother, Max, was a leading Austrian jurist and an advocate for socialism. Another major influence on Schoenberg was his almost exact contemporary David Josef Bach (author of the above-cited remarks about the friends' attendance at band concerts), who opened young Arnold's mind to literature and philosophy and provided him with "the ethical and moral power needed to withstand vulgarity and commonplace popularity,"[11] the composer later declared. Bach would develop into an influential figure in early-twentieth-century Viennese cultural life.

Most important of all, however, was Schoenberg's encounter, at the age of twenty, with Alexander von Zemlinsky, a promising young composer and conductor three years his senior, "to whom I owe most of my knowledge of the technique and the problems of composing,"[12] he would acknowledge. Zemlinsky, a prodigious musical talent, had had the advantage of solid conservatory training; one of his most significant teachers of composition was Robert Fuchs, whose impressive list of pupils had already included Gustav Mahler, Jean Sibelius, and Hugo Wolf. Thanks to Zemlinsky, Schoenberg—an exceptionally quick study—absorbed some of the essential training that he had so far lacked and opened his ears and his mind to the music of Wagner. "I had been a 'Brahmsian' when I met Zemlinsky," he would recall, referring to a time when adher-

ents of Wagner's music tended to be anti-Brahms, and vice versa. But Zemlinsky's "love embraced both Brahms and Wagner and soon thereafter I became an equally confirmed addict. No wonder that the music I composed at that time mirrored the influence of both these masters, to which a flavor of Liszt, Bruckner, and perhaps also Hugo Wolf was added."[13] Schoenberg joined Polyhymnia, an amateur catch-as-catch-can chamber orchestra that Zemlinsky conducted. "At the single cello desk sat a young man, fervently ill-treating his instrument," Zemlinsky recalled.

> Not that the instrument deserved any better; it had been bought with three painfully saved-up Gulden at Vienna's so-called Tandelmarkt [flea market]. This cellist was none other than Arnold Schoenberg. At that time Schoenberg was still a junior bank clerk, but he was not overzealous in his profession, preferring music paper to the paper-money at the bank.[14]

Adler, Bach, and Zemlinsky were all Jews* who questioned the established artistic, religious, social, and political norms of the society in which they lived—facts that cannot be too strongly emphasized in the story of Schoenberg's development and his relationship to his hometown. The ethnic and social identity of these young men automatically set them at odds with the predominantly

* Zemlinsky's father had converted from Catholicism to Judaism in order to marry Zemlinsky's mother, a Sephardic Jew who, although of part-Muslim extraction, raised her son in the Jewish faith. His father had also added (*motu proprio* and with no legal basis) the ennobling "von" to the family surname; Alexander himself did not use it, and we will not use it hereafter in referring to him.

10 | SCHOENBERG

Catholic and conservative society that dictated public opinion in pre–First World War Vienna. For the rest of his life Schoenberg would see himself as a lonely David using his slingshot to fend off hordes of cultural Philistines who were incapable of grasping, or unwilling to grasp, the beauty and the importance of his ideas and his work. In addition, he always bore the psychological burden of not having had proper conservatory training, or at least something that resembled a systematic approach to the science of music. The need to prove that he was not merely equal to but better than those who had enjoyed educational privileges that had not been available to him; the deep-seated insecurity that created his touchiness, inability to tolerate opposition, and need to vaunt his genius and his extreme originality; and even, perhaps, the desire to invent or employ approaches to composition that no one else had dared to invent or employ—all of these aspects of his artistic makeup derived, at least in part, from the haphazard beginnings of his musical life.

————

SCHOENBERG'S LATE-IN-LIFE ASSESSMENT OF THE INFLUENCE OF Brahms, Wagner, Liszt, Bruckner, and Wolf on his own early compositions was right on target, and in another retrospective glance at his early years he added the name of Dvořák, whose "voice" can be heard particularly in the thematic material of some of the young Schoenberg's music. For instance: the fundamentally classical procedures that he used in structuring his early (1897), unnumbered String Quartet in D Major are typically Brahmsian, especially in the two outer movements of the four-movement piece, but some of the melodic substance sounds like pure Dvořák, who was only in his

mid-fifties at the time and still producing one work after another.*
The quartet's nature is largely sunny; there is some turbulence in
the middle movements, but it feels forced, even superimposed, as if
the young composer had decided that he needed to season his work
with some *Sturm und Drang* in order to be taken seriously. Yet it is a
well-made piece, and it was praised even by the much-feared music
critic Eduard Hanslick. Given the fact that only a few years earlier
any attempt to write a work in this genre would have been unthink-
able for someone who hadn't even known that systematic approaches
to musical harmony and structure existed, it's clear that Zemlinsky
had done well by his gifted pupil.

By the time Schoenberg completed this ambitious quartet, the
Werner bank had failed and the young clerk had announced—to his
own joy but his family's dismay—that he would never again work in
any financial enterprise or, for that matter, in any field except music.
From then on, he was forever trying to figure out how he could
devote himself to composition and yet survive—a quandary that has
affected (and afflicted) aspiring artists in every generation. He made
some money by orchestrating popular music for composers who did
not know how to orchestrate, and by "de-orchestrating"—making
piano arrangements—of more accomplished composers' works for
the concert hall or the opera or operetta theater. He also earned a lit-
tle by rehearsing and conducting several workers' choirs—a popular
form of recreation at the time—in the nearby villages of Stockerau,
Meidling, and Mödling. The orchestrating and de-orchestrating

* For a thorough study of the young Schoenberg's music, from his earliest extant attempts at com-
position through the Second String Quartet, see Walter Frisch, *The Early Works of Arnold Schoen-
berg, 1893–1908* (Berkeley: University of California Press, 1993).

jobs had the added benefit of improving his understanding of how wind instruments and the piano worked (he was, after all, a string player), and the choral jobs increased his familiarity with vocal techniques and perhaps helped him when he began to write lieder, German art-songs.

Schoenberg's early lieder, for solo voice with piano accompaniment, written even before he composed the D Major String Quartet, were settings of texts by poets whose works he had begun to read voraciously. Quite a few of the texts that he chose were by early-nineteenth-century poets (Nikolaus Lenau, Emanuel Geibel, Robert Reinick, Oskar von Redwitz, Wilhelm Wackernagel, and Martin Greif), some of whom had already had their poetry set to music by Robert Schumann, Brahms, and other masters, but Schoenberg also set poems by such living writers as Ludwig Pfau, Ada Christen, Paul Heyse, Alfred Gold, and Jaroslav Vrchlický. On the whole, the poems he chose are typical of German high and late Romanticism: they overflow with tears and abound in nature imagery—birds, stars, sun, rocks, meadows, flower buds, roses (singly and in bunches), carnations, grapes, elderberry bushes, rushes, and laurel trees. A few of the songs are humorous, although the humor is heavy-handed, definitely not of the effervescent, risqué sort that Johann Strauss II and his contemporaries used in their operettas. Schoenberg enjoyed Strauss's music and eventually arranged some of it for various instrumental combinations, but the Vienna that that music evokes—the Vienna of diademed ladies, lavish soirées, and the mutton-chop-whiskered Emperor Franz Joseph—was not Schoenberg's Vienna.

One could be accused of unnecessary cruelty for describing the music of these youthful lieder as "Johannes Brahms meets Hugo

Wolf" had not Schoenberg himself later characterized the pieces as derivative. (Even in his fifties and sixties he not only acknowledged his great debt to Brahms but even considered himself one of the few authentic exemplars and extenders of a "Brahms tradition"—few because, he said, most of the Brahmsians who were his contemporaries were musical conservatives, and most of the modernists didn't properly understand Brahms as he did.) Some of the early songs are beautiful, and in a few—for instance, "Der Pflanze, die dort über dem Abgrund schwebt" (Pfau) and "Drüben geht die Sonne scheiden" (Lenau)—one hears real originality beginning to express itself. What a shame that Schoenberg's name still frightens so many music lovers! Some of these songs would be listened to with pleasure even by musical reactionaries if a different name were attached to them.

Vocal music also constituted Schoenberg's earliest published works: Two Songs for baritone, Op. 1 (1898); Four Lieder, Op. 2 (1899); and Six Lieder, Op. 3 (1898–1903). Noteworthy differences can be heard between, on the one hand, the D Major String Quartet and the lieder that he had written up to 1897, and, on the other, these new works; the changes are likely attributable to his growing awareness of the music not only of Wagner but also of Schoenberg's older contemporary Richard Strauss. Schoenberg, in his 1933 essay, "Brahms the Progressive," would offer the opinion that by the late 1890s the Wagner-versus-Brahms controversy had been resolved: "What had been the object of dispute had been reduced to the difference between two personalities, between two styles of expression, not contradictory enough to prevent the inclusion of qualities of both in one work," he would recall. But he was wrong in saying that "Mahler, Strauss, [Max] Reger, and many

14 | SCHOENBERG

others had grown up under the influence of both,"[15] or at least in grouping those three names together: Reger was indeed a Brahmsian epigone who happened also to have considerable talent, but the even more gifted Mahler and Strauss showed little interest in Brahms's Romantic classicism; they considered themselves Wagner's musical progeny.

Schoenberg himself, in the twelve songs that comprise his first three opus-numbered works, began to venture into radical post-Wagnerian territory. In the Op. 1 lieder in particular, he piled hyper-Wagnerian emotional overkill on top of Brahmsian restraint, but without applying Brahmsian self-critical criteria and without possessing Wagner's genius for creating unforgettable melodic motives. In addition, he chose texts that called for, or at least could be interpreted as calling for, over-the-top treatment. "Dank" (Thanks) and "Abschied" (Farewell), by Baron Karl von Levetzow, a young poet and dramatist with whom Schoenberg had become acquainted at Vienna's Café Glattauer—a gathering place for aspiring young artists—contained expressions like: "You created for me the never-before-suspected: beautiful sorrow! / Deep into my soul you plunged / A dark sword-pain." Or: "I myself become night and beauty, / All-embracing limitless grief."* When baritone Eduard Gärtner, a locally respected singing teacher, gave the songs' premieres at the Bösendorfer Hall on December 1, 1900, accompanied at the piano by Zemlinsky (to whom Opp. 1, 2, and 3 are dedicated), the public's reaction was negative. Schoenberg's friend David Josef Bach reported shouts, laughter, and jeers from the

* "Schufst mir das Niegeahnte: den schönen Schmerz! / Tief in die Seele bohrtest du mir / Ein finsteres Schwertweh." "Ich selber werde Nacht und Schönheit. / Allumfassend unbegrenztes Weh!"

A BOY FROM MATZAH ISLAND | 15

audience, and Schoenberg himself, recalling the event two decades later, remarked that from that day on "the scandal has never ceased."[16]

Both songs call for a great deal of forceful (all right: strained) singing, and whereas not even today's musical conservatives would find Schoenberg's harmonies here too daring, the pieces assault the listener with thick textures and a barrage of sound. They bring to mind Schoenberg biographer Mark Berry's comment that the composer's "density of musical argument" and "superfluity of musical expression and expressiveness" are what created and continue to create difficulties for listeners, far more than his later "break with tonality" or "adoption of the twelve-note method."[17] In other words, it's not so much the modernist techniques as the piled-on, hyper-Romantic content of many of Schoenberg's works that leaves some listeners feeling flummoxed.

On the other hand, the four songs that comprise Op. 2 demonstrate a dramatic change in tone and texture. Not only are the vocal lines less strenuous in these slightly later pieces: the piano writing, too, is lighter, less attention-grabbing, and more sophisticated. "Erwartung" (Anticipation), the first song—not to be confused with Schoenberg's later monodrama of the same name—is extremely delicate, quietly radiant, and so is the fourth lied, "Waldsonne" (Forest sun), which teems with nature imagery and memories of love. The second piece, "Schenk mir deinen goldenen Kamm" (Give me your golden comb), is much more intense, with harmonies that bring *Tristan* to mind, whereas the third, "Erhebung" (Exaltation), is a short, rhapsodic love song.

Some of the credit for the gigantic qualitative leap between Op. 1 and Op. 2 must go to the texts that Schoenberg chose to set for the first three of the four Op. 2 lieder. He had discovered them in

16 | SCHOENBERG

a collection called *Weib und Welt: Gedichte und Märchen* (Woman and World: Poems and Tales), which had been published in 1896 by Richard Dehmel (1863–1920), an already well-known and extremely controversial poet who had been taken to court and charged with promoting obscenity and blasphemy in his work—accusations similar to those made against Schnitzler and other "decadent" writers of the day. Although Dehmel was acquitted, the tribunal censured him and ordered that his books be burned—a decision that greatly increased their circulation among liberals in general and young readers in particular. Schoenberg—liberal and young—was immediately attracted to the intense sensuality of Dehmel's works. "Your poems have had a decisive influence on my development as a composer," he would write to Dehmel a few years later. "They were what first made me try to find a new tone in the lyrical mode. Or rather, I found it without even looking, simply by reflecting in music what your poems stirred up in me."*

———

"JESUS BETTELT" (JESUS PRAYS) IS THE SUBTITLE OF ONE OF THE Dehmel poems that Schoenberg set in his Op. 2 lieder, and the composer's use of that text makes one wonder about the degree of sincerity in his decision, taken in 1898, to convert to Christianity. At seventeen he had described himself as a nonbeliever, but at twenty-three he was baptized into the Lutheran faith. Yet here he was, barely a year later, daring to provide music for a poem in which an Oedipal Jesus wants to picture his mother, the Madonna, in her

* Arnold Schönberg Center, http://www.schoenberg.at/index.php/en/joomla-license-3/vier-lieder-fuer-eine-singstimme-und-klavier-op-2-1899. The fourth poem, "Waldsonne," was by Johannes Schlaf, an exponent of Naturalism in drama and poetry, a translator of Whitman and Zola into German, and, late in life, an enthusiastic Nazi.

bath, and then pleads with the reformed prostitute Mary Magdalene to bless him and to lay her heart upon his head.

Still, one wonders why, if Schoenberg had abjured Judaism only for career reasons, he chose to become a Protestant rather than a Catholic. Roman Catholicism was, after all, the state religion of the Austro-Hungarian Empire, in which he had thus far lived all his life, and membership in the dominant faith sometimes served as a meal ticket. It's true that Jews who converted to Christianity, no matter which denomination, were still considered Jews as far as the empire's bred-in-the-bone anti-Semites were concerned. Nevertheless, becoming a Catholic might have provided Schoenberg with the *possibility* of advantages that he could not have enjoyed as a Jew,[*] whereas becoming a Lutheran was an odd move.

A curious fact: Dehmel, who was not Jewish, and Schoenberg, who had formally abandoned Judaism, were each married twice, both times to Jewish or part-Jewish women. Dehmel at one point believed that high cultural achievement depended on racial admixture, but he later claimed that the Jewish influence in German culture had become too strong. This ambivalence was typical of the complicated relationship between the liberal German concept of making the Jews full-fledged Germans through *Bildung*—educational and cultural formation, and specifically Germanic educational and cultural formation—and underlying anti-Semitism. As Steven J. Cahn has convincingly pointed out, in an essay on Schoenberg, Vienna,

[*] Even forty years later, when the young Erich Leinsdorf, a native Viennese Jew (his surname was originally Landauer), asked to conduct some performances with what had by then become the Vienna State Opera in the Republic of Austria, he was told by Erwin Kerber, the ensemble's chief administrator: "Leinsdorf, if the rosary hung down from your fly, I could engage you." (See Erich Leinsdorf, *Cadenza: A Musical Career* [Boston: Houghton Mifflin, 1976], p. 46.)

and anti-Semitism, "*Bildung* anathematized anti-Semitism and fostered a German-Jewish symbiosis, thus serving as a valid basis for German-Jewish identity, yet *Bildung* also contained a latent anti-Judaism that sought to emancipate Jews not only from degradation and persecution, but from Judaism itself."[18]

In the end, Schoenberg's decision to convert to Protestantism set him at odds with the reviled religious minority into which he had been born and yet did him no good with the majority Catholic community that he wished, at least in theory, to win over through his art. This is an early but important example of the aforementioned David-versus-the-Philistines aspect of our subject's behavior patterns. Although a group of acolytes and supporters would soon form around him and would expand almost exponentially in the following decades, Schoenberg evidently needed to feel that the world at large was against him. This perception allowed him to face that world pugnaciously, slingshot in hand, and to avoid defending himself by always going on the offensive, thereby counterbalancing his profound internal insecurity. He made an obvious statement to that effect through the text that he chose for the first of the Six Lieder, Op. 3. "Wie Georg von Frundsberg von sich selber sang" (How Georg von Frundsberg sang of himself), drawn from the folk collection *Des knaben Wunderhorn* (The Youth's Magic Horn), is a complaint on the part of a dutiful knight who considers himself insufficiently appreciated by his lord. "My faithful service remains unrecognized. I receive no thanks or reward for it [. . .]. I have gone through much distress and danger. What joy will it bring me?"*

* ". . . mein treuer Dienst / Bleibt unerkennt. . . . Kein Dank noch Lohn davon ich bring gross Not, Gefahr / Ich bestanden han, was Freude soll / ich haben dran?"

Another bit of biography may perhaps be legitimately extracted from the gently amusing text—by the Swiss writer Gottfried Keller—of the fifth song, "Geübtes Herz" (Well-trained heart): A man compares his loving heart to an old fiddle that has had much joy and sorrow played upon it. As a result, he says, his heart's value, like that of the violin, has increased, and he commends it to the woman he loves as a worthwhile prize. Schoenberg, who had had a series of crushes—including one, at seventeen, on his fourteen-year-old cousin Malvina Goldschmied—eventually fell in love with Mathilde von Zemlinsky, Alexander's sister and a friend of Arnold's own sister, Ottilie. So perhaps not only the poet but also the composer possessed a fiddle-heart. In order to marry Arnold, Mathilde had to convert from Judaism to Lutheranism. (Her brother, Alexander, and Schoenberg's sister and brother, Ottilie and Heinrich, would also become Christian converts and would marry other Christians or Christian converts.) When Arnold and Mathilde married, on October 18, 1901, Mathilde was already six months pregnant. By an odd coincidence, Schoenberg had already written a work based on a text about an unmarried pregnant woman.

————

VERKLÄRTE NACHT (TRANSFIGURED NIGHT), OP. 4, A SEXTET FOR TWO violins, two violas, and two cellos, is the earliest (1899) among the very few works by Schoenberg that have been absorbed into Western art music's nebulously defined, indeed indefinable, "standard repertoire." He took its title from a five-verse, thirty-six-line poem in Dehmel's *Weib und Welt*—the same collection that he had drawn upon for some of his Opp. 2 and 3 lieder. But instead of setting the poem's words in what might have been an extended,

almost cantata-length song, Schoenberg used pure instrumental music to evoke in sound not only the outlines of the poem's story but also and above all the emotional impact that the text had had on him. Just as Berlioz, Liszt, Richard Strauss, and others had deployed full orchestral forces to recount unvoiced stories in their programmatic symphonies or tone poems (think, for instance, of Berlioz's *Symphonie fantastique*, Liszt's *Tasso: Lamento e trionfo*, and Strauss's *Don Juan, Till Eulenspiegel*, and many other works), so Schoenberg now used a chamber ensemble for the same purpose. He even had Dehmel's poem printed at the beginning of his score, so that the work's potential performers could have a fuller understanding of what he was trying to communicate through it. (The poem should always be printed in concert programs, in the original German and/or in translation, wherever it is performed, to allow audiences to enjoy the same advantage.) The story line, a shocker at the turn of the twentieth century, reads today like a hackneyed B-movie or soap opera plot: A man and a woman walk in the woods at night; she confesses that in her desire to have a child she had sinned by giving herself to a stranger whom she didn't love; now she is pregnant but, having found "you," the man she is with and whom she loves, she is full of remorse. Her lover, however, generously tells her that their love will "transfigure" the child, which will be his as well as hers.

Schoenberg's half-hour-long tone poem is constructed as a single unit, not a group of separate movements; that unit, however, comprises five tightly connected segments, each of which corresponds to one of the poem's verses. The piece begins beautifully, mysteriously, in D minor, and modulates into many near and distant keys before it ends in D major; complex tonal relationships are explored

even within each key. In some ways, the piece's hyper-Romanticism and dense textures seem like a return to the excesses of the Op. 1 lieder, rather than a logical progression from the more contained, linear path established in the lieder of Opp. 2 and 3 (some of which, however, were written or revised after *Verklärte Nacht*). Extreme dissonances are especially pronounced in the second and third segments, which correspond to the woman's anguished telling of her story; the tensions ease at the point (bar 229, *Sehr breit und langsam*— Very broad and slow) that reflects the beginning of the man's "love conquers all" declaration.

When *Verklärte Nacht* was first performed in public, by the esteemed Rosé Quartet plus an extra viola and an extra cello, at Vienna's Bösendorfer Hall on October 18, 1902—three years after Schoenberg composed it—some audience members found it not only unbearably dissonant but also morally objectionable. Those matters are unlikely to trouble today's listeners, who can also admire Schoenberg's command of his materials. Late in life, Schoenberg referred to Wagner's influence on the "thematic construction" and the "sonority" of *Verklärte Nacht* and to Brahms's influence on both the "technique of developing variation" and the work's uneven bar patterns. But, he said, "I think there were also some Schoenbergian elements . . . in the length of some of the melodies . . . , in contrapuntal and motival [*sic*] combinations, and in the semi-contrapuntal movement of the harmony and its basses against the melody. Finally, there were already some passages of unfixed tonality which may be considered premonitions of the future."[19]

The work does, however, betray an emotionally adolescent quality, with long stretches of screaming and breast-beating— characteristics that, by the way, are absent from Dehmel's noctur-

nal, quietly emotional poem. (After Dehmel had heard the piece he wrote to Schoenberg: "I had intended to follow the motives of my text in your composition, but soon forgot to do so, I was so enthralled by the music." The compliment seems sincere, but Dehmel may also have been subtly implying that although he liked the music, he found little correspondence between it and the poem.) And when the screaming and breast-beating stop (at bar 229, as above), Schoenberg first falls back on what could be described as "Siegfried's Funeral Music meets the 'New World' Symphony," with respect to thematic material, and then moves through a sequence of major keys—from D to B-flat to D-flat to F and back to D-flat and D—in a drawn-out Romantic gesture of a sort that Schoenberg himself would later describe—in others' works but not his own—as *"Ach, so blumenreiche Romantik"* (Ah, so over-flowery Romantic").[20]

Although *Verklärte Nacht* may be the most frequently performed of Schoenberg's works, it is not one of his most accomplished ones. And no sooner had he finished writing it than he became fascinated by a newly published German translation of some mid-nineteenth-century Danish poems. Setting those texts would occupy him off and on for over a decade. In the meantime, however, a job opportunity opened up for him, and it entailed a change of venue.

In December 1901, two months after their wedding, Arnold and Mathilde Schoenberg moved to Berlin, where the twenty-seven-year-old husband took up a position as music director of Überbrettl, a proto-cabaret ensemble. He no doubt hoped that the job would begin to bring some relief to his dire economic situation—his need to provide for his wife, the baby they were expecting (little Gertrud, known as Trudi, was born in Berlin in January 1902), and himself,

in addition to trying to assist his widowed mother. And perhaps a transfer from hostile Vienna to unknown Berlin appealed to him not only as a potential source of much-needed cash but also as a desirable change of atmosphere. The twentieth century was still new, and young Arnold and Mathilde were full of hope.

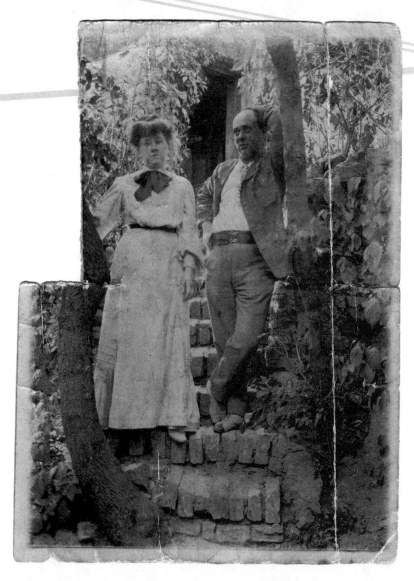

Schoenberg with his first wife, Mathilde, *née* Zemlinsky, at Payerbach, Lower Austria, in 1901. Photograph by Heinrich Schoenberg, Arnold's brother.

II

FORMING THE

BATTLE LINES

Since Austria's humiliating defeat by Prussia in the brief Austro-Prussian War of 1866, and especially after Prussia easily defeated France in the Franco-Prussian War of 1870, the Kingdom of Prussia—transmuted into the German Empire by Wilhelm I and his "Iron Chancellor" Otto von Bismarck— had become the dominant power in continental Western Europe. Franz Joseph's Austro-Hungarian Empire was relegated to second place in the German-speaking world, and Berlin, with a population that had almost quadrupled in forty years, from about 500,000 in 1860 to nearly 2,000,000 in 1900, had supplanted Vienna as that world's de facto political, industrial, and military capital. The citizens of Catholic Vienna liked to see themselves as more easygoing (*gemütlich*) and more culturally advanced than their counterparts in sternly Protestant, northern Berlin, but those stereotypes, like most others, don't bear close scrutiny. With respect to art music, Berlin in 1900 boasted two major opera houses, the Royal Opera "Unter den Linden" and the New Royal Opera in the former Kroll Theater; the city's excellent Philharmonic Orchestra

performed in its own fine concert hall under the baton of Arthur Nikisch, one of the most celebrated conductors in the world; the historic Sing-Akademie zu Berlin was led by the highly respected Georg Schumann; and abundant recitals and chamber music concerts took place in the Beethoven-Saal and elsewhere.

And now there was Überbrettl, which, according to most sources, was Germany's first literary *Kabarett*—a combination of French-style cabaret, English-style music-hall, and German-style gallows humor. Even the company's name was a double parody: *Brettl*—literally, "little board"—had come to mean politically satirical theater, and Überbrettl was a takeoff on the recently deceased Friedrich Nietzsche's concept of the *Übermensch* (superman). In short: Super-cabaret.

Schoenberg's Überbrettl job and the move that it required had come about thanks to his encounter in Vienna with the company's founder, Ernst von Wolzogen (1855–1934), a writer, satirist, and editor who would become an ardent right-wing nationalist during the post–First World War Weimar Republic and a Hitler enthusiast even before the Nazis came to power. He was also the half-brother of Baron Hans Paul von Wolzogen (1848–1938), co-founder and editor of Richard Wagner's self-serving, jingoistic, anti-Semitic periodical, *Bayreuther Blätter*, which the baron would continue to oversee until his death. But in 1901, the baron's forty-six-year-old brother Ernst was the opposite of an ultra-conservative racist. He had opened the avant-garde-leaning Überbrettl, with its strong Jewish contingent, early that year in a venue near Berlin's central Alexanderplatz, and at first the ensemble enjoyed great success: would-be audience members had to reserve tickets weeks in advance, and the company even traveled to Vienna in April and September. Its music director at the time was Oscar Straus (1870–1954), a native of Vienna who had

FORMING THE BATTLE LINES | 27

previously served as an assistant conductor to Mahler at the Hamburg Opera and who would later become famous as a composer of operettas and film scores. One of Überbrettl's September performances in Vienna fell on the eve of Yom Kippur, the Jewish day of atonement, and as Straus's devout uncle—who, it seems, helped him out financially—obliged him to attend synagogue services that evening, Straus persuaded Wolzogen to engage Schoenberg as his one-time substitute. Schoenberg's work impressed Wolzogen, who later described the young musician's "small build, harsh features, and dark complexion," and who invited him to become Überbrettl's new music director in Berlin.[1]

By December 1901, the month in which Schoenberg arrived in the German capital, financial problems had forced Wolzogen to relocate his ensemble to the Kreuzberg district, which was then a poor, overpopulated area of the city. He engaged the architect and designer August Endell to decorate a small theater, in keeping with the dictates of the fashionably radical Jugendstil (Art Nouveau style), and there, in what was redubbed the Buntes (Colorful) Theater, Überbrettl's performances continued.

The company's repertoire consisted of songs and more substantial musical-theatrical pieces; many of the songs were settings of poems taken from the *Deutsche Chansons* collection of Otto Julius Bierbaum (1865–1910),* whose satirical *Stilpe, Ein Roman aus der Frosch Prospektive* (Stilpe, a Novel from the Frog's Perspective) had been Wolzogen's initial inspiration for creating Überbrettl. Other song texts included poems by Schoenberg's acquaintances Levet-

* Bierbaum believed that art could be simultaneously utilitarian, amusing, and intellectually engaging—an idea that had much in common with Vienna's contemporaneous Secession and subsequent Werkstätte artistic movements. He is remembered today as the originator of the popular German saying, "*Humor ist, wenn man trotzdem lacht*" ("Humor is when you laugh anyway").

zow and Dehmel and by such popular writers as Christian Morgenstern and Bierbaum himself. Also performed were items by the ever-controversial Arthur Schnitzler and the even more notorious Frank Wedekind, who, at thirty-seven, had already written two of his most scandal-provoking works, *Frühlings Erwachen* (Spring's Awakening) and *Erdgeist* (Earth Spirit). Most of these writers were artistic radicals, and all of them were viewed by conservatives as wreckers of traditional religious and moral precepts and as questioners of the established political order; the writers' presence, whether only literary or also physical, created the ensemble's main appeal to Berliners of liberal leanings.

What exactly Schoenberg's job as Überbrettl's music director entailed is unclear today and may have been unclear, at least in part, to Schoenberg himself. Even before his move to Berlin he had composed eight cabaret-style songs for the company; these pieces, now known as the Brettl-Lieder, are brief satirical gems, some of them harmonically and rhythmically striking and by no means easy for performers. Seven of the eight are scored for voice accompanied only by the piano, but the eighth, "Nachtwandler" (Night Stroller), also requires piccolo, trumpet, and snare drum; as far as is known, only "Nachtwandler" was ever performed at Überbrettl, and that one only once, because the trumpet player claimed that his part was too difficult. Or perhaps, as Schoenberg biographer Allen Shawn has suggested, the audience was put off by the composer's "subverting the directness of the [popular cabaret] style with asymmetries of phrasing and momentary tonal ambiguities," inasmuch as the Überbrettl songs "anticipated by twenty-five years the sophisticated music theater style of [Kurt] Weill and [Hanns] Eisler."[2] Besides, as the person responsible for the company's performances, Schoenberg must have been hampered by his lack of

keyboard fluency, whereas Oscar Straus, his predecessor, was an accomplished pianist.

Whatever Schoenberg's satisfactions or disappointments at Überbrettl may have been, he still had to supplement his meager wages by orchestrating other people's music. Worse still, the ensemble's original audiences found the new Kreuzberg location less central and therefore more inconvenient than the Alexanderplatz theater, and attendance dwindled until, in May 1902, Wolzogen, strapped for funds, withdrew from the venture. The Buntes Theater became a venue for other entertainments, and Schoenberg's contract was not renewed.

He would probably have been in despair had he not in the meantime made the acquaintance of Richard Strauss, who, although only ten years older than Schoenberg, was already the best-known musical modernist in the German-speaking world and beyond. Strauss's tone poems *Don Juan, Tod und Verklärung* (Death and Transfiguration), *Till Eulenspiegel, Also sprach Zarathustra, Don Quixote*, and *Ein Heldenleben* (A Hero's Life) were already being performed all over Europe and in the Americas, and within a few years his operas would outpace in popularity those of any other living German composer. In fact, the successful premiere of his second opera, *Feuersnot*, had taken place only a month before Schoenberg's move to Berlin,[*] and the author of the work's scandalous libretto was none other than Ernst von Wolzogen. One needn't go too far out on a biographical limb to surmise that Schoenberg met Strauss through Wolzogen.

Strauss was impressed with the compositions that Schoenberg

[*] *Feuersnot* (Need for Fire), like its predecessor, *Guntram*, was superseded within a decade by *Salome, Elektra*, and *Der Rosenkavalier* and has not maintained a place for itself in the so-called "standard" opera repertoire, although it is occasionally revived. Early in its existence, however, it was widely performed throughout the German-speaking world.

showed him. He immediately helped him, first by arranging for him to teach composition at Berlin's Stern Conservatory; then by paying him to help with the copying of the instrumental and vocal parts of his *Taillefer*, a short, massively orchestrated potboiler of a cantata that he had written for the University of Heidelberg, where he was to receive an honorary doctorate; and, finally, by backing Schoenberg's ultimately successful application for a grant awarded annually by the Liszt Foundation. In a letter written at the time, Schoenberg described Strauss as "a wholly wonderful and warm-hearted person."[3]

What had particularly impressed Strauss was the work that Schoenberg had done up to that time on the *Gurrelieder*—settings of a recent German translation of the mid-nineteenth-century Danish poet Jens Peter Jacobsen's *Gurresange*—Songs of Gurre, a verse version of a medieval tale of illicit love and terrible revenge.* In Vienna early in 1900, Schoenberg had composed voice-and-piano settings of nine of these poems, with the intention of entering them in a song-cycle competition organized by the city's Tonkünstler-verein (Musical Artists' Society). Versions of what happened differ: either Schoenberg missed the competition's deadline or he simply decided not to bother submitting the songs because he and Zemlinsky deemed them too original to stand a chance of winning. In either case, he quickly completed the cycle but then began to think of expanding it into a vast, three-part choral-orchestral work with solo voices—a sort of operatic oratorio made up of scenes, many of which are disconnected from each other, time-wise, along the lines of Berlioz's *La Damnation de Faust*. (There is no indication, how-

* Gurre was the site of the twelfth-century royal castle that is the story's main location. The castle's ruins are located about thirty-five kilometers north of Copenhagen.

ever, that Schoenberg was familiar with that half-century-old masterpiece, which was rarely performed at the time.) He had special forty-eight-staved music paper printed, with the intention of scoring the *Gurrelieder* for an orchestra of a size that not even Strauss had employed up to that time: four flutes, four piccolos, three oboes, two English horns, three clarinets (all three switching between instruments in B-flat and A), two E-flat clarinets, two bass clarinets, three bassoons, two contrabassoons, ten horns (with the seventh through tenth doubling on Wagner tubas), six trumpets, bass trumpet, alto trombone, four tenor trombones, bass trombone, contrabass trombone, tuba, six timpani, percussion (tenor drum, snare drum, bass drum, large iron chains, cymbals, glockenspiel, ratchet, tam-tam, triangle, and xylophone), four harps, celesta, and a huge string section made up of twenty first violins, twenty second violins, sixteen violas, sixteen cellos, and twelve double basses. In addition, there were to be three four-part male choruses, an eight-part mixed chorus, a narrator, and five solo singers: soprano, mezzo-soprano, two tenors, and bass-baritone.

Schoenberg began the process of orchestration in August 1901 but was interrupted by his ongoing hackwork, which was necessary for sheer survival, and then by the upheaval owing to Mathilde's pregnancy, their marriage, their move to Berlin, the birth of their daughter, his Überbrettl duties, and other tasks. He did not resume work on the *Gurrelieder* until mid-1902, and then only briefly. How much of the orchestration he had been able to show Strauss is unclear, yet whatever there was sufficed to convince the older composer not only of his young colleague's originality but also of his competence—and Strauss, the consummate professional musician, would not have given Schoenberg a second thought had he not considered him a fully formed and thoroughly competent practitioner

of the art of composition. Perhaps Strauss even perceived that the *Gurrelieder* would become a landmark achievement.

———

THE INDIVIDUAL SONGS THAT MADE UP THE ORIGINAL PIANO-VOCAL version of the *Gurrelieder* cycle are well worth getting to know in that form; those music lovers who are not fond of supersized orchestral spectaculars may even prefer listening to them this way. The first two songs—tenor Waldemar's "Nun dämpft die Dämmerung" and soprano Tove's "Oh, wenn des Mondes Strahlen leise gleiten"—are deeply, quietly sensual; others vary greatly in tone. "Ross! Mein Ross!" is impetuous; much of "Es ist Mitternacht" expresses anguished foreboding; "Du sendest mir" is at times reminiscent of Isolde's Liebestod, not only in its musical content but also in its demands on the soprano; and the multifaceted, eleven-minute-long song of the *Waldtaube* (turtledove—a mezzo-soprano) begins like a melancholy siciliana but then undergoes a series of bold harmonic and dramatic transformations. Tove's joyful "Sterne jubeln" is essentially a waltz, the go-to genre for every turn-of-the-twentieth-century Austro-German composer who wanted to express exaltation—even, for instance, the brilliantly kitsch, murderously orgasmic waltzes of the title ladies in Strauss's *Salome* and *Elektra*.

Like Wagner at the beginning of *Das Rheingold* and *Die Walküre*, Schoenberg opened the *Gurrelieder*—in their final, orchestral form— with extended instrumental passages that establish the tone of what will be the work's first main segment. And, again like Wagner in the opening passages of the *Ring*'s first two music dramas, Schoenberg deployed stunning instrumental textures to create a chain of atmospheric passages, rather than producing a formal prelude or overture. But unlike Wagner, whose textures are nearly always transparent no

FORMING THE BATTLE LINES | 33

matter how heavy his instrumentation may be, and who put together multiple strands of sound in such a way as to make them all audible (apart from simple doublings), Schoenberg, in the first two of the *Gurrelieder*'s three parts, followed Strauss's technique of creating what I think of as "sound platforms"—intentionally thick subordinate passages on top of which the main musical motifs are meant to appear in high relief. Not even Pierre Boulez, a wizard at extricating every musical line from dense passages that defeat most conductors, was able to shine light onto all of the ornamental figurations and other decorative elements in the *Gurrelieder* score.

There is a noteworthy schism, however, between the first two parts of the *Gurrelieder*, on the one hand, and the third, final part on the other. According to Leonard Stein, Schoenberg's assistant during the composer's American years, Schoenberg himself said that nearly the whole massive piece was completed in 1901, before his move to Berlin, "with only the final chorus in rough sketch and the orchestration more or less worked out. However, the pressure of earning a living . . . , the apparent hopelessness of securing a performance of a work of such magnitude, and, probably most important, the changes of style and expression that were taking place in his own compositions, caused him to put aside this work for a number of years." When he finally took it up again, a decade later, he "made a few revisions," Stein reported, but did not rewrite the earlier parts of the work. Thus the score's last few numbers, with their still supersized but slightly more transparent orchestration, have a different sound than the rest of the piece—"a matter [Schoenberg] was well aware of," Stein said.[4]

In listening to the *Gurrelieder* one would never guess that only a few years earlier Schoenberg had been a dedicated Brahmsian and a Wagner-skeptic: Wagner's spirit presides over this work, and not only because Schoenberg makes use of Wagner-inspired leitmotivs—

musical motifs that represent specific characters, places, objects, or ideas. With respect to harmony and expressive content, too, the *Gurrelieder* are Wagner's direct descendants, especially in the work's first two parts. In Part One, Waldemar's "So tanzen die Engel" and Tove's responsive "Nun sag ich Dir," for instance, seem almost to have sprung out of the exchange between Siegmund ("Winterstürme wichen dem Wonnemond") and Sieglinde ("Du bist der Lenz") in the first act of *Die Walküre*. The main difference—apart from the fact that Schoenberg, two generations younger than Wagner, sometimes pushed harmonic combinations and progressions even further than his predecessor had done—is that the characters' emotions and soul-states often change more quickly here than in even the most intense Wagnerian scenes. Wagner's characters famously tend to dwell at considerable length on their thoughts and feelings, and yet Wagner was a master of holding back, of making listeners wait for a scene's climax; Schoenberg, on the contrary, often piles one orchestral explosion onto another, climax atop climax, clashing mood-change over clashing mood-change, as, for instance, in "Ross! Mein Ross!" This procedure weakens the dramatic structure of a work that, although it is not a theater piece, is certainly a drama.

The *Gurrelieder*'s Part Two, which consists only of Waldemar's anguished, blasphemous "Herrgott, weisst du, was du tatest," maintains the thick orchestral textures of Part One, and so do Part Three's first three segments: Waldemar's "Erwacht, König Waldemars Mannen wert!" the Peasant's "Deckel des Sarges klappert und klappt," and Waldemar's troops' "Gegrüsst, o König, an Gurre-Sees Strand!" But with the Fool's entrance ("Ein seltsamer Vogel") the tone changes. Wagner is still a hovering presence, but now it is the Wagner of *Die Meistersinger*—including, I think, a tip of the hat to the master's satirical treatment of Beckmesser. (Let's not get into the

FORMING THE BATTLE LINES | 35

question of Wagner's presumed use of Beckmesser for anti-Semitic purposes, especially since we don't know whether Schoenberg's adoption of Beckmesser-like music was conscious, or, for that matter, whether my identification of the musical relationship is correct.) Finally, the third part's brilliantly orchestrated prelude and monodrama (with narrator), "Des Sommerwindes wilde Jagd"—"Herr Gänsefuss," are charmingly, flowingly transparent, and they lead directly into the powerful, radiant final chorus, "Seht die Sonne!"

Stein's list of reasons for Schoenberg's long delay in completing the *Gurrelieder* is convincing and bears summarizing: (1) lack of time, owing to his need to earn money through hackwork; (2) the extreme unlikelihood of a little-known composer managing to have so vast and demanding a work performed; and (3) the composer's ongoing musical development during the period in question. A complete performance did eventually take place, but let's save that story for later. More immediately tantalizing is the question of why, in 1901, a little-known, struggling composer in his twenties would have decided to focus on so gargantuan a project (a complete performance of the *Gurrelieder* lasts about an hour and three-quarters and requires, ideally, at least two hundred fifty participants) as a first serious venture into writing for orchestra and chorus, instead of trying his hand at one or more compositions that might at least have had a chance of being performed reasonably soon. In this case, as with Schoenberg's decision to convert to Lutheranism rather than Catholicism in Catholic Vienna, one can hardly help noting his apparent, albeit perhaps subconscious, need to create his own stumbling blocks so that he could say that his head was "bloody, but unbowed." It's true that his astonishing gift and radical ideas would have led him in any case into direct battle with the prevailing forces of his day, but he seems to have had an

36 | SCHOENBERG

additional talent for making matters even worse for himself than they need have been.

A final comment on the *Gurrelieder* comes from Schoenberg himself. Late in life, he joked that he could just as well have orchestrated it with harmonium and guitar[5]—in other words, experience had in the meantime taught him how to make a strong musical impact without having to resort to massive orchestral effects.

———

THE ONE MAJOR WORK THAT SCHOENBERG COMPLETED DURING THE first of what would prove to be several Berlin periods in his career was the tone poem *Pelleas und Melisande*, Op. 5, composed between the summer of 1902, after his Überbrettl job came to an end, and late February 1903. According to some sources, it was Richard Strauss who had turned Schoenberg's attention to Maurice Maeterlinck's Symbolist play *Pelléas et Mélisande* and had suggested that his younger colleague write an opera based on it. Oddly, neither Strauss nor Schoenberg seems to have been aware that Claude Debussy, whose music was still little known outside France, had completed an opera on that text, and that that opera had had its premiere at Paris's Opéra-Comique, on April 30, 1902, presumably not long before Strauss first mentioned the idea to Schoenberg. Schoenberg later wrote: "I had first planned to convert *Pelléas and Mélisande* into an opera, but I gave up this plan, though I did not know that Debussy was working on his opera at the same time." (Debussy's opera had in fact been completed by 1898, but its premiere had been delayed.) Schoenberg continued:

> I still regret that I did not carry out my initial intention. It would have differed from Debussy's [opera]. I might have

FORMING THE BATTLE LINES | 37

missed the wonderful perfume of the poem; but I might have made my characters more singing.

On the other hand, the symphonic poem helped me, in that it taught me to express moods and characters in precisely formulated units, a technique that my opera would perhaps not have promoted so well.

Thus my fate evidently guided me with great foresight.[6]

Whatever the correct "origin story" of Schoenberg's *Pelleas und Melisande* (without the acute French accent marks) may be, and notwithstanding his view, through hindsight, of Destiny showing him the way toward becoming the famously controversial Arnold Schoenberg of later years, the fact is that in this work he created a vast, three-quarters-of-an-hour-long orchestral canvas in which he depicted in sound eight of the fifteen scenes that make up Maeterlinck's play. I agree with Boulez's statement that a comparison between Debussy's and Schoenberg's same-named works "is not justified. One must content oneself with saying that Debussy's aesthetic is [. . .] newer than the romantic pathos in which Schoenberg's work [. . .] is bathed."[7] Debussy was a dozen years older than Schoenberg, and by the time he wrote *Pelléas* his musical personality was fully formed; Schoenberg's *Pelleas*, despite its original elements, is situated entirely within the confines of late German Romanticism.

Alban Berg, in a later analysis of Schoenberg's tone poem, described it as having a four-movement symphonic structure, with leitmotivs connected to individual characters, states of being, and so on, as in the *Gurrelieder*.[8] And, again as in the *Gurrelieder*, Schoenberg demanded a lavish, post-Wagnerian complement of instruments: *Pelleas* requires seventeen woodwind players, eighteen brass, two timpanists, six percussion instruments, two harps, and sixty-

four string players. Years later, he would say that he considered the music of his *Pelleas* far more advanced than, and just as beautiful as, the *Gurrelieder.*[9]

Did Schoenberg try to have his new work performed in Berlin or anywhere else, perhaps by enlisting support from Strauss or from another recent Berlin acquaintance, the famed composer and piano virtuoso Ferruccio Busoni? If so, his efforts were unsuccessful. And within a few months of having completed *Pelleas*, Schoenberg's financial situation had deteriorated to such a degree that in July 1903, little more than a year and a half after having arrived in Berlin, Arnold and Mathilde moved back to Vienna, with little Berlin-born Trudi. As Willi Reich, one of Schoenberg's biographers, pointed out, the still young composer brought back to his native city not only the impressive *Pelleas* score but also the experience that he had acquired as an instructor at Berlin's Stern Conservatory—"the first practical demonstration of his genius for teaching," Reich said. This ability would be a mainstay of Schoenberg's survival for the rest of his life and would "bring forth fruit a hundredfold."[10]

ALTHOUGH THERE IS NO EVIDENCE THAT SCHOENBERG EVER ENCOUNtered Sigmund Freud, a fellow Viennese Jew who was his senior by half a generation, people who knew the composer remembered him discussing Freud's theories with friends, or at least using what little he knew of those theories as touchstones for his own thoughts on subjects psychological. During the eight years of what was, in effect, Schoenberg's Second Viennese Period, from 1903 to 1911, Freud published six important books, including *The Psychopathology of Everyday Life* and *Three Essays on the Theory of Sexuality*; three

major case studies ("Dora," "Little Hans,"* and the "Rat Man"); and several key papers.

But Freud was in no way the only significant cultural figure in Vienna in those years, and Schoenberg did come into direct contact with several of the others, including his exact contemporary, the controversial writer and journalist Karl Kraus (1874–1936); the slightly older modernist architect Adolf Loos (1870–1933); and the very young painter Oskar Kokoschka (1886–1980). Kraus once gave Schoenberg excellent advice as to why not to respond to negative newspaper criticism of his work; Kokoschka's relationship with Schoenberg was at first superficial and would develop later on. But Loos was probably responsible for introducing Schoenberg to Eugenie Schwarzwald (*née* Nussbaum; 1872–1940), an educationist, feminist, social activist, and *salonière* who was one of the first women in the German-speaking countries to receive a university doctorate, and who had set up a forward-looking school for girls and young women in Vienna at a time when the Austrian government did not support public education for females over the age of fourteen.

"Frau Doktor" or "Genia," as Schwarzwald was known, was thirty-one in 1903, at the time of Schoenberg's return to Vienna, and was married to Hermann Schwarzwald (1871–1939), an up-and-coming financier who, two decades later, would help stabilize the fledgling Austrian Republic's banking system in the aftermath

* The "Little Hans" of Freud's study of early castration anxiety and the Oedipal complex was the son of the Viennese music critic Max Graf. The boy, Herbert Graf (1903–1973), grew up to become one of the best-known opera stage directors of his day. Among many other achievements, he put on the premiere production of Schoenberg's *Von heute auf morgen*, in 1930, and, after fleeing from the Nazis and immigrating to the United States, he was a leading stage director at New York's Metropolitan Opera.

40 | SCHOENBERG

of the terrible post–World War I inflationary period.* In 1903–4, Schoenberg, Zemlinsky, and one of their pupils, Elsa Bienenfeld, set up music courses within Frau Doktor Schwarzwald's school buildings; Schoenberg taught harmony and counterpoint, Zemlinsky form and orchestration, and Bienenfeld music history.† The enterprise would not endure, but Schoenberg's connection to the Schwarzwald school would produce further results later on.

The best-known and most helpful of Schoenberg's new Viennese acquaintances was Gustav Mahler, who at the time was less famous as a composer than as the outstanding, irascible conductor of the city's Court Opera—a position he had held since 1897. In 1902, after having read through the score of *Verklärte Nacht*, Mahler, who was fourteen years older than Schoenberg, had suggested to his brother-in-law, Arnold Rosé, concertmaster of the Opera orchestra and the Vienna Philharmonic, that Rosé perform it with his string quartet (plus second viola and second cello), and his suggestion had led to the work's contentiously received premiere. Schoenberg, who was still in Berlin, did not attend that performance. He and Mahler may have met for the first time when Rosé reprogrammed *Verklärte Nacht* on a concert in March 1904, but it was not until the following December, when Schoenberg, Zemlinsky, and some of their students attended Mahler's final rehearsal for the Viennese premiere of his

* For more information on the fascinating Schwarzwalds, see the essay "'Genia' Schwarzwald and Her Viennese 'Salon'" by Deborah Holmes, in G. Bischof et al. (eds.), *Austrian Lives* (see my Bibliography), and the German book *Leben mit provisorischer Genehmigung* (H. Deichmann, ed., Bibliography). I wrote briefly about the Schwarzwalds in my Profile of Hans Deichmann, "Der Ordinäre," in *The New Yorker*, June 4, 1990.

† Bienenfeld (1877–1942), also of Jewish descent, was an important Austrian musicologist and music critic during the early decades of the twentieth century, but in 1938 she was forbidden to exercise her profession. In 1942 she was deported to and killed at the Maly Trostinets concentration camp near Minsk.

Third Symphony, that Schoenberg felt the full impact of Mahler's music. Later that same day, he wrote to Mahler:

> I saw your soul naked, stripped bare. It lay before me like a wild, mysterious landscape with terrifying reefs and chasms; and at the next turning there were delightful, sunlit meadows, idyllic resting-places. . . . I saw the forces of good and evil locked in mortal combat, saw a man agonizingly striving for inner harmony, sensed a human being, a drama, the *truth*, the unrelenting truth.[11]

After that, Mahler and Schoenberg saw each other on many occasions. The older composer appreciated the younger one's gifts but found his touchy personality hard to take. According to the wildly unreliable memoirs of the notoriously beautiful and seductive Alma Mahler-Werfel, Mahler's widow, her husband and Schoenberg once had such a stormy argument that Mahler told her not to let "that conceited puppy" into their home again.[12] But they made up (Schoenberg and Zemlinsky even visited the Mahlers at their summer home, Maiernigg, on the Wörthersee in Carinthia, in July 1905, when Gustav was completing his Seventh Symphony), and Mahler, although he found some of Schoenberg's musical experiments puzzling, helped him financially. "During his last days and while his mind was still unclouded," Alma recalled, "his thoughts often went anxiously to Schoenberg. 'If I go, he will have nobody left.' "[13]

Shortly after Mahler's death, in 1911, Schoenberg wrote about him as a "saint" and "martyr," but in later years, after having learned of some doubts that Mahler had expressed about him, his enthusiasm dimmed somewhat. The fact that the worldwide demand for performances of Mahler's music did not begin until after Schoen-

berg's death may also account for some of the latter's neglect of his sometime-mentor's posthumous reputation: perhaps the story of a fellow Austrian Jew whose work was not widely performed even two, three, and four decades after his death may have been too painful for Schoenberg to contemplate.

———

ARNOLD, MATHILDE, AND ONE-YEAR-OLD TRUDI HAD AT FIRST TAKEN up residence in the same house as Zemlinsky*—Mathilde's brother—upon their return to Vienna in 1903, and despite their straitened economic circumstances the Schoenbergs were able to spend part of the summer in the resort village of Payerbach in Lower Austria, about a hundred kilometers southwest of Vienna, where Arnold resumed work on the orchestration of the *Gurrelieder* before again setting the task aside. (One of the mysteries of Schoenbergian biography is that he nearly always managed to spend his summer working holidays in desirable places, no matter how little money he had in his wallet. Perhaps kind friends assisted him financially, or simply hosted him and his family—or both.) All in all, the year was a musically productive one for him: he put the finishing touches to the six songs that would eventually appear as his Op. 3; began work on what would become the Eight Songs, Op. 6, and the Six Songs for voice and orchestra, Op. 8; and had the satisfaction of finally seeing two of his works—the Op. 1 and Op. 2 songs—appear in print, under the aegis of the Dreililien publishing company in Berlin.

Schoenberg had given up teaching at the Schwarzwald school

* This according to most sources. But according to others, the Schoenbergs lived in the same house as Arnold's sister, Ottilie, and her family, and only next door to Zemlinsky. They may all have been living in the same apartment building.

in 1904 because—as far as can be determined—he believed that there weren't enough talented composition students in his class. But his name had come to the attention of several young aspiring musicians, including the future composer and musicologist Egon Wellesz (1885–1974), who would eventually become one of Schoenberg's earliest biographers. Wellesz later recalled his first visit, in October 1905, to a "small, dark room facing onto the courtyard, at No. 68–70 Liechtensteinstrasse. Arnold Schoenberg, cigarette in hand, his head inclined, pacing ceaselessly to and fro. On a chest, a parcel of unusually large music paper—the still incomplete score of the *Gurrelieder.* On the music desk of the piano, the recently published vocal score of Strauss's *Salome,* open at the first page. Schoenberg said, 'Perhaps in twenty years' time someone will be able to explain these harmonic progressions theoretically.' "[14]

Wellesz said that he and his fellow students "were interested in all that was new and out of the ordinary, and all of us had a strong dislike of the cut-and-dried instruction given us at the Conservatoire at the time. It was less the method that disturbed than the feeling that the teachers incessantly criticized all that seemed to us to be great and important."[15] Yet Schoenberg, despite the fact that in his own work he was pushing forward in ways that stimulated the imaginations of the younger generation, wanted his pupils to study the great composers of the past. "Don't try to learn anything from this," he wrote in a copy of one of his own works that he gave to the young composer Karl Horwitz (1884–1925); "rather learn from Mozart, Beethoven, and Brahms! Then, perhaps, some of the things contained here will strike you as worthy of consideration."[16] Along with Wellesz and Horwitz, Schoenberg's private students soon came to include the future musicologists Heinrich Jalowetz (1882–1946) and Erwin Stein (1886–1958) and, most famously and

44 | SCHOENBERG

most significantly, the composers Anton Webern (1883–1945) and Alban Berg (1885–1935). So powerful was his influence on these, his younger contemporaries, that Jean Sibelius would later say—only half-jokingly—that Schoenberg's greatest works were his students. And indeed, about Schoenberg as a teacher, Jalowetz wrote, a few years later: "All the artistic rules which seem dry in old text-books and from the lips of bad teachers appear in his lessons to have been born at that moment from an immediate perception [. . .]. In this manner every stage of his teaching becomes an experience for his pupil, and really sinks into his personality."[17]

Some of the students, together with Schoenberg, Zemlinsky, and a few others, set up what they called the *Vereinigung schaffender Tonkünstler* (Union of Creative Musicians), as a counterfoil to the overall conservatism of Viennese musical life. Mahler himself accepted the double position of honorary president and principal conductor, and during the group's first and only season, 1904–5, he conducted the world premieres of his *Kindertotenlieder* and parts of *Des Knaben Wunderhorn* as well as the Viennese premiere of Strauss's *Sinfonia Domestica*. Other new works presented by the Union included Zemlinsky's orchestral fantasy *Die Seejungfrau* (The Mermaid) and Schoenberg's *Pelleas und Melisande*—each work conducted by its composer. Wellesz later recalled "how difficult it was to get a grasp" of *Pelleas*, and that "Mahler himself had no easy task ... to get a lucid idea of the part-writing,"[18] although some of the problem may have been attributable to Schoenberg's mediocre abilities as a conductor. Schoenberg, toward the end of his life, remembered that the reviews of *Pelleas* had been "unusually violent, and one of the critics suggested to put me in an asylum and keep music paper out of my reach."[19] Another critic described the work as "an assassination of

sound, a crime against nature"[20]—a puzzling remark about a piece that, although harmonically bold, was by no means belligerently radical. But no one who knew Vienna well was surprised by any of this. Paul Stefan (1879–1943), a music critic and historian, and the author of one of the earliest studies of Mahler's life and work, described local attitudes toward music and toward life in general at the time as consisting of a "lack of persistence, fear of anything new, [. . .] a cold heart and lack of hospitality, a frame of mind that can only be called *petit-bourgeois* and bureaucratic, a need to dominate."[21] In other words, not welcoming toward The New, whatever that might be.

Nothing, however, could stop Schoenberg from forging ahead on his musical path—a path that was constantly twisting and turning in audacious new directions. Before 1905 was at an end he had completed not only the previously mentioned Six Songs for voice and orchestra, Op. 8, but also his String Quartet No. 1, in D minor, Op. 7. (He did not admit the early String Quartet in D Major into the official canon of his works.) This piece, more than forty minutes long but in a single-movement form, mixes all sorts of elements— extreme fast and slow tempi, sonata form and scherzo fragments, juxtapositions of harsh dissonance against pure diatonic melody, and much else. A thorough study of the first movement of Beethoven's "Eroica" Symphony while he was writing this quartet had taught him, he said, "how to avoid monotony and emptiness; how to create variety out of unity; how to create new forms out of basic material; how much can be achieved by slight modifications if not by developing variation out of often rather insignificant little formulations. From this masterpiece I learned also much of the creation of harmonic contrasts and their application."[22] This declaration conclusively demonstrates the eclectic quality of the creative mind, because

the *Allegro con brio* of the "Eroica," despite its thematic variety and high drama, is essentially a model of self-possession and rock-like stability, whereas Schoenberg's First Quartet rarely maintains any individual state of being for more than a few seconds—a fact that detracts nothing from the wealth of invention and the overall power of his first mature venture into the string quartet literature but that is fascinating all the same.

Then, in 1906—the year in which Mathilde gave birth to their son, Georg (Görgi)—Schoenberg wrote his extraordinary *Kammersymphonie* (Chamber Symphony) No. 1, in E Major, Op. 9, with which, in the opinion of this writer, he truly became Arnold Schoenberg, a twentieth-century composer. In all of his previous works, including the recent string quartet, no matter how bold his harmonies or how radical his authorial voice may have sounded to audiences of the time, today's listeners can perceive, above all else, the dense textures and the nineteenth-century *Schwärmerei*—overblown passions—of the late Romantic era. Nor was he done with the *Schwärmerei*: they would reappear, with the addition of some Freudian-era angst, in many of his subsequent works. But the Chamber Symphony, scored for only fifteen solo instruments, swept away the dust and cobwebs that had burdened Schoenberg's style until that moment. The emotion is as intense as in his earlier works, but the doors and windows have been flung open and fresh air has entered the house. Just as his architect friend Adolf Loos was about to shock Vienna with the externally unadorned, internally luminous Goldman & Salatsch building (now called the Looshaus) in the city's center, so Schoenberg shocked local music lovers by suddenly turning away from the gigantic orchestra and vast pro-

portions of Mahler's symphonies and Strauss's later tone poems and recent *Sinfonia Domestica*, and of his own *Gurrelieder* and *Pelleas*. Instead, he presented a symphonic work of slim proportions and pared-down instrumentation.

Today, the Chamber Symphony feels like a liberation, but its premiere in Vienna's Musikvereinssaal on February 8, 1907—with Schoenberg conducting the Rosé Quartet plus eleven other members of the Court Opera Orchestra—provoked impatient and derisive reactions. The local correspondent of Berlin's *Vossische Zeitung* commented insultingly that although he was not indulging in the shenanigans of Vienna's *Fasching* (carnival), he had attended the Schoenberg premiere "so as not to lose touch completely with the spirit of Eternal Foolery."[23] According to Alma Mahler (and in this case her recollection is backed up by others who were present), some audience members "began to push their chairs back noisily half-way through, and some went out in open protest. Mahler got up angrily and enforced silence," she recalled. "As soon as the performance was over, he stood at the front of the dress-circle and applauded until the last of the demonstrators had gone." Afterward, he admitted: " 'I don't understand [Schoenberg's] music . . . , but he's young and perhaps he's right. I am old and I daresay my ear is not sensitive enough.' " (Mahler was only forty-six at the time; Schoenberg was thirty-two.) Yet, she added, "There was undoubtedly more behind the appeal Schoenberg's music made to Mahler, or else he would not have shown up so prominently as his champion."[24] By a curious coincidence, Mahler had composed his Eighth Symphony, which lasts nearly an hour and a half and requires enormous forces (thus its nickname, the "Symphony of a Thousand"), in 1906, precisely while Schoenberg

was writing his Chamber Symphony, which lasts twenty minutes and requires only fifteen players.*

Despite its reduced instrumental complement, the Chamber Symphony is in no way a "neoclassical" piece, in the sense in which the term is applied to Stravinsky's works of the 1920s, '30s, and '40s: in those pieces, bold twentieth-century harmonies and (above all) rhythms were applied to eighteenth- and nineteenth-century forms, often with chamber orchestra–sized ensembles. The *Kammersymphonie*, on the contrary, remains—as each of Schoenberg's works remains—an example of late Austro-German Romanticism or post-Romantic Expressionism. The score is chock-a-block not only with common technical indications (for instance, "at the frog" and "at the bridge" for the strings) but also with detailed and occasionally expressionistic instructions to potential performers: *deutlich* (clearly), *etwas zögernd beginnen* (begin somewhat hesitantly), *fast ohne jede Verlangsamung* (almost without any slowing down), *schmetternd* (resounding), *schreiend* (shouting), and so on. The musical texture has been focused in a new, more sinewy, more vibrant way, but the expressive impulse is emotive, sometimes to an extreme degree.

In form, the *Kammersymphonie* may be considered either a mini-symphony with short, contiguous movements or (more logically, in my opinion) an extended, multi-themed, segmented single movement. Schoenberg at times pushes tonal barriers to their limits, but the key of E major feels at least vaguely like "home" through

* Schoenberg provided a chart to show how the musicians were to be grouped: in the front row, from left to right, the flute, second violin, first violin, conductor, cello, and double bass; next, directly in front of the conductor, the viola; in the third row, from left to right, the oboe, English horn, clarinet in D, clarinet in A, bass clarinet, bassoon, and contrabassoon; and, centered in the back row, two horns. He presumably meant for the instrumentalists in the front row not to be entirely flush with the conductor—otherwise they wouldn't be able to see the beat or the cues. Why the viola was to have a row of its own is a mystery.

several parts of the piece and makes itself felt in no uncertain terms in the work's exhilarating ending—just as, in the preceding First String Quartet, all the harmonic meanderings lead unmistakably to D major.

There are technical difficulties for the performers, the most obvious one being balance between strings and winds: since ten wind instruments can easily counterbalance an orchestra's entire string section, in this case conductors face the problem of making only five string instruments audible against ten winds. One wonders, for instance, what Schoenberg had in mind at rehearsal 28 in the score, where the flute and clarinet are instructed to play quick groups of sixty-fourth notes *forte*—underpinned by *forte* legato passages for the second horn, viola, and cello—while two lonely violins have to play pizzicato notes *mezzo forte*. Could he have meant to make the pizzicato notes inaudible? It seems unlikely, but that would be the result if his instructions were obeyed to the letter. And there are other, similar miscalculations in the piece. On the other hand, since Schoenberg's later adaptations of the work for fuller string sections sound too "fat," conductors should work to obtain the best possible balance using the original instrumentation. As Boulez has pointed out, even in the reinforced version "the string parts require great virtuosity, and production of a satisfactory ensemble remains uncertain."[25] Stravinsky, too, was in agreement on these points, and added some other comments as well:

> I admire the *Kammersymphonie*, but am not attracted by the sound of the solo strings—they remind me of the economy-sized movie-theatre orchestras of the 1920s—though I agree that the multiple-string version tames and blunts the piece unduly. At times the *Kammersymphonie* sounds to me like

50 | SCHOENBERG

a joint creation of Wagner, Mahler, Brahms, and Strauss, as though one of these composers had written the upper line, one the bass, etc. But the triplets were written not by Brahms, whose triplets are lyrical, but by Mahler, whose triplets are rhetorical. Nevertheless the *Kammersymphonie* is more polyphonic than the music of any of these composers.[*][26]

"The climax of my first period is definitely reached in the *Kammersymphonie*, Op. 9," Schoenberg wrote many years later, and indeed, with respect to his harmonic idiom, it does belong to that early period in his maturity: it is, after all, still a tonal work, however complex its harmonic language may be. Yet, as he himself said, the Chamber Symphony "make[s] great progress in the direction of the *emancipation of the dissonance*"[27]—a term he often used to describe atonality, which he was about to embrace. At least equally important, however, is the work's shedding of the external (not internal or emotional!) trappings—the instrumental elephantiasis—of late Romanticism, and in this sense the Chamber Symphony signals the beginning of a distinctly new style, not the climax of a previous one. He would continue this trend in the Chamber Symphony No. 2, begun almost alongside its predecessor but not completed until many years later, and in the meantime he would often return to the huge orchestral deployments of the past, although he would use them in more succinct ways than he had previously done.

Schoenberg couldn't resist patting himself on the back for his achievements in the Chamber Symphony. "This is also the place to speak of the miraculous contributions of the subconscious," he

[*] It seems to me that Brahms could "out-polyphonize" any of the others named herein, when he so wished, but we'll let Stravinsky have his say!

wrote. "I am convinced that in the works of the great masters many miracles can be discovered, the extreme profundity and prophetic foresight of which seem superhuman. In all modesty, I will quote here one example from the *Kammersymphonie* [. . .]." (Modesty, it seems, is in the eye, or ear, of the beholder.) And, continuing his thoughts about miracles for the great masters, Schoenberg said that "if one has done his duty with the utmost sincerity and has worked out everything as near to perfection as he is capable of doing, then the Almighty presents him with a gift, with additional features of beauty such as he never could have produced by his talents alone."[28]

DURING THE SPRING OF 1906, WHILE HE WAS WORKING ON THE *Kammersymphonie,* Schoenberg made the acquaintance of Richard Gerstl, a twenty-two-year-old, half-Jewish, Viennese-born painter who rejected not only the academic art of his day but also the works of the innovative Gustav Klimt and others of the generation immediately preceding his own.* Schoenberg had long been interested in the visual arts, and he had a notion that if he, and possibly also his wife, could learn to paint well, the sale of their paintings could perhaps supplement his meager earnings from teaching. Schoenberg did gradually acquire considerable skill as a painter, but in the meantime Gerstl became not only his teacher but also a family friend, a neighbor (he moved into an apartment in the building in

* Some sources give 1907 as the year of Schoenberg and Gerstl's first encounter, but according to Raymond Coffer, who has made a thorough study of the relationship, 1906 is the correct year. For this and other details of the Schoenberg-Gerstl story, see the Web site that Coffer has dedicated to Gerstl: www.richardgerstl.com. Speaking of Klimt: Schoenberg's grandson, lawyer E. Randol Schoenberg, managed to force the Austrian government to restore five Klimt paintings that had been stolen by the Nazis from an Austrian Jewish family to Maria Altmann, a member of that family, more than sixty years after the theft.

52 | SCHOENBERG

which the Schoenbergs lived), and part of the composer's circle of acolytes and supporters.

Gerstl was among the friends who followed the Schoenbergs to their working holidays in the resort town of Gmunden on the Traunsee during the summers of 1907 and 1908. Late in August 1908, toward the end of their second Gmunden vacation, Schoenberg discovered his wife alone with Gerstl, probably in the farmhouse that the painter had rented. After some altercations, Mathilde escaped with her lover; Arnold eventually discovered their whereabouts in Vienna and persuaded Mathilde to return home for the sake of their children: Trudi was six years old at the time, Görgi only two. Gerstl moved to a flat down the street from the Schoenbergs, and Mathilde continued to divide her time between the two men until Webern, presumably at his mentor's behest, convinced her to end her affair with Gerstl. On November 4, 1908, Gerstl—who had in the meantime been ostracized by all of his former friends in the Schoenberg circle—burned much of his work and the documents of his life and committed suicide by stabbing and hanging himself, naked, in front of a mirror in his studio. He was twenty-five years old.

Although the Gerstl story was well known among Schoenberg's intimates, it was hushed up by the composer's early biographers: the index in Wellesz's 1925 book skips from *George-Lieder* to Gesualdo da Venosa, and even the one in Reich's biography of 1968—long after all of the protagonists were dead—proceeds directly from Gershwin to Gesellschaft der Musikfreunde. There was no mention of Gerstl; furthermore, the painter's remaining works were nearly forgotten until a dealer discovered them in the early 1930s—but within a few years even those were banned by the Nazis. Today, Gerstl's relatively few surviving paintings— including several important ones of Schoenberg and members of

Schoenberg's family and circle of friends—have caused many art historians to regard him as an "Austrian van Gogh" or a forerunner of German Expressionist painting.

As for Mathilde, even before her marriage to Arnold she had been considered a "loose woman" by the conventional standards of the time: she was said to have had a lover before she met her future husband, and when she and Arnold married she was already six months pregnant. Arnold, however, was anything but an easygoing domestic partner. Convinced of his own genius and of the supreme urgency of his needs over all other considerations, he was high-strung, often irascible, prone to mood swings, and, according to some (although not all) of his acquaintances during the early part of his career, sometimes given to excessive drinking. Josepha (Seffi) Wally, the Schoenbergs' maid a decade after the Gerstl affair, reported a "negative, aggressive atmosphere in the Schoenberg house, very turbulent with permanent quarrels," and described Schoenberg himself as tyrannical.[29] His wife, like many other intelligent women of her day, resented the fact that she was expected to live only for her husband and children and not even to have, let alone realize, any aspirations of her own. Shortly after Gerstl's suicide, she sent a note as blood-chilling as it was insensitive to his brother, Alois: "Believe me, of the two of us, Richard chose for himself the easier path. To have to go on living in such a situation is terribly hard."[30] In other words, death was better than returning to domesticity—especially as domesticity was conceived in her day—and to the opprobrium that she faced within Schoenberg's circle and beyond. The soprano Marya Freund (1876–1966), who knew the Schoenbergs well, said that Mathilde "tolerated with indulgence and patience Schönberg's trying originality in everyday life, and his authoritarian character made me understand the

patience necessary for her, the wife, the mistress of the house, the mother of two children, to have in order to endure the misery."*[31]

At least one piece of evidence demonstrates that Schoenberg continued to respect his wife. Two years after the Gerstl affair, he wrote to Alma Mahler, criticizing her for not paying any attention to Mathilde, who, he said, was "one of the most intelligent women I know! . . . I am firmly convinced that upon closer acquaintance you would summon up greater sympathy for her than for most other women. For one can really make conversation with her, due to her remarkable astuteness, her rare tact and sense of comportment. To be sure: she is not an outgoing person. Due to modesty, a kind of shyness."[32]

Mathilde may have had other affairs, and, according to Alban Berg and his wife, Helene Nahowski, Frau Schoenberg in her forties pursued her husband's student Hugo Breuer, twenty-two years her junior. Somehow, however, Mathilde and Arnold managed to remain together for the rest of her life.

———

SOME MUSICAL SLEUTHS HAVE TRIED TO READ THE TALE OF THE Schoenberg-Gerstl triangle, with its horrific coda, as a sort of backstory to the creation of the composer's groundbreaking String Quartet No. 2, Op. 10. In reality, however, Arnold had nearly completed

* While I was writing this book, I came across a passage in Blume Lempel's short story "A Snowstorm in Summerland" that made me think of Mathilde's quandary: "I realize why Eve sought the company of the serpent. It's because she couldn't have a real conversation with Adam. All he could do was obey his Creator's rules to the letter. No surprises from his quarter. So she turned to the snake, forfeiting the free meals in exchange for independence." Except that in Mathilde's case one would have to change "his Creator's rules" to "his rules as a creative artist." B. Lempel (trans. E. Cassedy and Y. A. Taub), *Oedipus in Brooklyn and Other Stories* (Simsbury, CT: Mandel Vilar Press, and Takoma Park, MD: Dryad Press, 2016), pp. 192–93.

the work, at Gmunden during the summer of 1908, before his discovery of Mathilde and Richard's affair. The piece is even dedicated "To My Wife," although the dedication may have been a later peace offering, after the initial shock and the inevitable mutual recriminations had abated.

Despite its lower opus number, the Second Quartet postdates the beautiful Two Ballads for voice and piano, Op. 12, and the equally lovely, brief, almost otherworldly choral piece *Friede auf Erden* (Peace on Earth), Op. 13, which Schoenberg would later describe as "an illusion" from a time in which he had believed "that this pure harmony among human beings was conceivable."[33]

Two aspects of the quartet were novelties. The first of them was the use of the human voice in the last two of its four movements. Voices had already been deployed in symphonies—by Beethoven in the Ninth, of course, and much more recently by Mahler in his Second, Third, Fourth, and Eighth symphonies—but not in string quartets by well-known composers. The impulse for this new factor came to Schoenberg from the poetry of Stefan George (1868–1933), who was supplanting Richard Dehmel as the composer's favorite literary interest.* George, a Nietzsche admirer who deplored the German literary scene of his time, was heavily influenced by the poetry of Baudelaire (he translated *Les fleurs du mal* into German), Verlaine, and especially Stéphane Mallarmé, whose salon he frequented in Paris; he also made new German translations of Dante and Shakespeare. But his 1907 collection, *Der siebente Ring* (The Seventh Ring), marked the beginning of a move toward a new lyricism, away

* Although George was primarily gay, he and Dehmel had at one time been in love with, or at least fixated on, the same woman, Ida Coblenz, who eventually married Dehmel—an outcome that George never forgave.

56 | SCHOENBERG

from the Symbolist-aligned aestheticism of his early works, and it was from this book that Schoenberg selected the poems "Litanei" (Litany) and "Entrückung" (Rapture) to set within his quartet. The composer's sense of identification with the texts is clear: "Litanei" includes lines that translate as

> Long was the journey, weary are the limbs,
> Empty are the coffers, full only the anguish.

In other words, Schoenberg used George's words to describe the practical and emotional difficulties of his own artistic struggles. But then, in "Entrückung," he must have been thinking of his art and of what the future held for it, or at least of his aspirations for it:

> I feel air from another planet.
> [. . .] Trees and paths that I loved [have turned] pale
> So that I barely know them [. . .].
> I feel as if I were floating above the highest cloud
> In a sea of crystal sparkles—
> I am but a spark from a holy fire
> I am but a roaring of the holy voice.[*]

The air from that "other planet" brings us to the quartet's second startling aspect: the absence of a clear-cut tonality (key) in most of the fourth (final) movement. Indeed, in parts of all four movements

[*] From "Litanei": "Lang war die reise, / matt sind die glieder, / Leer sind die schreine, / voll nur die qual." From "Entrückung": "Ich fühle luft von anderem planeten. / [. . .] bäum und wege die ich liebte fahlen / Dass ich sie kaum mehr kenne [. . .] / Ich fühle wie ich über letzter wolke / In einem meer kristalinen glanzes schwimme— / Ich bin ein funke nur vom heiligen feuer / Ich bin ein dröhnen nur der heiligen stimme."

Schoenberg takes us into regions so remote from the presumed main key that we seem to have been cut loose from our tonal moorings. Still, the first movement begins and ends in F-sharp minor (its first two bars are downright Brahmsian), the second in D minor, and the third in E-flat minor. The fourth movement alone has no key signature, and only at the end settles—rather unconvincingly—into F-sharp major.*

Four decades later Schoenberg tried to describe that transformative moment in his musical life:

> I renounced a tonal center—a procedure incorrectly called "atonality." In the first and second movements there are many sections in which the individual parts proceed regardless of whether or not their meeting results in codified harmonies [i.e., traditional harmonic progressions]. Still, here, and also in the third and fourth movements, the key is presented distinctly at all the main dividing-points of the formal organization. Yet the overwhelming multitude of dissonances cannot be counterbalanced any longer by occasional returns to such tonal triads as represent a key. It seemed inadequate to force a movement into the Procrustean bed of a tonality without supporting it by harmonic progressions that pertain to it.[34]

In typical fashion, however, Schoenberg couldn't resist finishing his account with a bit of praise for himself, finger-wagging at his colleagues, and reference to the undeniably unjust rejection he

* Schoenberg's Two Songs for voice and piano, Op. 14, the Second String Quartet's immediate predecessors, are also essentially atonal but they, like the quartet's first three movements, bear key signatures: the first one is nominally in D major or B minor and ends in B minor; the second one is nominally in C major or A minor and ends in C major, but with an A added to the closing triad.

suffered: "This dilemma"—the crisis in tonality—"was my concern, and it should have occupied the minds of all my contemporaries also. That I was the first to venture the decisive step will not be considered universally a merit—a fact I regret but have to ignore." In other words, all composers of his day ought to have realized that traditional tonality had exhausted itself and ought to have had the courage that he had shown: they, too, should have entered boldly into the territory that he was exploring, but he alone had been wise and daring enough to do what had to be done. And he alone had faced the consequences.

To most musicians today, even among those who dislike his music, Schoenberg is at the very least the patriarch and leading representative of a highly significant development in the history of Western art music. Thus his statement reads like the someday-you'll-be-sorry-you-didn't-understand-me whining of a famous man who saw himself as a lone prophet preaching God's truth to a multitude of mockers and doubters. In 1908, however, at the time of the Second Quartet's premiere, and to a considerable extent even in 1947, when Schoenberg wrote the words cited above, most professional musicians who were not directly or indirectly influenced by him considered his works and the works of his followers to be beyond the pale. It was an either/or situation; one was either for Schoenberg (a small minority) or against him (the vast majority), and he was in the unenviable and nearly untenable psychological situation of feeling persecuted by, and simultaneously superior to, his detractors. He was accused of "anarchy and revolution," as he said in the same statement, "whereas, on the contrary, this music was distinctly a product of evolution, and no more revolutionary than any other development in the history of music."[35] Of course, evolution produces many dead

ends, but we'll have a look at that issue later in the story, to try to determine how the matter does or does not pertain to Schoenberg's work. The most important fact, with respect to his own development, is that he saw himself as forging ahead along the same road on which Bach and Mozart and Beethoven and Brahms and Wagner and Mahler had traveled. His work may be considered revolutionary, but he himself was not a revolutionary—certainly not in the way in which Stravinsky personified a revolution in Western music by *not* following the Germanic "line" that had come to dominate European art music during the nineteenth century. Schoenberg's greatest desire was to *extend* that line, not to break or end it.

All of which explains his anger and disappointment over the reactions that his Second Quartet provoked at its premiere, on December 21, 1908 (barely a month and a half after Gerstl's suicide) by the brave Rosé Quartet and the even braver soprano Marie Gutheil-Schoder, one of Vienna's leading opera stars. Mahler had described Gutheil-Schoder as a musical genius, and she must have needed every bit of skill she possessed in order to learn and perform an extremely novel and difficult part in a range that stretched from the A below middle C to the C above the treble clef. But such was the turmoil at the premiere that one local newspaper, the *Neues Wiener Tagblatt*, instead of printing a review of the concert, reported the outcome in a column that chronicled local accidents and felonies:

> The events that unfolded between 8 and 9 o'clock yesterday evening in the Bösendorfer Hall are unique in the whole history of concert life in Vienna: a regular fiasco ensued during the performance of a work whose author has already made

a public nuisance of himself with other products of his pen. Never, however, has he gone as far as he did yesterday.[36]

Another newspaper, the *Neue Wiener Abendblatt*, was even more insulting:

> [. . .] the composition is not an aesthetic but a pathological case. Out of respect for the composer we will assume that he is tone-deaf and thus musically *non compos [mentis]* [. . .] otherwise the Quartet would have to be declared a public nuisance, and its author brought to trial by the Department of Health. We cannot imagine in what way the subscribers of the Rosé Quartet concerts had sinned, to cause the leader of that group to program such a worthless assault on their ears.[37]

There were hisses and laughter while the performance was taking place. One music critic, Joseph Karpath, shouted, "Stop it! That's enough!" which the musicologist Richard Specht countered with "Quiet! Go on playing!" Another observer reported that most of the audience "took against the work; various dissonances caused elegant ladies to utter cries of pain, putting their hands to their delicate ears, and elderly gentlemen to shed tears. . . ."[38] Max Kalbeck, Brahms's biographer, who had previously opposed the music of Wagner, Bruckner, and Wolf, described the quartet as "cats' music," and Arthur Schnitzler wrote in his diary, "I do not believe in Schoenberg. I understood Bruckner and Mahler right away, must I fail now?"[39] Even Loos and Kraus, who defended Schoenberg, did so less out of support for the quartet itself than "because what they had witnessed confirmed the strength of [his]

FORMING THE BATTLE LINES | 61

personal conviction and the importance of adhering to one's artistic principles," as Bojan Bujić has put the matter.[40] In short, it's no wonder that Schoenberg was always on the defensive—usually by being offensive toward anyone who did not perceive his "truth."

By the way: in his above-quoted statement, as in some of his other writings, Schoenberg criticized the use of the words "atonal" and "atonality." He even dissociated himself, in print, from composers who called themselves atonalists, "for I am a musician and have nothing to do with things atonal,"[41] since music, by its nature, is made up of tones, he said. But he did use the term himself without offering any serious alternatives. In his and others' atonal works, chords and other note combinations, both consonant and dissonant, are heard, but there is no central key around which everything else gravitates. What term other than "atonality" could be used? "Non-tonality" and "absence of tonality" are more awkward ways of saying the same thing, although the former has sometimes been used in lumping together all of Schoenberg's atonal and twelve-tone works. "Polytonality" and "multi-tonality" are incorrect because they imply that there is more than one tonal center when in fact there is none, unless one thinks of every chord or group of chords as creating its own tonality. Paul Lansky and George Perle, in their entry "Atonality" in the 1980 edition of *The New Grove Dictionary of Music and Musicians*, stated that the term "may be used in three senses: first, to describe all music which is not tonal; second, to describe all music which is neither tonal nor serial; and third, to describe specifically the post-tonal and pre–twelve-note music of Berg, Webern and Schoenberg."[42] Parts of Schoenberg's Second String Quartet and parts or all of many of his other pre–twelve-tone works—and some later ones as well—fit into all three of these

categories, and we shall continue to describe those compositions as atonal.*

FROM A TWENTY-FIRST-CENTURY PERSPECTIVE, THERE IS SOME-thing almost comical, verging on the absurd, about Schoenberg's choice of poetic texts for the songs that make up his first entirely key-signature-less work, namely *Das Buch der hängenden Gärten* (The Book of the Hanging Gardens), a cycle of fifteen songs for voice and piano, on poems by Stefan George. "With the George Lieder," he wrote, "for the first time I have succeeded in approaching an ideal of expression and form that has been in my mind for years. Now that I have set out along this path once and for all, I am conscious of having broken through every restriction of a bygone aesthetic."[43] For these songs, which were completed in 1909, Schoenberg drew upon a story cycle of thirty-one poems that constitute the final part of a larger volume (*Die Bücher der Hirten- und Preisgedichte, der Sagen und Sänge, und der hängenden Gärten*—The Books of Pastoral and Eulogistic Poems, of Legends and Ballads, and of the Hang-ing Gardens) that George had published fourteen years earlier, at the height of his Mallarmé-influenced Symbolist period. George's poems wallow (forgive me the term) in a sort of attenuated, fin-de-siècle sensuality, whereas Schoenberg's music was uncompromis-ingly radical, to a degree that struck most listeners of his day as not merely unpleasant but downright incomprehensible.

* I heartily recommend the LaSalle Quartet's recordings (made for Deutsche Grammophon, 1968–1970) of the Second Quartet and all of Schoenberg's other string quartets. They are not only well played—they also communicate a sense of conviction and authority that only long practical familiarity with this music permitted. The excellent soprano soloist in the Second Quartet record-ing is Margaret Price.

FORMING THE BATTLE LINES | 63

Here is a stanza typical of those that Schoenberg chose to set to music:

Tell me, upon which path
Will she step today—
That I from the most abundant trunk
May fetch delicate woven silks,
Pluck roses and violets,
That I may lay my cheek
As a footstool under the sole of her foot.[44]

And yet, however incongruous the notes themselves sounded to audiences in Schoenberg's day as a setting for verses of this sort, the emotional *tone* of the setting is perfectly in keeping with the text. There are few fast or even moderately fast basic tempi, although there are some violent outbursts in both the vocal line and the piano part. Eight of the lieder end on dissonant chords, but No. 3 ends on an inverted D-flat major triad; Nos. 6, 8, 9, and 14 end on single notes (D, E, G-sharp, and D, respectively); No. 11 on a perfect fourth (C-sharp and F-sharp); and No. 15—the last song—on a minor sixth (D and B-flat). All of them end vaporously, which, again, fits the style of the poetry.

The overall mood is mysterious—perhaps too uniformly so, by the time one reaches the end of the twenty-five-minute-long cycle. And therein lies one of the principal, perhaps *the* principal communicative problem of atonal and, later, twelve-tone music for people accustomed only to the specific sorts of contrasts found in tonal music. Even in the twenty-first century, the same contrasts prevail in most Western music, from folk to pop to jazz to rap to hymns to the so-called standard repertoire heard in concert halls and opera

SCHOENBERG

houses. Our ears remain attuned to the diatonic major-minor contrast and to the resolution of dissonance into consonance. The words of atonal songs, as of any other songs, may be loving or angry, serene or anguished, sensual or stark, luminous or gloomy, joyful or tragic, and the vocal or instrumental articulation of the notes may vary in keeping with the words; but the notes themselves, the sequences of notes and chords in atonal and other post-tonal music, do not in themselves communicate these alternations to most listeners, no matter how dedicated and competent the performers may be in putting across the intended emotional content. And there can be no doubt that music's emotional content was of primary importance to Schoenberg! How, if not for most listeners' inability to perceive that content, can one explain the exclusion, from today's vocal recitals, of a striking masterpiece like the *Buch der hängenden Gärten* cycle ("a spiritual continuation of the great romantic Lieder cycles of Beethoven, Schubert, and Schumann," in the critic H. H. Stuckenschmidt's estimation)[45] or other Schoenberg lieder? I sense that most listeners—and I include many musicians—perceive atonal and other forms of post-tonal music as emotionally monochromatic. Or is the ongoing resistance to post-tonal music still, after a hundred years and more, a question of insufficient exposure? I don't think so.

Schoenberg himself was "intoxicated by the enthusiasm of having freed music from the shackles of tonality," he wrote late in life, and this feeling had led him to seek "further liberty of expression."

In fact, I myself and my pupils Anton von Webern and Alban Berg, and even Alois Hába,* believed that now music could

* Hába, a Czech composer (1893–1973), met Schoenberg after World War I and was influenced by him.

renounce motivic features and remain coherent and comprehensible nevertheless. [. . .] New characters had emerged, new moods and more rapid changes of expression had been created, and new types of beginning, continuing, contrasting, repeating, and ending had come into use. Forty years have since proved that the psychological basis of all these changes was correct. Music without a constant reference to a tonic was comprehensible, could produce characters and moods, could provoke emotions, and was not devoid of gaiety or humor.[46]

Unfortunately, even today many listeners do not perceive that variety of characters, moods, and emotions, *especially* gaiety or humor, in post-tonal music. A pianist who played Beethoven's "Diabelli" Variations, or a listener who who heard someone else playing them, soon after the work's publication in 1823, might have found some of the variations difficult to follow but would immediately have been amused by the pompous march (Variation 1) that follows the silly waltz theme itself, or by the parody of Leporello's "Notte e giorno faticar" from *Don Giovanni* (Variation 22), or by the three scherzo-like variations (Nos. 25–27), and so on. There are parts of many of Schoenberg's compositions—the *Kammersymphonie, Pierrot Lunaire*, the last of the Five Piano Pieces, Op. 23, for instance— that were intended to be lighthearted, and after one has studied them in depth or listened to them repeatedly one can perceive that lightheartedness. But that quality, and many other "characters, moods, and emotions" as well, are not immediately perceptible to most listeners who are familiar only with traditional diatonic harmonic language.

Many years ago, a friend of mine, trying to interest his sister and brother-in-law in classical music, played them a recording of the first

movement of the "Eroica" Symphony. The tactic didn't work. They didn't like the piece because, they said, "It's so sad." Their reaction seemed to me incomprehensible, almost physiologically impossible. If they had said that the piece was too long or too complicated, I would have understood their opinion, coming as it did from people who had had little or no exposure to anything other than the popular song repertoire of the day. But "sad"? The first movement of the "Eroica"? Inconceivable! I do, however, know not only casual listeners but also professional musicians who say that they hear no joy or even simple happiness in post-tonal music; to them, the music of Schoenberg and company communicates only anguish, depression, or nervous tension, and the musicians among them attribute this perception to the absence of the major-minor and dissonant-consonant relationships.

Think of Mark Twain's well-known quip about Wagner's music being better than it sounds. In my blasphemous opinion, much of Wagner's music—on the contrary—sounds better than it is (I'm with Nietzsche on that matter); whereas much of Schoenberg's music is, truly, better than it sounds. Sound, however, is the prime element of music; if the *sound* of a piece of music does not communicate to open-minded listeners the emotions or states of being intended by its composer, it has failed.

This vexing issue continues to dominate the entire conflicted and conflictual history of twentieth- and twenty-first-century Western art music, and we shall continue to butt our heads against it through the rest of the Schoenberg story.

> I strive for complete liberation from all forms. . . . Away with harmony as cement or bricks of a building. Harmony is expression and nothing else. . . . My music must be *brief*. Concise! In two notes: not built, but "*expressed*"!![47]

Thus wrote Schoenberg to Ferruccio Busoni in August 1909, after having sent him the first two of his Three Piano Pieces, Op. 11, which he completed shortly after he had finished the *Buch der hängenden Gärten*. To me, these concise pieces—about fourteen minutes of music in total—feel almost like an extension of that song cycle, but their expressive content is even more distilled, because the human voice has been eliminated. Harmony, now, is indeed "expression and nothing else." And while he was completing this new, tripartite work, Schoenberg was also working to finish his anti-symphonic essay, Five Pieces for Orchestra, Op. 16.

I call the latter work "anti-symphonic" because instead of a group of thematically developed symphonic movements, Schoenberg created a series of brief orchestral vignettes, each of which grows out of fragments. Once again, he would have said that by exploding the old form he was doing something new but not revolutionary: he was using subtle motivic development techniques akin to those that Beethoven and Brahms had so brilliantly explored but without building those motivic fragments into extended themes, let alone sonata forms or rondo forms or any of the other traditional molds within which his predecessors had worked. The pieces are "not cyclically related," as Schoenberg wrote to Richard Strauss. "I am expecting colossal things of them, sound and mood especially. That is all they are about: [. . .] no architecture, no structure. Merely a bright, uninterrupted interchange of colors, rhythms and moods."[48]

For the Five Pieces, Schoenberg required huge orchestral forces of a sort that he had not used since the *Pelleas* score of seven years earlier—not in a completed work, in any case. (At the time, the *Gurrelieder* orchestration was still unfinished.) Woodwinds, brass, percussion, and strings are fully deployed, although not all of them are used in every piece, and the impenetrable textures of some of the

68 | SCHOENBERG

earlier works have disappeared. Boulez, from the double vantage point of composer and conductor of twentieth-century music, commented that the Five Pieces, taken as a unit, demonstrate Schoenberg's "desire to treat the large orchestra almost like an expanded chamber group. Unlike Debussy's writing, which treats the orchestra 'acoustically,' Schoenberg's is parceled out among an ensemble of soloists and utilizes the orchestral groups in large, homogeneous ensembles."[49]

When C. F. Peters, the Leipzig-based company that published the work in 1912,* asked Schoenberg to provide a title for each of the five pieces, he did so reluctantly because, as he wrote in his diary, "the wonderful thing about music is that one can say everything so that knowing people understand it, and yet one has one's secrets that one confesses to oneself—one does not spread them around—but titles do."[50] Still, the titles are worth citing as possible—but by no means sole, much less obligatory—ways of thinking about the pieces they represent. Number 1, *Vorgefühle* (Premonitions), presents brief phrases—quick, contrasting snatches of raucous sound that follow each other in rapid succession, often in three-against-four rhythmic patterns, with terrifying shrieks from the upper woodwinds and strings and brutal poundings from the lower woodwinds, brass, strings, and percussion. *Vergangenes* (Past, or Bygone), the second and longest piece, is basically slow, but sped-up sequences exist as miniatures within longer phrases. About halfway through the piece, the celesta—sometimes joined by the harp, punctuating woodwinds, and

* In 1909, Schoenberg had signed a contract with the Vienna-based music publisher Universal Edition. The contract, he told Mahler, was "very advantageous—for them." But evidently it was not exclusive, as the Peters contract demonstrates.

FORMING THE BATTLE LINES | 69

tremolo strings—sprinkles fast notes over the somber, underlying texture.

The third piece's title, *Farben* (Colors), is misleading: you will be sorely disappointed if you expect to hear each instrument's sound-color brought into high relief. Schoenberg, ever the contrarian, made sure to give the most colorful title to the least *obviously* colorful of all of the Five Pieces. The hues in this slow, subdued, forty-four-bar segment are pale pastels, or they may even bring to mind the bleak tones (if not the subject or style) of James McNeill Whistler's painting "Arrangement in Grey and Black," also known as "Whistler's Mother." In a note published in the score, Schoenberg warned conductors not to emphasize individual instrumental voices in this piece but rather to make sure that the players obey the printed dynamic marks. The practicality of this instruction is somewhat restricted, however, because the dynamic level of the entire piece ranges only from *pp* (very soft) to *ppp* (very, very soft), with occasional, short, "hairpin" crescendo-diminuendo signs < > and a single rise to a *mezzo piano* for the whole orchestra. His intention, however, is clear: Don't fool around with balances that weren't meant to be calibrated according to traditional norms! These *Farben* are the opposite of the colors potentially evoked from the orchestral palette of, for instance, Alexander Scriabin, a Schoenberg contemporary. The Russian composer even wrote a part for a *clavier à lumières*, a color keyboard, which was meant to bathe concert halls in shifting colored lights that would accompany the music's shifting harmonies during performances of his *Prometheus: Poem of Fire*—composed, by the way, only a few months after Schoenberg's Five Pieces. No synesthesia for Schoenberg—or at least not of so obvious a kind.

In the fourth piece, *Peripetie* (Turning Points), Schoenberg returns to the jagged, frequently changing orchestral outbursts

of the first piece, but in a more compressed format. There are a few seconds here and there—the muted horns just after No. 1 in the score, for instance, and the solo cello part at No. 7—that to our ears may seem to pre-echo things that would be heard four years later in *The Rite of Spring*, but of course this is a case of aural illusion: Stravinsky had nearly completed *The Rite* by the time Schoenberg's Five Pieces were published. The final piece, *Das obligate Rezitativ* (The Obbligato Recitative—a reference to instrumental and operatic works of the eighteenth and early nineteenth century), is a sort of fatal waltz, in unchanging 3/8 time from start to finish, but in a soundscape that Johann Strauss II, the Waltz King, who had died only a decade earlier, and whose music Schoenberg loved, would have found completely foreign and largely unintelligible.

So, unfortunately, did another, much younger Strauss—Richard—who had until then given moral and even material support to Schoenberg. The Five Pieces for Orchestra, of which Schoenberg had expected "colossal things" (as he had written to Strauss), were too much even for the composer of *Elektra*, which had shocked large swaths of the public at its premiere earlier in that same year, 1909. Strauss told Alma Mahler that Schoenberg needed psychiatric care and that he would do better to shovel snow than to continue scribbling notes.[51] No surprise, then, that when Schoenberg learned of Strauss's opinion, their relationship, such as it was, came to an end.

———

ALL IN ALL, 1909 WAS ONE OF THE MOST FERTILE YEARS IN SCHOEN-berg's creative life: it began, as we have seen, with the completion of the *Buch der hängenden Gärten*, continued with the composition of

FORMING THE BATTLE LINES | 71

the Three Pieces for Piano and the Five Pieces for Orchestra, and ended—at least with respect to completed works—with *Erwartung* (Expectation, or Anticipation), Op. 17. This one-act monodrama originated almost by accident during the summer, when he and his family plus Zemlinsky, Berg, Webern, and the painter and print-maker Max Oppenheimer (later known as MOPP) were vacation-ing at Steinakirchen in Lower Austria. A new acquaintance that summer was Marie Pappenheim, an extraordinary young woman from a remarkable Austrian Jewish family: her older brother, Mar-tin, was a neurologist and psychiatrist, a member of Freud's inner circle, and later, after he emigrated from Austria, a father of psy-chiatry in Mandate Palestine; her niece, Else Pappenheim, became a leading psychoanalyst, first at Johns Hopkins University in Bal-timore and then in New York City, after having fled Austria in 1938; and Marie and Martin's younger sister, Gisela Sternfeld, was a chemist who also ended up in the United States.

Marie, nicknamed Mitzi, or Mizzi—a former student at the Schwarzwald school, twenty-six years old at the time of her encounter with the Schoenberg circle—had recently become the first woman to graduate from the University of Vienna's Faculty of Medicine; her initial specialization was in dermatology, but she and Wilhelm Reich later founded the Socialist Society for Sexual Counseling and Research. She was a committed socialist (later communist), a pub-lished poet, and, eventually, a translator from the French of libretti for operas by Darius Milhaud and Jacques Ibert. In 1906, Karl Kraus had printed some of her poems in *Die Fackel* (The Torch), his con-troversial literary and political review, and she would publish other writings as well—some under her maiden name, others under her subsequent married name, Marie Frischauf, and still others under a pseudonym, Marie Heim. She, too, would flee Nazi-dominated

Europe—to Mexico, in her case—but would return to Austria after the Second World War.

Shortly after Schoenberg met Pappenheim, he said to her: "Write an opera text for me, Miss!" She did, and she later claimed that the ideas behind *Erwartung* were her own: "I received neither a clue to nor an indication of what I should write (would also not have accepted it)," she reported, adding that Schoenberg and Zemlinsky had talked only about the libretti of Franz Schreker's operas and Debussy's *Pelléas*. "I wrote lying in the grass, with pencil, on large sheets of paper, had no copy, scarcely read through what I had written."[52] At the time, however, Schoenberg wrote to Busoni that he had "started on a new composition, something for the theater; something quite new. The librettist (a lady), acting on my suggestions, has conceived and formulated everything just as I envisaged it."[53] Given that Schoenberg's letter was written while *Erwartung* was being conceived and that Pappenheim was recalling the episode decades later, his statement seems more plausible than hers. Equally important is the central fact of the work's story line: a woman's lover dies a violent death: one can hardly help wondering whether Schoenberg was visiting a second death upon Gerstl.

In any case, and regardless of who originated the idea for the story, Schoenberg revised Pappenheim's text, and as he did so he jotted down musical ideas. Then, between August 27 and September 12, he composed the entire work excepting the orchestration, which was completed by early October. With all due respect to Marie Pappenheim—a fascinating figure—I agree with Boulez's opinion that *Erwartung*'s libretto "brings into play an Expressionism of very dubious quality," and that it has aged badly.[54] The entire text is the frenzied monologue of a jealous woman who has lost her lover to another woman; she searches for him and finds his murdered

body—or perhaps she herself has killed him and has returned to the scene of the crime: we cannot know. Schoenberg wrote, more than twenty years later, that he had meant only "to represent in *slow motion* everything that happens during a single second of maximum spiritual excitement,"[55] but his statement only adds to the confusion. Musicologist Bryan R. Simms believes that the unnamed protagonist "exhibits classical symptoms of hysteria as they were defined by [Josef] Breuer and Freud in the *Studien über Hysterie*"—a study with which Pappenheim was likely familiar and that is now considered typical of the sexism of the time. The hysteria, and the closely connected rage that causes the woman to murder her lover (if she is indeed his murderer, which most commentators doubt), stem not only from jealousy but also "because she had become totally dependent upon him," Simms says.[56]

Hysteria certainly reigns in *Erwartung*, not only in the terribly difficult vocal line but also in the shock-and-awe sounds emitted by a vast orchestra: seventeen woodwinds, twelve brass, harp, celesta, glockenspiel, xylophone, timpani, six percussion instruments, and a string section of sixty-eight to seventy-four players. I would add to Boulez's statement my own opinion—with which devout Schoenbergians will take serious issue—that the entire work, music and all, can and perhaps should be characterized as "Expressionism of very dubious quality." It not only grabs the attention of listeners through its musical paralleling of the stream-of-consciousness narrative: it also beats them into submission. But then, I am an impatient listener who has never been either a Wagnerite or a Mahlerite, so readers should probably not pay any attention to what I say about hyperemotional music. In any case, as an example of Schoenberg's recently found sense of liberation "from all [pre-]determined formal designs" (Boulez again), *Erwartung* remains an important work in the history

74 | SCHOENBERG

of twentieth-century music for the theater. To me, the most beautiful part—and I don't mean this facetiously—is the ending, which evaporates inconclusively, like the protagonist's nearly incoherent, repetitive musings. Her last words—"*Ich suchte* . . ." (I was seeking . . .)—are followed by soft, upward-moving scales in the winds and strings, leading nowhere. The effect is stunning.

Artur Bodanzky, a former assistant conductor to Mahler in Vienna, was serving as chief conductor in Mannheim in 1910 and wanted his ensemble to give the world premiere of *Erwartung* at that time, a year after its composition. He invited Schoenberg to conduct it, and the composer's letter in response to the invitation provides some alarming information, not only about his conducting abilities at the time but also about his familiarity, or lack thereof, with his own music. "Well, if I've got to conduct, I must have my *piano reduction*," Schoenberg wrote. In other words, he didn't know his own piece well enough to re-study it from his own full score. This raises serious questions as to how much of the actual sound of his music he retained in his mind's ear once he had finished writing out the notes—not a matter one would have doubted with respect to his illustrious predecessors, or even with respect to Schoenberg himself vis-à-vis his tonal works. Worse still:

> For your offer to conduct preliminary rehearsals [. . .] I don't think it would be a good idea—for me. First of all, I shall probably need the rehearsals to a certain extent in order *to be sure of myself*, and besides it's probably better if I know somewhat more about it than the orchestra does. And if they've rehearsed it already, they're ahead of me instead of vice versa.[57]

Such statements play directly into the hands of those who claim that post-tonal music is hard to grasp.

The project fell through; Bodanzky made an attempt to revive it nearly four years later, but when Schoenberg learned that the Mannheim theater and its orchestra were too small for *Erwartung*'s requirements he refused to proceed.[58] In the end, the premiere would not take place until 1924, and Schoenberg would not conduct it.

IN ADDITION TO COMPOSING *ERWARTUNG* TO MIZZI PAPPENHEIM'S libretto in that summer of 1909, Schoenberg also painted her portrait—one of a growing number of works in his "second profession," to which he had been applying himself from time to time, at least since his initial encounters with Gerstl, three years earlier. At one point (and as mentioned earlier), when he was despairing of ever being able to support himself through music, he even considered becoming a professional portrait painter, although his mostly self-taught technique struck many trained artists as unworthy of consideration: August Macke, for instance, writing to Franz Marc, described some of the faces that Schoenberg painted as "green-eyed bread-rolls,"[59] and Schnitzler wrote that Schoenberg's painterly talent was "undetectable."[60] On the other hand, an older friend and colleague of Macke and Marc, one Wassily Kandinsky, believed in the validity of Schoenberg's efforts as a painter.

Macke, Marc, and Kandinsky were among the founders of the Blaue Reiter (Blue Rider) group, a loose association of Expressionist artists that also included, among others, Paul Klee, Lyonel Feininger, and, unusually for the time, two women: Marianne von Werefkin and Gabriele Münter, who was Kandinsky's companion

at the time.* Some of them held not only the logical and commonly accepted belief that literature, music, and the visual arts were inter-related but also the somewhat shakier theory that practicing more than one art contributed to proficiency in others; Schoenberg, of course, fit that particular bill. He exhibited some of his paintings in Vienna in 1910 and even sold a few of them. One sale, to an anony-mous buyer, had in fact been made by Mahler, who was trying to help Schoenberg financially and who had already, that same year, made him an outright gift of 800 Austrian crowns.

Schoenberg would continue for many years to exercise his skills as a painter, producing portraits of himself and others (including intentionally distorted psychological self-portraits), set and costume designs for his stage works, and even designs for playing cards. Thanks to Kandinsky, some of Schoenberg's paintings and writings were included in a Blaue Reiter exhibition that toured Germany, and his work in the visual arts and relationship with Kandinsky have been studied in depth.† But, as he himself often said, as a painter he was an unschooled amateur, in music a thoroughly trained professional.

Apart from composition, one of his major gifts was as a teacher, and among the most enduring results of his experiences in that role was his book, *Harmonielehre*, written in 1910–11 and twice revised;

* Macke and Marc would both die as soldiers in the German army during the First World War. Regarding Münter: purely by chance, I saw an exhibition of her work at the Louisiana Museum of Modern Art, near Copenhagen, in 2018. Although unfamiliar with her name until then, I was much taken with the high quality, variety, and originality of her work, which, in addition to its intrinsic value, had influenced Kandinsky and others.

† For more on Schoenberg as painter, see Kandinsky's essay "The Paintings" and Paris von Güt-ersloh's chapter "Schoenberg the Painter," in *Schoenberg and His World* (Walter Frisch, ed.), pp. 238–49. Allen Shawn also discusses Schoenberg's relationship to the visual arts and artists at length and interestingly in the chapter "Farben" in his book, *Arnold Schoenberg's Journey*. Readers fluent in German may wish to look into the volume (edited by Jelena Hahl-Koch) *Arnold Schönberg—Wassily Kandinsky: Briefe, Bilder und Dokumente einer aussergewöhnlichen Begegnung*. See my Bibliography for information on all of these books.

the final edition was prepared in 1921 and published the following year. The title may be translated literally as "harmony apprenticeship" or "harmony lesson(s)" but usually appears in English as *Theory of Harmony*. The first sentence of its preface is a beautiful eye-opener: "I have learned this book from my pupils," Schoenberg wrote. And he went on to say that "since the instructions I gave were untested products of my own thoughts, I was compelled by my errors, which were quickly exposed, to examine my instructions anew and improve their formulation. [. . .] From the errors made by my pupils as a result of inadequate or wrong instructions I learned how to give the right instructions."[61]

Many people who have never looked into *Harmonielehre* have assumed that Schoenberg used it to propound and promote his twelve-tone theory, whereas even the book's final edition was published before he had completely formulated and adopted that system. Indeed, in his text he goes so far as to dissociate himself from certain forms of radicalization in the world of music in the early 1920s: "The sad part is just that the idea [that] 'one may write anything today' keeps so many young people from first learning something accepted and respectable, from first understanding the classics, from first acquiring *Kultur*," he wrote.[62] Thus, *Harmonielehre* deals with tonal music and is divided into twenty-two sections that cover such subjects as "Consonance and Dissonance," "The Major Mode and the Diatonic Chords," "Modulation," "Rhythm and Harmony," and "Chorale Harmonization." It makes use of examples from works by Bach, Mozart, Beethoven, Wagner, Brahms, and other masters of the past but also refers, at least *en passant*, to many of Schoenberg's contemporaries, including Puccini, Mahler, Debussy, Richard Strauss, and Bartók. On the other hand, as Alex Ross has pointed out, *Harmonielehre* is also "an

autopsy of a system that has ceased to function." By Schoenberg's lights, tonality had become "diffuse, unsystematic, incoherent—in a word, diseased," Ross says. Unfortunately, the notion of degeneracy in the arts meshed uncomfortably with ideas of social, racial, and sexual degeneracy that certain demagogues would begin to develop in dangerous ways as the twentieth century unfolded: in music, Ross writes, the idea was "that some musical languages were healthy while others were degenerate, that true composers required a pure place in a polluted world, that only by assuming a militant asceticism could they withstand the almost sexual allure of dubious chords."[63]

In any case, and as one would expect, Schoenberg's approach, in *Harmonielehre*, was unorthodox ("I agree with some points, others I find questionable," the famed musicologist Guido Adler wrote to him in 1912),[64] and his book is not often used as a primary text for music students. It is, however, treasured by many musicians, not only for its inherent usefulness but also for the insight it gives into the thinking of Arnold Schoenberg.

———

VERY SOON AFTER HE HAD COMPLETED *ERWARTUNG*, SCHOENBERG SET to work on another vocal stage work, *Die glückliche Hand*—an even shorter piece (it lasts about twenty minutes) than the half-hour-long *Erwartung*, but again with a huge orchestra, and again free of all traditional formal designs. The title can mean "the lucky hand" or "the right touch," but in this case it is usually translated as "The Hand of Fate." And if the Mathilde-Gerstl story may have been alluded to in *Erwartung*, in *Die glückliche Hand* it became part of the central allegory. Schoenberg wrote his own libretto for what he called a *Drama mit Musik*, but he might as well have called it a *Psychodrama*

mit Musik. Outwardly, he had forgiven Mathilde her transgressions of a year and a half earlier, but *Die glückliche Hand* is unforgiving to the point of misogyny, which is not surprising since, at the time, Schoenberg was heavily influenced by the stage works of the vehemently misogynistic August Strindberg. Strindberg, however, was a master of dramatic form and clarity, whereas Schoenberg's text is, frankly, a mess: Boulez described it as "oscillating between socially preoccupied realism and second-hand mysticism,"[65] but I am more inclined to call it a clumsy attempt at a sort of "deposition from the cross" for artists—artists who offer salvation-by-genius to humanity and receive in return only the scorn and pain of symbolic crucifixion, not to mention maltreatment by women (since artists, the work seems to imply, are invariably male).

In *Die glückliche Hand*'s first scene, a Man (baritone) lies on the stage with a monstrous creature (his ego) painfully attached to him, biting his neck. A mixed chorus (three each of sopranos, altos, tenors, and basses) warns him, like a chorus in an ancient Greek tragedy, that he is foolish to seek earthly happiness—he who has divinity within him. Scene 2: A Woman (silent role) approaches him and offers him a goblet from which he drinks (echoes of *Tristan und Isolde*), but she then notices and is immediately attracted to a wealthy-looking Gentleman (silent role), who embraces and goes off with her. The Man becomes even unhappier when the Woman, after having returned, disappears a second time. During the complicated third scene, the Man enters a goldsmith's workshop in a cave (echoes, this time, of Mime and the Nibelungs in *Siegfried*), criticizes the workers, and fashions a magnificent jewel from a block of gold. When he gives it to the workers, they attack him instead of thanking him, just as Schoenberg, in presenting works of originality to the world, was attacked instead of being thanked. The Woman, her left

breast exposed, returns with the Gentleman. The Man pursues her, climbing over rocks, one of which the Woman manages to dislodge so that it hits him. Scene 4: The Man is alone with his ego-monster attached to him, as in Scene 1, and is upbraided by the chorus for having again sought what he cannot have.

Schoenberg may have thought of his portrayal of the Man as an example of self-laceration, as indeed it was. But it was also an act of self-vindication. And the character who appears as a symbol of uncomprehending, small-minded selfishness is the Woman—presumably Mathilde Zemlinsky Schoenberg. The story does not redound to its author's glory.

Since the work's librettist was also its composer, a close relationship between words and music must have existed in his mind, but it is not necessarily apparent even to the most well-disposed of listeners. And after one has thoroughly studied the score and the libretto (which, by the way, contains Schoenberg's exceptionally detailed and interesting instructions for stage décor and lighting), and listened to the piece multiple times, and come to love some of the mystical choral writing—even then, the frequency of cataclysmic orchestral outbursts seems a form of random overkill, as if the shock effect were its own reason for existing.

Berg's *Wozzeck* and *Lulu*, direct descendants of *Erwartung* and *Die glückliche Hand*, have a dramaturgical logic that Schoenberg's pieces lack. Schoenberg, however, would no doubt have said that he never intended to make things easy for anyone. In October 1910, while he was working on *Die glückliche Hand*,[*] he wrote to Alma

[*] Schoenberg would not put the finishing touches to *Die glückliche Hand* until 1913 and, like *Erwartung*, it would not be performed until 1924.

Mahler: "It meant something to my emotions as I wrote it down [. . .]. I want to express myself—but I hope that I will be misunderstood."

———

ALMOST EVERY YEAR IN ARNOLD SCHOENBERG'S ADULT LIFE HAD ITS bad periods, but 1910 must have appeared to him, both at the time and in retrospect, as one of the worst. Following the tremendous creative flow of the previous year, he now suffered a stretch of near paralysis, as far as composition was concerned: he began but never completed Three Pieces for Chamber Orchestra, and wrote little else. This situation, combined with ongoing economic hardship and public opprobrium for his work, made him contemplate suicide. "I would have liked it if what I will leave behind appeared richer," he wrote in a will that he drafted at the time. "Richer in number of works and achievements, more richly developed and deeper of meaning and intention. I would have liked to have left the world one or another additional idea [. . .]. I would also have liked—I cannot deny it—to have reaped the fame for it."[66]

This was the year in which he had felt compelled to ask Mahler for financial help: "I have no money and have to pay the rent," he wrote to his mentor on August 2. "I cannot tell you how unhappy it makes me to have to tarnish my relationship to you by bringing up such a matter. [. . .] I should not have done it on my own behalf [. . .]. But when one has a wife and children one is no longer the only person who counts."[67] The ever-generous Mahler immediately complied and also sent a warm letter of recommendation on his friend's behalf to Vienna's Academy of Music and Fine Arts, where Schoenberg was trying to secure a professorship. (The application was also supported by eighty-year-old Karl Goldmark, a popular composer in his day and a sometime friend of Brahms.) In the end,

82 | SCHOENBERG

however, the Academy offered Schoenberg only what would today be called an adjunct position, with irregular and inadequate pay; he accepted, but purely out of dire necessity.

One bright spot for him, that year, was a well-received performance of his *Pelleas und Melisande*, in Berlin in October, under the well-regarded conductor Oskar Fried, a Mahler disciple; Schoenberg managed to attend the concert, and the success of his piece must have made him wonder whether he should perhaps turn his back again on Vienna—to which he began to refer as the "City of Songs by Murdered Artists"[68]—and try his luck for a second time in the German capital. The death, the following May, of the fifty-year-old Mahler, Schoenberg's sole supporter among Vienna's most esteemed musicians,* may have pushed him further toward making the leap.

By then, however, he had again begun to feel a need for creative work: before the end of 1911 he had written the miniature gems that comprise the Six Little Piano Pieces, Op. 19 (the last of which, added after Mahler's death and as a tribute to him, bears the indication, in its final bars, "with very tender expression");† he had at last completed orchestrating the *Gurrelieder*; and he had composed *Herzgewächse*, Op. 20, a brief setting, for soprano, celesta, harmonium, and harp, of a German translation of Maeterlinck's poem "Feuillage du coeur" (Foliage of the Heart) from the collection *Serres chaudes* (Hothouses). This piece was written for and published in the Blaue Reiter's 1912 *Almanac*.

* By the time of his death, Mahler had lost much of his power in Vienna's musical life. Four years earlier he had given up his position as music director of the Court Opera, where he had faced ongoing opposition, and had become chief conductor of the Metropolitan Opera in New York—a post he had shared, the following season, with Arturo Toscanini. In 1909 he had left the Metropolitan to become conductor of the New York Philharmonic. He still considered Vienna his home, but his influence there had waned.

† Schoenberg also dedicated his *Harmonielehre*—which was published that year—to Mahler.

In August 1911, Schoenberg and his family were vacationing as cheaply as possible in a tiny Bavarian village on Lake Starnberg (where King Ludwig II of Bavaria had drowned, in 1886) when he found himself so strapped for cash that he couldn't pay his bills in order to leave. This must have been the turning point for him. "It's high time I leave Vienna," he wrote to Alban Berg on September 19, from what had become a holiday prison. "It just won't work. My works suffer and it's almost impossible for me to make a living in Vienna. But since there may well be such an opportunity for me in Berlin, I must take advantage of it! [. . .] Perhaps I may yet manage to extricate myself from these disgusting money problems that are plaguing me again just now."[69]

Berg, alarmed, sent out a message to Schoenberg's friends, pupils, and other supporters: "Catastrophe has overtaken him with unexpected speed," he wrote, "and help from a distant source would be too late."[70] Somehow, Schoenberg received sufficient funds to pay his bills and proceed with his family to Berlin. He arranged with Berg and other friends to have the family's most essential possessions packed up and sent off, and the Schoenbergs—Arnold (now nearly thirty-seven years old), Mathilde (thirty-four), Trudi (nine), and Görgi (five)—headed north to Berlin instead of returning eastward to Vienna. "Whether I ever return to Vienna will depend above all on whether or not I am ever again offered the opportunity to make a living in Vienna," he wrote to Guido Adler on January 13, 1912. "At present it does not appear so. You see, except for my friend [the composer and conductor Franz] Schreker [. . .], nobody in Vienna considers it necessary to perform anything I have written."[71] And to the president of Vienna's Academy of Music and Fine Arts: "Perhaps after some time I shall feel a greater affection for my native city than I do now, and I shall then wish to return."[72]

The return would take place, but so would further departures.

Soldier Schoenberg, Vienna, 1916. Photograph by Alban Berg.

III

WAR, INTERNAL AND EXTERNAL

The Schoenbergs had barely settled into a large apartment—rented to them at a nominal fee, in a villa owned by the sculptor Ferdinand Lepcke in the Zehlendorf quarter of Berlin—when the actress Albertine Zehme approached Arnold with a request: Would he be willing to compose a substantial work for speaking voice with instrumental accompaniment? He had already begun lecturing at the Stern Conservatory (the same institution at which he had worked during his first Berlin sojourn, thanks to a recommendation from the then-supportive Richard Strauss), but his creativity was stimulated by this new proposal. During the late winter, spring, and summer of 1912 he composed *Three Times Seven Poems from Albert Giraud's Pierrot Lunaire*, Op. 21, more commonly known simply as *Pierrot Lunaire*. Schoenberg used Otto Erich Hartleben's German translation of Giraud's French poems, and he scored the piece for piano, flute (plus piccolo), clarinet (plus bass clarinet), violin (plus viola), and cello.

Giraud (originally Emile Albert Kayenbergh), a Symbolist poet like his more famous fellow Belgian, Maeterlinck, was only twenty-

four when, in 1884, he published the fifty-poem cycle, *Pierrot lunaire: Rondels bergamasques* (Moonstruck Pierrot, Bergamask Rondels). In this work he used the foolish-naïve-pathetic-sympathetic *commedia dell'arte* figure of Pierrot to express, mostly by analogy, critiques of social norms and romantic love, concepts of artistic freedom, and even a sort of proto-Existentialism. Schoenberg, who was susceptible to numerical superstitions (in particular, triskaidekaphobia—fear of the number thirteen—but also fixation on the "mystical" number seven), chose to set "three times seven," rather than the more prosaic number twenty-one, of Giraud's poems, and to experiment with a style of recitation that he called *Sprechgesang* (speech-song, or intoned speech), in which the *Sprechstimme* (speaking voice) goes higher and lower in pitch and in precisely indicated rhythms, but only occasionally sings actual notes. Schoenberg indicated the pitch levels by writing notes, on the treble clef, with the letter x through their stems. Some musicians—Glenn Gould among them—have speculated that *Sprechgesang* was created as a way of allowing singers who do not have perfect pitch to perform atonal works without fear, but the fact that *Pierrot* was originally written for an actress who was not a singer obviates that interpretation. On the other hand, the technique did, as a byproduct, make performances of the work feasible *also* for singers who do not have perfect pitch. Zehme, whose husband was a well-to-do lawyer, paid Schoenberg a thousand marks to compose *Pierrot Lunaire*, and by February 11, 1912, Webern, who was living near the Schoenbergs at the time, wrote excitedly to Berg that their teacher was writing "for an extremely talented Viennese woman natural, melodramatic music to poetry, which she will recite."[1]

In his earlier vocal-orchestral works, Schoenberg had tended to

paint inflated, hyper-Romantic texts onto large-scale canvases, but in *Pierrot Lunaire* he accompanied minuscule individual poem-songs with severely reduced instrumental combinations. The cycle represents a complete about-face after the auto-flagellations of *Erwartung* and *Die glückliche Hand*: "not the work of a madman, as was often the criticism in the first few years of its existence," wrote his Scottish biographer, Malcolm MacDonald, "but the work of a very sane one who knows he may have been near madness."[2] And Pierre Boulez described the work as "the center of gravity" of Schoenberg's entire oeuvre and as displaying "a plenitude of conception which Schoenberg very rarely attained" as well as "a concentration in thought and in realization."[3]

Each of the twenty-one poems that Schoenberg selected consists of two four-line stanzas and one five-line stanza. (Did he notice that 4 + 4 + 5 = 13? It seems likely that he did.) In Giraud's original French version, most of the stanzas follow a precise rhyme scheme (ABBA, ABAB, ABBAA), although in a few of them each line rhymes with all the other lines. But Schoenberg set Hartleben's German translation, in which each poem has a reasonably clear rhythmic pattern but is unrhymed.* None of the songs has a key signature; the time signatures and descriptive tempo indications vary (Schoenberg also inserted metronome marks in *Pierrot*, which he had not done

* In 1950, when Robert Craft, a young American musician, told Schoenberg that he was going to conduct a performance of *Pierrot Lunaire* in New York, Schoenberg tried unsuccessfully to persuade him to use Ingolf Dahl's English translation of the text instead of the original German, which was in any case a translation from the French. (See I. Stravinsky and R. Craft, *Themes and Episodes*, New York, Knopf, 1967, p. 167.) This undoubtedly seemed natural to Schoenberg, who had grown up in Europe at a time in which operas and other secular vocal-orchestral works were almost always performed in the local language. Thus in Germany, Italian, French, and Russian operas were performed in German; in Italy, German, French, and Russian operas were performed in Italian; and so on.

in many of his previous compositions), and so do the indications between the songs: "substantial pause," "shortest possible pause," and so on. Each group of seven songs is meant to be a separate unit, but the three units are part of an overall structure. A performance of the entire work takes thirty-five to forty minutes.

Great delicacy and great liveliness: these are the most immediately striking elements of *Pierrot Lunaire*, although, as in all music, the balance among those and other elements depends on the performers, and especially on the voice of the reciting artist. If we compare, for instance, a recording with Anja Silja and the Ensemble InterContemporain conducted by Pierre Boulez against one by Kiera Duffy with members of the Chicago Symphony Orchestra and pianist Pierre-Laurent Aimard conducted by Cristian Macelaru, we hear more forcefulness and irony from Silja and more moonstruck lightness from Duffy.

There is little or nothing of the "contrarian" Schoenberg in the music of *Pierrot*: the music "fulfills" the words and adds dimensions to them, to such a degree that one feels as if the words have grown out of the music itself, in a sort of onomatopoeic symbiosis, which of course is not the case. For instance, in the first poem-song, "Mondestrunken" (Moon-drunk), one hears the tinkling drops of a strange wine made of moonlight—"the wine that one drinks with one's eyes." Or in "Nacht" (Night), the first song in Part Two, the horror of "ominous giant black moths" that have "killed the sun's radiance" chills the blood from the piano's very first low, slow notes. (I am referring only to Hartleben's German titles and texts, which differ, sometimes considerably, from Giraud's original French versions.)

Altogether, *Pierrot* is an astonishing collection of musical miniatures; an expression, through music-accompanied speech, of a vast

gamut of thoughts and emotions; and a unique point of departure for many future developments in twentieth-century music. Boulez described the whole work as a superior form of cabaret, with comic as well as tragic aspects, and he cautioned performers of the title role not to take the poetry at face value but instead to pay at least equal attention to what the music is saying.[4] In other words: Don't miss the irony.

For the fifty-five-year-old Albertine Zehme to perform this startlingly original piece to the composer's satisfaction, or at least as well as he thought her capable of doing, she had to put herself through twenty-five rehearsals.[*] Schoenberg enlisted twenty-year-old Eduard Steuermann—a fellow Austrian Jew who had come to Berlin to study piano with Busoni, and whom Busoni sent to Schoenberg for composition lessons—to teach the title role to Zehme. Steuermann's sister, the actress and (later, in America) screenwriter Salka Viertel, recalled that Zehme had had to accept Schoenberg's instructions not only for the music but also for the interpretation of the poems, "and she had to let Steuermann teach her the complicated rhythms and the vocal modulations" of the *Sprechgesang*.[†] Regarding the barebones staging of *Pierrot*, Viertel reported that "since the flutist was bald, Frau Zehme begged Schoenberg that no one but herself would be seen by the public. Schoenberg thereupon came up with a well-

[*] The number of rehearsals is given as fifty in some sources, but this source seems to me more reliable: J. Brand et al. (eds.), *The Berg-Schoenberg Correspondence: Selected Letters* (New York and London: W. W. Norton, 1987), p. 115n.

[†] Eduard Steuermann changed the spelling of his first name to Edward after he fled to the United States in 1938; by then he was one of the best-known exponents of Schoenberg's music. Eduard and Salka had a sister, Rose, a soprano, who gave some early performances of *Pierrot Lunaire*; she married the Austrian actor and director Josef Gielen, and they were the parents of the conductor Michael Gielen.

thought-out system of screens, which hid the musicians but allowed Frau Zehme to see his baton." Why the flutist's baldness would have bothered Zehme is hard to understand; perhaps she feared that light reflecting from his head would detract from her lunar whiteface makeup, but in that case the reflection from the bald head of the conductor—Schoenberg himself—would have been even more distracting. In any case, Viertel continued, the audience at the first performance, on October 16, 1912, "greeted Pierrot—who was wearing a huge ruff below the made-up, anxious face, and whose legs were displayed coquettishly—with inauspicious murmurings. I was amazed at how Frau Zehme mastered her nervousness and [. . .] courageously recited one poem after another."*

"To the astonishment of the critics," as H. H. Stuckenschmidt wrily commented, the performance "resulted in an ovation for Schoenberg," with most of the audience remaining in the hall and demanding that the entire piece be repeated. Alfred Kerr, Germany's best-known theater critic, declared that *Pierrot Lunaire* appeared to him "not as the end of music, but as the beginning of a new stage in listening. [. . . Zehme] did not give a perfect performance; much was amateurish, yet it was all the more shattering than what a more accomplished actress could have achieved; unselfishly and unaffectedly she gave all of herself. Yes, she even prostituted herself, renouncing all shame (as it should be in art), in an absolute task of precision as a servant of the work."[5] Older listeners tended to be less enthusiastic, but some were open-minded enough to admit that the

* S. Viertel, *Das unbelehrbare Herz. Erinnerungen an ein Leben mit Künstlern des 20. Jahrhunderts* (Hamburg and Düsseldorf: Eichhorn Verlag, 1970); quoted in https://www .leipzig.de/jugend-familie-und-soziales/frauen/1000-jahre-leipzig-100-frauenportraets/ detailseite-frauenportraets/projekt/zehme-albertine-geborene-aman.

problem may have been theirs rather than the composer's. Guido Adler, then in his late fifties, told Schoenberg: "A former student [. . .] wrote me that he liked *Pierrot Lunaire*. Now I envy him for this! I would like to be just, but must always remain *truthful* in what I feel and communicate. Is it possible that this may change—that is to say, my way of perceiving things?" And he ended with "cordial regards from your truly faithful Guido Adler."[6] Yet on the whole, the first performances were so well received that Zehme was able to realize her dream of taking *Pierrot* on tour to various German and Austrian cities—a plan that had been encouraged by the impresario Emil Gutmann, who may also have been behind Zehme's original invitation to Schoenberg to write a work for herself. Schoenberg conducted most of the performances, but Hermann Scherchen, an aspiring twenty-one-year-old conductor, made his debut by taking over one or more of them, when Schoenberg had to be away.

An early Berlin *Pierrot* performance, in December 1912, took place during a stay, in the city, of Sergei Diaghilev's groundbreaking modernist Ballets Russes ensemble, which performed, among other works, Stravinsky's *Petrushka*, a year and a half after the piece's world premiere in Paris. The timing provided Stravinsky and Schoenberg with what would prove to be the only significant encounters of their lives—encounters facilitated by the fact that Stravinsky, as a child, had had a German governess and spoke the language fluently.

"I remember sitting with Schoenberg, his wife Mathilde, and Diaghilev at a performance of *Petrushka*," Stravinsky recalled half a century later, and Schoenberg remembered that he had "really liked *Petrushka*, parts of it very much indeed."[7] Stravinsky reciprocated by attending a performance of *Pierrot Lunaire*:

I have a clear memory of Schoenberg in his green room after he had conducted the fourth performance of *Pierrot lunaire* in the Choralion-saal [. . .]. I still have my cancelled ticket. Albertine Zehme, the *Sprechstimme* artist, wore a Pierrot costume and accompanied her epiglottal sounds with a small amount of pantomime. I remember that and the fact that the musicians were seated behind a curtain, but I was too occupied with the copy of the score Schoenberg had given me to notice anything else. I also remember that the audience was quiet and attentive and that I wanted Frau Zehme to be quiet too, so that I could hear the *music*. [. . .] The real wealth of *Pierrot*—sound and substance, for *Pierrot* is the solar plexus as well as the mind of early twentieth-century music—was beyond me as it was beyond all of us at that time, and when Boulez wrote that I had understood it *d'une façon impressioniste* [in an impressionistic way], he was not kind but correct. [. . .] Diaghilev and I were equally impressed with *Pierrot*, though he dubbed it a product of the *Jugendstil* [Art Nouveau] movement, aesthetically. I encountered Schoenberg several times during my short stay in Berlin, and I was in his home more than once.[8]

Stravinsky, who was thirty years old in 1912 and on the verge of becoming an emblem of modernism, went so far as to say that "the great event" in his life at that time was his experience of *Pierrot*, and that he "contaminated" Ravel with his enthusiasm, "whereas Debussy, when I told him about it, merely stared at me and said nothing," Stravinsky later wrote.[9] (Debussy seems never to have heard any of Schoenberg's music, although he did make an unsuccessful attempt to read through the score of one of Schoenberg's

string quartets.)[10] In a letter written shortly after his Berlin visit, Stravinsky described Schoenberg as "that truly outstanding artist of our time" and added that *Pierrot* "most intensively displayed the whole extraordinary stamp of his creative genius." During the same period, London's *Daily Mail* reported Stravinsky as having said that "Schoenberg is one of the greatest creative spirits of our age."*[11]

What an amazing coincidence it is that two extraordinarily groundbreaking modernist works—Schoenberg's *Pierrot Lunaire* and Stravinsky's *The Rite of Spring* (which would receive its scandal-provoking premiere in Paris less than half a year after the two composers' encounter)—were both being written in 1912, and that both pieces were born of specific commissions: Diaghilev's ensemble had needed a ballet accompanied by an orchestra, and Zehme had required a solo part with only a small ensemble to accompany her. But neither composer could have imagined that *The Rite of Spring*, more than any other single composition, would explode the hegemonic position of the German-speaking countries in the world of European art music—a position that Schoenberg, on the contrary, wished to extend. And all this practically on the eve of a war that would place Germany and Russia on opposite sides and that would dramatically alter the future of the entire European continent.

During the following decades, Schoenberg would heap scorn on the music of Stravinsky's neoclassical period (he lampooned his colleague as "little Modernsky"), and Stravinsky in those years would

* Many years later, in a conversation with the writer Franz Werfel, Stravinsky suggested that *Pierrot* "should be recorded without voice so that the record buyer could add the ululations himself, a 'do-it-yourself' record." (I. Stravinsky and R. Craft, *Expositions and Developments*, p. 78.)

94 | SCHOENBERG

demonstrate only minimal curiosity toward Schoenberg's twelve-tone system; thus from the 1920s onward the two men avoided each other's company.

SCHOENBERG'S REASON FOR CALLING ON HERMANN SCHERCHEN TO conduct at least one of the *Pierrot* performances was that he himself had been engaged to conduct his *Pelleas und Melisande* in Amsterdam, The Hague, and St. Petersburg; he had conducted it in Prague, too, the previous February. This was also the period in which a group of his students published *Arnold Schönberg*, a collection of essays in honor of their teacher,* and all these events plus the success of *Pierrot* made 1912 a relatively happy year for Schoenberg.

Not that all opposition suddenly ceased—quite the contrary! Walter Dahms, a critic for Berlin's *Kleine Journal*, had "welcomed" Schoenberg to Berlin in February 1912 with an open letter in which he said that the city already had so many "peddlers of humbug [. . .] that one more makes no difference. But now people are taking your presence here as their cue to keep performing your 'compositions' (forgive the old-fashioned term!)"—thus, Dahms suggested, money should be collected "to facilitate your hasty return to Vienna."[12] And despite the success of *Pierrot Lunaire* later that year, Webern reported to Berg that fewer and fewer people were attending Schoenberg's

* One of Schoenberg's pupils at the time was Count Gilberto Gravina, grandson of the celebrated conductor and pianist Hans von Bülow and Cosima Liszt von Bülow Wagner—both of them dyed-in-the-wool anti-Semites (although Cosima was one-quarter Jewish). Bülow had died in 1894, but one wonders whether Cosima, who believed that music had more or less ended with the death of Wagner, her second husband, knew that her grandson was studying with Schoenberg.

lectures at the Stern Conservatory and that their teacher did not have enough private pupils to keep his domestic economy afloat.

Schoenberg did indeed return to Vienna, although only briefly and not for the reasons Dahms had suggested. He visited his hometown for the premiere, at long last, of the *Gurrelieder*, on February 23, 1913, in the Great Hall of the Musikverein, with Franz Schreker conducting the Vienna Philharmonic and the Philharmonic Chorus, augmented by the members of a large amateur choral society. Schoenberg's cousin Hans Nachod sang the role of Waldemar, and the other parts were taken by Martha Winternitz-Dorda (Tove), Marya Freund (the Wood-Dove), Alfred Boruttan (Klaus the Fool), a Mr. Nosalewicz (the Peasant), and a Mr. Gregori (Speaker). Many audience members attended with the hope of witnessing or even participating in a noisy row, but instead the evening ended in triumph. There were calls for Schoenberg to take bows with the performers, and eventually he was pulled onto the stage. True to form, however, he showed his thanks only to the performers and refused to turn and bow to the audience. After all, the *Gurrelieder* had been conceived and mostly composed ten to thirteen years earlier; it represented a preceding stage in his development, and in the meantime Vienna had either ignored or shown open hostility toward his more recent and more thoroughly original works. Why, then, should he smile complacently at people and offer them his thanks, since many of them had caused him nothing but grief in the past? To make matters worse, on the day of the final *Gurrelieder* rehearsal, the father of one of his former pupils, demanding to be repaid for some money that he had once loaned to Schoenberg (and that Schoenberg believed to have been repaid by the son, who had owed him money for lessons), sent law enforcement agents to

the boardinghouse where the composer was staying, to take any of his money and personal effects they could find. To return to Berlin after the triumphant *Gurrelieder* premiere, Schoenberg had to borrow money from friends.[13]

Still, Schoenberg can't be entirely forgiven for his behavior toward the audience that evening. Two years earlier, he had published, in the widely circulated *Gutmann Concert Calendar*, a shockingly arrogant statement that had presaged his behavior in Vienna: "The artist never has a relationship with the world, but rather always against it," he wrote; "he turns his back on it, just as it deserves. But his most fervent wish is to be so independent that he can proudly call out to it: Elemia, Elem-ia." This invented word was an anything-but-subtle transliteration of the letters L-M-I-A, which stood for the German expression *Leck mir im Arsch*, the closest (albeit slightly milder) American English version of which is "Kiss my ass."[14] The remark bears witness—in case any further examples were necessary—to Schoenberg's vision of artists, especially himself, as superior to other human beings, and to his belief that dedication to art was more important than dedication to other human endeavors.

I find a pleasant corrective to his statement, and to the attitude that provoked it, in a declaration made half a century later by Ingmar Bergman: "I loathe the whole of this humble attitude toward artists, who *really ought to be given a kick in the ass*." But then I remember that poor Schoenberg had already received many such kicks, and would continue to receive them for the rest of his life. His arrogance was a form of defense against others and against the inevitable self-doubt that grew out of others' negative attitudes toward him. And—as was the case at the outset of his career—sometimes he simply couldn't stop himself from offend-

ing even those people who were simply trying to be sincere with him. When a conductor declined to conduct Schoenberg's Chamber Symphony, saying, "Honestly, I don't understand your music," Schoenberg blurted out: "I do not understand why you have to be truthful only where my music is concerned. After all, you perform the classics without understanding them."[15]

Not surprisingly, his show of contempt for the public in general and the Viennese public in particular did not go over well in his hometown. Only thirty-six days after the *Gurrelieder* had been applauded and cheered at the Musikvereinssaal, Schoenberg—back again in Vienna—lived through one of the worst experiences in his artistic life. The Akademische Verband für Literatur und Musik (Academic Association for Literature and Music) had engaged him to conduct a concert made up of Webern's Six Pieces for Orchestra, Op. 6; Schoenberg's own Chamber Symphony, Op. 9; some orchestral songs by Zemlinsky; two of Berg's "Altenberg" Lieder; and Mahler's *Kindertotenlieder*. Egon Wellesz, who was present at the event, noted that many audience members had come with the express intention of creating a scene, and that early in the concert "there arose an altercation between students, who were enthusiastically applauding, and certain people who sought to disturb the performance by shouts and hisses. When it came to the songs by Berg, however, the noise was so great that one could scarcely hear anything at all." When Schoenberg requested that people at least show respect for Mahler's work, the reaction turned violent. As Wellesz recalled:

> The performance ended in a wild struggle in which blows were exchanged. It found its echo in the law courts, where a [physician] declared that the effect of the music was "for a certain section of the public, so nerve-racking, and therefore so

harmful for the nervous system, that many who were present already showed obvious signs of severe attacks of neurosis."[16]

This was the *Skandalkonzert*—famous, or infamous, in the annals of European music, although somewhat overshadowed two months later by the violent reactions to Stravinsky's *Rite of Spring* at the Théâtre des Champs-Élysées in Paris.

(An aside: I find fascinating and heartwarming the comments of Nuria Schoenberg Nono, Arnold Schoenberg's daughter from his second marriage, about the musical "scandals" that took place in her father's day. "It's a bit of a shame that there is no confrontation anymore," she said. "Everything is in order today; [audiences] only have enthusiasm for the great interpreters, and that is right—but the music itself often has little or nothing to do with its success; the music is much less important in terms of audience response. No-one would take up a passionate position for music anymore today; things have become very vapid.")[17]

Nor had things turned out much better for Schoenberg in London, where, in September 1912, Sir Henry Wood had conducted the world premiere of the Five Pieces for Orchestra, at the Proms. "It is not often that an English audience hisses the music it does not like," wrote Ernest Newman, the most authoritative English music critic of the day,

> but a good third of the people at Queen's Hall last Tuesday permitted themselves that luxury after the performance of the five orchestral pieces of Schoenberg. Another third of the audience was only not hissing because it was laughing, and the remaining third seemed too puzzled either to laugh or to hiss; so that on the whole it does not look as if Schoenberg has so far made many friends in London.[18]

WAR, INTERNAL AND EXTERNAL | 99

And yet Newman's curiosity was piqued. A few months later, he obtained a copy of the *Gurrelieder* score, and he wrote about the work in the January 1914 edition of *The Musical Times*. Newman was under the mistaken impression that Schoenberg had completed the entire composition in 1900, but his comments are worth noting all the same.

> One's first feelings after a thorough study of the score are regret that this work should have remained in manuscript for thirteen years, and amazement that it should have been written by a young man of twenty-six. [. . .] [I]ts general idiom, even today, is more advanced than that of any contemporary German music [. . .]. Schönberg's style is one wholly native to him. It could not have been developed, say, out of Strauss or any other composer of our time, for there is simply nothing in Strauss out of which Schönberg's rich harmonic language could have been evolved."[19]

By the time Newman had published this second article, Schoenberg himself had been to London, where the not-to-be-intimidated Sir Henry Wood had invited him to conduct a second performance of the Five Pieces for Orchestra. This was not only Schoenberg's first opportunity to conduct the pieces but also his first chance to hear them played. Afterward, he reported to Berg:

> The audience greeted me with applause before I conducted. There was hardly any applause after the first piece. Pretty strong after the 2nd. A bit less after the 3rd. Very strong after the 4th!! Strongest at the end. The 4th caused a sensation. I had to take a number of bows and in the end I asked the orchestra to stand. The pieces sound very beautiful. It's an

entirely new sound. Extraordinarily elegant and refined. Very individual. I miscalculated a few dynamic things. Muted brass was often too weak! Or incorrectly marked. That can be very deceptive. But most of it was fine. [. . .] The first piece is very difficult. It caused me the most trouble. I wasn't quite able to finish rehearsing the 3rd, 4th, and 5th. I was afraid I wouldn't finish. But they went fairly well notwithstanding.[20]

Many years later, Schoenberg recalled his difficulty in communicating with the London orchestra in his almost nonexistent English, as well as his inability to get the orchestra's six horns to play a fast passage correctly. "In desperation I turned to Mr. Wood: 'This should perhaps be played by eight horns.' 'My God, no; there would only be more false notes,' he replied, and we both laughed heartily."[21]

Schoenberg also conducted the Five Pieces in Leipzig (where he led the *Gurrelieder* as well, after sixteen rehearsals) and Amsterdam, and by then the work had also received its North American premiere, with the Chicago Symphony Orchestra conducted by Frederick Stock, on October 31, 1913. More immediately important was a decision by Arthur Nikisch, the most influential conductor in Germany (he was in charge of both the Berlin Philharmonic and the Leipzig Gewandhaus Orchestra), to perform Schoenberg's Chamber Symphony in Leipzig early in 1914. Afterward, Schoenberg wrote to Nikisch: "I was particularly delighted when at the final rehearsal I realized that you had applied yourself to my music with great devotion and warm interest." (Nikisch had a reputation for not doing a great deal of advanced study of the works he was to conduct, occasionally even sight-reading scores at first rehearsals.) "[I]n this complicated contrapuntal texture, which reveals its meaning only to people of insight, all the important main parts and

also the secondary parts were clearly and meaningfully brought out,"[22] Schoenberg said.

Although these performances within and beyond the German-speaking world did not make Schoenberg's music popular, they confirmed the fact that many musicians were taking his work seriously and were curious about his development and potential influence. But then that development ground nearly to a halt.

For one thing, Schoenberg seems to have been unsure how to proceed, following the relative success—but also the unrepeatability—of the *Pierrot Lunaire* experiment. For another, on July 28, 1914, Archduke Franz Ferdinand, heir to the throne of the Austro-Hungarian Empire, and his consort, Duchess Sophie of Hohenberg, were assassinated at Sarajevo by a Bosnian Serb who opposed the empire's annexation of Bosnia. That event set off an absurd diplomatic chain reaction that led to the cataclysm of the First World War, in which Arnold Schoenberg, like tens of millions of others, would find himself caught up.

LONDON, ST. PETERSBURG, AND CHICAGO HAD WELCOMED SCHOENberg's music, or at least given it a hearing, in the months before the war began, but as of August 1914 Great Britain and Russia were allied against Germany and Austro-Hungary, and early in 1917 the United States joined Britain and Russia (and France and Italy) against the Germanic nations and their allies. Travel to enemy countries was impossible among the belligerents, and works by most living exponents—and even some dead ones—of "enemy music" were generally excluded from programs in the opposing nations. Within Germany and Austro-Hungary, there was little money available for anything except the war effort and

102 | SCHOENBERG

barely any interest in performing difficult new music. Schoenberg complained to Zemlinsky that his fellow musicians "hold patriotic artistic soirées in C major [. . .]. Now the only language one can use is that of the gun, and those who are unable to use this language should crawl into a corner and try to be inconspicuous."[23] On the other hand, he was a rabid supporter of Teutonic supremacy and, at first, even of the war effort, and he used his enthusiasm to denounce not only the very much alive Stravinsky and Ravel but even poor Georges Bizet, who had been dead for nearly forty years. "Now comes the reckoning!" he wrote to Alma Mahler as early as August 1914. "Now we will throw these mediocre kitschmongers into slavery, and teach them to venerate the German spirit and to worship the German God." Later, however, he admitted that these opinions had been a form of "war psychosis."[24]

In April 1915 Schoenberg visited Vienna to conduct what was apparently a not entirely successful performance of Beethoven's Ninth Symphony (he never did become a first-rate conductor), and that summer he and Mathilde and their children had to return to the Austrian capital because Arnold, although he was nearly forty-one, had to be available for military service. Lilly Lieser, a friend of Alma Mahler's, gave the Schoenbergs the use of an apartment in Vienna's Hietzing district (they would live there until April 1918, when they would move to nearby Mödling), and in December 1915 Schoenberg was called to report for duty. An officer, seeing the draftee's name, asked him whether he was "that controversial composer Schoenberg," to which the draftee answered with what has become one of his best-known statements: "Somebody had to be, and nobody else wanted to, so I took on the job myself."[25]

At Bruck an der Leitha, southeast of Vienna, the "controversial composer" received training to become an officer in the Imperial Army, but when he began to suffer severe asthma attacks he was reassigned to garrison duty in the capital. He was discharged in October 1916, called up again in September 1917, and permanently discharged, in December, for being physically unfit. During those last three months, however, he also resumed teaching at the Schwarzwald School, where he had last taught in 1903–4, upon his first return to Vienna from Berlin.* According to an announcement in the *Neue Wiener Tagblatt* of September 14, 1917, Schoenberg was "starting a composition seminar (harmony, counterpoint, form, orchestration) based on new types of principles, and the requirements are such that even the less well-off may participate."[26]

Eugenie Schwarzwald and her school's supporters rejected the hyper-nationalistic, paternalistic order that they and other liberals hoped would end forever once the horrendous war had come to a close, whichever side won. The school was "run on the most progressive modern educational principles," according to Wellesz, "by a comradely community of teachers with modern attitudes" that favored "tolerant social and humanitarian world citizenship."[27] It was now coeducational, no longer for girls only, and, in the desperate economic situation that Austria faced during the final year of the war and then in the wake of defeat, "Frau Doktor" Schwarzwald

* I was disconcerted to find, in an English translation of Wellesz's *Arnold Schönberg*, a reference to Schoenberg teaching at a place called the Black Forest School—a place I'd never heard of—but I laughed when I realized that the translator had simply translated Schwarzwald literally as Black Forest, without realizing that in this case it was a surname.

also managed to procure food for her students, many of whom were on the verge of starvation.*

Schoenberg's courses continued through 1918 and 1919 and into 1920; his pupils at the school would eventually number over a hundred, including the budding composers Max Deutsch, Viktor Ullmann, and Hanns Eisler; the musicologists Paul Pisk, Josef Rufer, and Erwin Ratz; the violinist Rudolf Kolisch; the conductors Karl Rankl and Felix Greissle; and the pianists Rudolf Serkin and Eduard Steuermann.† Other gifted youngsters wanted to study with him but couldn't, for one reason or another. One of them, the nineteen-year-old Kurt Weill, had been deeply impressed by one of Schoenberg's earlier works, and he wrote to his brother, Hanns, in June 1919:

> Think of everything in Strauss that is false, trivial, veneered and contrived being replaced by the finest kind of modernism, in Mahler's sense, as the result of a great personality expressing itself in the most profound way; then you have Arnold Schoenberg as I am getting to know him now from his Gurre-Lieder. Together with [the philosopher Ernst] Cassirer's lecture on Spinoza, this work has kept me calm amidst inner struggles. I don't mind how it comes about, but—sooner or later—I must go to Vienna.

* The postwar German Republican government invited Eugenie Schwarzwald to set up a similar system in a wing of the former Imperial Palace in Berlin; the institution became known, informally, as the *Schlossküche*—the palace-kitchen.

† Steuermann, like Schoenberg, had returned to Vienna from Berlin. For the record: Among these pupils, the only ones who were not Jewish or part-Jewish were Rankl, Ratz, and Rufer. Rankl, however, was married to a Jewish woman and later fled the Nazis with her, and Ratz and his wife hid several Jews in their apartment during the Nazi years and were posthumously awarded the title of Righteous Among the Nations by Israel's Yad Vashem Holocaust Memorial Center. Among the Jews, Ullmann was murdered at Auschwitz; the others managed to flee abroad.

Weill did write to Schoenberg, who "sent me from Vienna an extremely nice card in which he announces, in the most noble fashion, that he will accommodate me in every way."* But Weill, who lived in the northeastern German town of Dessau, did not have the wherewithal to travel to and survive in Vienna, and he later came to see himself as Schoenberg's polar opposite: in his collaborations with Bertolt Brecht on social-activist works like *The Three-Penny Opera* and *Rise and Fall of the City of Mahagonny*, he would be a composer for the people and for his own day, rather than participating in what he believed to be a remarkable but elitist vanguard whose works would remain beyond most people's understanding, at least until a time well into the future, thus of little or no use to contemporary society.

The previously cited first sentence of Schoenberg's *Theory of Harmony*—"I have learned this book from my pupils"—might lead one to imagine that his humility toward teaching as a calling was reflected in the way he treated his students, but that was not always the case. Many of them, even among those who adored him, testified that he could be intimidating and even insulting. Eugenie Schwarzwald described Schoenberg as "one of Vienna's greatest educators" but also "a strict, unpleasant, often mistaken educator who has nevertheless achieved splendid educational results. Schoenberg has brought up a whole generation of students, has educated a public, and"—she couldn't resist adding—"has educated himself."[28] Gifted students were able to participate in Schoenberg's seminar even if they were unable to pay for it: Eugenie and Hermann

* For an interesting account of the Weill-Schoenberg relationship, or non-relationship, see David Drew, "Schoenberg and Weill," https://www.kwf.org/media/drew%20writings/schoenberg%20weill%20web.pdf, © by the Estate of David Drew. The two quotations, from Kurt Weill's letters to his brother Hanns (June 27 and July 19, 1919, respectively) are taken from that article.

Schwarzwald and the school's other supporters, along with the city of Vienna, made up for whatever part of Schoenberg's salary could not be covered by the pupils themselves. Yet the price that Schoenberg demanded of all his pupils was absolute loyalty to their teacher. Those who broke away were shunned forever by the Master, which is what happened to Rudolf Serkin.

Serkin, a *Schwarzwaldkind* (child of the Schwarzwald School, as many of the institution's ex-students continued to call themselves to the end of their lives), was introduced to Schoenberg toward the end of the war by Adolf Loos, a close friend of the Schwarzwalds and one of the school's supporters. Already an accomplished pianist at age fifteen, Serkin was a pupil of the well-known piano pedagogue Richard Robert (who also taught Clara Haskil and George Szell, among others), and he would later be revered as one of the finest concert pianists of the twentieth century. But he learned so much from Schoenberg—about music itself but also and above all about fanatical dedication to music—that for the rest of his life he would consider Schoenberg the greatest influence on his artistic development. During his two years as a Schoenberg student he played virtually nothing but contemporary music, he later claimed, yet he gradually discovered that he didn't really feel at all comfortable in that repertoire.

"Schoenberg was a fantastic man," Serkin recounted many years later, and "I loved him. But I could not love his music. I told him so, and he never forgave me. He said, 'It's up to you to decide whether you want to be on this side of the barricades or that one.'" About Schoenberg's piano pieces, Serkin said, "I had to tell him I didn't like them . . . He looked at me as if I were a soldier who had deserted."[29]

Before the break took place, however, Serkin had wholeheartedly participated in the Verein für Musikalische Privataufführun-

gen (Society for Private Musical Performances) that Schoenberg and some of his disciples had formed in Vienna. Disgusted by the violent pro-and-contra battles that had beset many earlier concerts of music by himself and by other avant-garde composers of the day, Schoenberg and like-minded friends and followers decided to create a subscription series in which contemporary music would be performed before people who wanted to familiarize themselves with current developments in the musical world in as serious and objective a way as possible. "Schoenberg once again has a wonderful idea," Berg wrote to his wife, on July 1, 1918: "to establish a society whose mission it is to present weekly performances of music from 'Mahler to the present' to its members."[30] At first glance, this society seems like a copy of the Vereinigung schaffender Tonkünstler (Union of Creative Musicians) that some of the same people had set up in 1904 and that had survived for only one season, but there were some significant differences: this time, performances would be open only to members, who would have to present what would today be called "photo ID" to be admitted; programs would not be made known in advance; no audible expressions of either enthusiasm (applause, cheers, etc.) or dislike (booing, hissing, etc.) would be made; the press would not be admitted; and no one in attendance was to publish an account of what had been performed. On the other hand, membership would be open to anyone willing to abide by the rules (subscription prices varied according to people's means), and, most important, the works performed were to be carefully prepared and then played more than once in the course of a season, so that first impressions of a work would not also be the last. Schoenberg and Berg were president and vice-president, respectively, of the society; Webern and Steuermann were also among the prime movers—which, by the way, meant that, among much else, they actually had to move chairs,

music stands, and so on; and many of Schoenberg's other pupils took part in organizing or performing in the concerts.

The society's very first concert took place on December 29, 1918, just seven weeks after the war-ending Armistice had been signed, leaving Austria virtually bankrupt. Nevertheless, the unusual program consisted of works not only by the Austrian Mahler but also by the Frenchman Debussy, who had died earlier that year, and the Russian Scriabin, who had died in 1915—both citizens of nations that had been Austria's wartime enemies. During the first season, 1918–19, forty-five works were given a total of ninety-five performances in twenty-six concerts, and by the time the society came to what was effectively an end, in December 1921, one hundred seventeen concerts comprising one hundred fifty-four twentieth-century works had been performed; most of the pieces had been given two or more hearings. Among living composers, Béla Bartók, Maurice Ravel, Paul Dukas, Erik Satie, Stravinsky, Busoni, Strauss, Zemlinsky, Hans Pfitzner, Josef Suk, Karol Szymanowski, Darius Milhaud, and Francis Poulenc were some of those represented, as was Max Reger, who had died in 1916 at the age of forty-three. At one concert, Ravel and the Italian composer Alfredo Casella played a four-hand piano arrangement of *La Valse*. All in all, the society performed a great service for Vienna's otherwise conservative musical life.

Schoenberg could be as difficult in his demands on the society as he was in his other endeavors. "[O]ver the last few weeks Schoenberg has been exclusively preoccupied, in thought and deed, with the Society," Berg wrote to Erwin Stein on June 2, 1921. "I must admit that there were times when carrying out his hundreds of wishes and thousands of enquiries and ideas turned into an indescribable

chase [. . .]. [H]is whims often took on indescribable dimensions; and I should have gone on feeling the effects far longer, were it not that in the last few days he has been a good deal more approachable."[31] Many years later the musicologist Paul Pisk, who helped organize the society's rehearsals, recalled: "you can't imagine how wearing it was for a normal human being to be with Schoenberg. Schoenberg was [. . .] not only temperamental but also tyrannical. He didn't allow any opposition."[32]

Performances that focused on compositions by Schoenberg and his disciples were relatively few throughout the society's existence, and in any case increased familiarity with their works did not always lead to greater love for them, as Serkin's case demonstrates. A young friend of Serkin's, the future philosopher Karl Popper, became a member of the Society in his mid-teens, even helped organize some of its rehearsals, and "got to know some of Schönberg's music intimately, especially the *Kammersymphonie* and *Pierrot Lunaire*," he wrote many years later. "After about two years I found I had succeeded in getting to know something— about a kind of music which now I liked even less than I had to begin with."[33] Others, however, warmed to Schoenberg's works— and, as a minimum, members became acquainted with what had been going on in the world of music since the death of Brahms a quarter-century earlier.

Beyond the Society's restricted precincts, Schoenberg was pleasantly surprised to find that a substantial number of music lovers in his hometown were beginning to warm to his work. At the Vienna Music Festival in June 1920, Zemlinsky conducted a well-received performance of *Pelleas und Melisande*—sweet revenge for Schoenberg, after the debacle of the performance that he himself had con-

ducted in the city twelve years earlier—and Willi Reich described a performance of the *Gurrelieder* that Schoenberg himself conducted at the Vienna State Opera (the former Court Opera) as "a genuine triumph."[34] Two days after the latter event, Schoenberg wrote to the State Opera orchestra musicians to say that however bitter he had been about not having had his music performed by them in the past, "by the end of the first quarter of an hour in which I had the pleasure of rehearsing with you, my only feeling was the enthusiasm which I am now trying, to the best of my feeble ability, to express."[35]

The focus on performing already extant music also gave Schoenberg an outlet for his abundant energies at a time when his creativity was at low ebb. Some of the reasons for this hiatus in composing may easily be surmised. Most obviously, Schoenberg would have been frustrated, not so much by compulsory registration for military service or even by the service itself as by the mandatory departure from Berlin that it had entailed. In the German capital his fortunes seemed to have been improving, however slowly, whereas in Vienna, his hometown, and notwithstanding his successes with works that he had written much earlier, he felt that his creative work was not merely unwanted but actively opposed. Then, after four years of war and the crushing defeat, Austria now faced economic and social upheaval, the dismantling of the Austro-Hungarian Empire into separate nation-states, the end of the six-and-a-half-century-old Hapsburg monarchy, the birth of the Austrian Republic, the rise of a radical left inspired by Russia's Bolshevik Revolution, and the counter-positioning of reactionary ultra-nationalistic groups. All of these factors impacted every area of society, including the performing arts. And—who knows?—

perhaps the concerts of the Society for Private Musical Performances, which deepened Schoenberg's familiarity with the works of other radical composers, may have caused him to reexamine his own creative plans; because however adamant, intolerant, and bullish a front he put on when he presented himself to the world at large, Schoenberg had periods of grave personal and artistic self-doubt—as when he had contemplated suicide in 1910.

Not that there was no compositional activity at all in Schoenberg's working life. Between 1913 and 1916 he wrote Four Orchestral Songs, Op. 22 (with soprano); the first song's text was a Stefan George translation of a poem by Ernest Dowson, the other three were settings of poems by Rilke. All were densely orchestrated—a return, to some extent, to the textures of *Erwartung* and *Die glückliche Hand*, as if *Pierrot Lunaire* had never existed—but *Pierrot* had been a one-of-a-kind experiment. In 1914 Schoenberg made sketches for a never-to-be-completed choral symphony that contained the germ of the (or a) twelve-tone method, and through this work he once again intended "to give personal things an objective, general form, behind which the author as person may withdraw";[36] thus he wrote to Alma Mahler. In 1917, however, he set down the words for an oratorio, *Die Jakobsleiter* (Jacob's Ladder), which was in part a transformation of the symphonic idea, and to which we'll return very soon. And in 1919 he began work on the Serenade, Op. 24, which he would finish four years later. Still, as a man who regarded composition as his calling in life, he must have felt considerable unease, if not actual depression, during these mostly fallow years.

By an odd coincidence, a similar creative slowdown had happened to Beethoven, also in and around Vienna, almost exactly a century earlier. With hindsight we know that during the eighteen-

teens Beethoven was gestating a new compositional style that would eventually produce his last four piano sonatas, the "Diabelli" Variations, the *Missa Solemnis*, the Ninth Symphony, and the last five string quartets. Schoenberg, in the late nineteen-teens and early 'twenties, was likewise thinking about new approaches to his own work; in notes to the 1922 edition of his *Harmonielehre* he wrote words that indirectly but clearly refer to his own situation at the time. From that text, we find confirmation of his belief not only in the High Romantic notion of what a creative artist is and does but also in himself as a messenger of God and, simultaneously, the bearer of a heavy cross, en route to his personal, private Golgotha:

> Masters are the only ones who may never write just anything, but must rather do what is necessary: fulfill their mission. To prepare for this mission with all diligence, laboring under a thousand doubts whether one is adequate, with a thousand scruples whether one correctly understood the bidding of a higher power, all that is reserved for those who have the courage and the zeal to shoulder the consequences as well as the burden which was loaded upon them against their will.[37]

Not "unwittingly" or "unconsciously" or "because they loved music and wanted to make it their life" but actually "against their will"—which of course meant "against *my* will."

Still, Schoenberg's apparently fallow period, like Beethoven's, led to new and surprising results. But unlike Beethoven's later works, most of which would be widely accepted, admired, and loved within

WAR, INTERNAL AND EXTERNAL | 113

a few decades of their creation or even sooner, Schoenberg's new offspring remain controversial to this day.

BEFORE, DURING, AND AFTER BOTH WORLD WARS, SCHOENBERG worked at various times on the aforementioned composition that became known as *Die Jakobsleiter* (Jacob's Ladder). Forty years elapsed between his original ideas for this work as a two-hour-long fourth (final) movement of a choral symphony that would have dwarfed any previous work in the symphonic genre, and his last, doomed attempts to finish this single "movement" in the form of an oratorio.

As early as 1911–12, Schoenberg had thought of creating a vocal-orchestral work that would be based on a combination of the "Jacob Wrestles" segment of Strindberg's autobiographical novel *Legends* (1897) with the final chapter, "The Assumption," of Balzac's 1834 novel *Séraphîta*—a very odd pairing, although both works have ties to the ideas of the eighteenth-century Swedish theologian and mystic Emanuel Swedenborg. On the one hand, Strindberg's lofty but unhappy solitude and his feeling of having been singled out for persecution, combined with his sense of superiority, blended perfectly with Schoenberg's self-view. Solitude, Strindberg says,

> has educated me [. . .] by depriving me of every friendly support. I have grown accustomed to speak to the Lord, to confide only in Him, and have as good as ceased to feel the need of men; an attitude which has always seemed to me to be the ideal one of independence and freedom.

SCHOENBERG

And then:

> The man "continually discontent" is an unfortunate being under the scourge of the invisible Powers, and it is with very good reason that people avoid him, for he is condemned to be a disturber of the peace [. . .] doomed to solitude and suffering [. . .].

There is also a direct reference to the biblical story of Jacob: Strindberg visits the church of St.-Sulpice in Paris

> in order to strengthen myself by looking at Eugène Delacroix's painting of Jacob wrestling with the angel. [. . .] I keep remembering the wrestler who holds himself upright although lamed in the sinew of his thigh.

And, again, the sense of persecution: "I have been punished where others have sinned [. . .]. The punishment has alighted on me while the guilty triumphed." Besides, we are in a new medieval period, Strindberg says, in which "crusades against Jews and Turks begin afresh; the Anti-Semites and Philhellenes see to that." And he asks a mysterious interlocutor to tell him whether his fate is to be a martyr or a prophet; if the latter, "I must have adequate support for my life instead of being, as I am, besmirched with poverty, which makes one's character deteriorate and ties one's hands." Finally, we find the shared Strindbergian-Schoenbergian sense of destiny: "Amid all my vacillations one thing seems certain to me, and that is that an invisible hand has undertaken my education [. . .]."[38]

Balzac's *Séraphîta* is, on the contrary, a work of pure fiction by an author who had little if any personal feeling for either Swe-

denborgian mysticism or the androgyny of his title character, but whose extraordinary imagination allowed him to enter fully into both.* What must have held particular appeal for Schoenberg was the combination, in the novel's "Assumption" chapter, of human genius with spirituality, musical imagery, and the visual and olfactory senses, as in the following excerpts:

> The *spirit* was above them, it gave off an odorless fragrance, it was melodious without the aid of sounds. [. . .] Suddenly the trumpets sounded, the trumpets of Victory won by the *angel* in this final trial; the clarion call reached into space like a sound within an echo, it [. . .] made the universe tremble. [. . .] Light gave birth to melody, melody gave birth to light, colors were light and melody, motion was a Number endowed with the Word; everything was at once sonorous, diaphanous, mobile. [. . .]

Two of the story's characters

> heard the various parts of the Infinite forming a living melody; and, every time the chord made itself heard [or felt] like an immense breath, the Worlds swept along by this unanimous movement leaned toward the immense Being who, from his impenetrable center, radiated everything from within him and brought everything back into him.

* For a convincing take on this subject, see Margaret Hayward, "The Myth of Balzac's Mysticism: His Father's Mesmerist Ideals," *History of European Ideas*, vol. 27 (2001): pp. 273–87. I wonder, too, whether Schoenberg knew that in 1894 Ruggero Leoncavallo, composer of the popular opera *Pagliacci*, had written a tone poem inspired by *Séraphîta*. Probably not—and the fact most likely wouldn't have influenced him had he been aware of it.

SCHOENBERG

The characters also came to understand

> the invisible ties through which the material worlds were connected to the spiritual worlds. In recalling the sublime efforts of the greatest human geniuses, they found the principle of melody in listening to heaven's songs, which gave the sensations of colors, of fragrances, of thought, and which recalled the innumerable details of every creation, as a song of the earth revives infinitesimal memories of love.[39]

In short: one need not wonder that Schoenberg never managed to complete the musical setting for this trans-cultural muddle of religion, philosophy, mysticism, chords, colors, fragrances, genius, solitude, and persecution. He had at first put Marie Pappenheim, his *Erwartung* librettist, to work on a German version of the *Séraphîta* story, and had approached Richard Dehmel about a collaboration on the Strindbergian aspect of the project. Dehmel respectfully demurred, and Schoenberg eventually decided to write the entire text himself—a task that he accomplished in about two years, from 1915 to 1917, despite interruptions for military service. The libretto begins with the Archangel Gabriel (baritone) telling someone whom we presume to be the protagonist—unnamed, invisible, and represented by the chorus—that his fate is to proceed without knowing why; Gabriel's tone is to be "sharp and dry," Schoenberg instructs. The response is a lament, with choral voices that are sometimes forceful, sometimes discouraged or even pleading, accompanied by an orchestra that alternates between violent explosions and mysterious gentleness:

The intolerable pressure . . . !
The heavy burden . . . !
What fearful pains . . . !
Burning longing . . . !
Hot desires . . . !
Illusions of fulfillment . . . !
Inconsolable loneliness . . . ! [. . .]
Pleasure in futility, self-esteem . . . !"*

Some Strindbergian misogyny is added to the mix, to demonstrate that becoming involved with women can impede a great man from reaching his heroic destiny:

Intimate hours, sweet delights . . . !
Bounding energy and successful action . . . !
A work is accomplished, a child comes into the world,
a woman kisses,
a man rejoices . . . and becomes blunted again . . .
[. . .] and dies,
is buried,
and forgotten. . . .[40]

Gabriel says, "No matter! Onward!" And the response is "How long?"

The chorus goes on to represent—sometimes with overlapping voices—the Malcontents, the Doubters, the Indifferent, the Rejoic-

* The unbracketed ellipses are present in Schoenberg's text; the bracketed ones are mine.

ers, and the Quietly Resigned; this last group is given a complacent waltz fragment on the words "one takes things as they come, yes, yes. . . ." (These words—meant to be sung "somewhat childishly, in a monotone"—are repeated quietly over simple humming by other voices in the chorus. Schoenberg may have been familiar with the "Humming Chorus" in Puccini's *Madama Butterfly*, which accompanies, summarizes, and symbolizes Butterfly's long and ultimately hopeless wait for her husband to return to her. But Schoenberg's purpose is entirely different: the humming, in this case, leads into the words, "Oh, how nicely one lives in the mire.") Legato winds and quietly staccato strings provide a moment of respite, until Gabriel once again forcefully urges his interlocutors onward. Individual singers take the parts of what I assume to be various aspects of the creative spirit and, more specifically, of Schoenberg as he saw himself: the One Who Is Called (tenor), the Rebellious One (tenor), the One Who Struggles (baritone), the Chosen One (baritone), the Monk (tenor), the One Who Is Dying (high soprano), and the Soul (high soprano)—all of them, except the Soul, in dialogue with Gabriel. Each one states something essential to his way of being, and each is rebuked—sometimes gently, sometimes harshly—by Gabriel. When the One Who Is Called speaks of seeking beauty, the music verges on tonal harmony; although Schoenberg no doubt meant to mock artists for taking the easy route, the equation of tonality with beauty was an odd move on his part. And when the tonal harmony evaporates, the One Who Is Called continues in a rapturous, waltz-like rhythm and with Richard Straussian instrumentation.

The main point of interest in the text is the displacement of Romantic-erotic angst, which had been at the center of most of

Schoenberg's previous large-scale vocal-orchestral works, by an attempt, however confused and ultimately futile (which the composer seems to have understood), to make sense of human existence in general and of artistic aspiration in particular. Perhaps this change also reflected a gradual change in his sensibilities as he approached middle age. In any case, the Romantic-erotic theme remains, but it is only one among many elements. And the principal aid to which Schoenberg turned, in his quest to find his way forward, was religion: "During these years, it was my only support," he wrote in 1922.[41] But Schoenberg's religious reference point was not Christianity, to which he had formally committed himself a quarter-century earlier, but rather the Old Testament—the sole source of spiritual instruction for his ancestors. Even the monk refers only to the Old Testament story of Sodom and Gomorrah, in his dialogue with Gabriel.

During the summer of 1917, while he was completing the *Jakobsleiter* libretto, Schoenberg also composed the first 601 bars of its music. Another hundred bars plus sketches for a few subsequent parts were written during the following five years, but then the work was set aside until 1944, when Schoenberg, then turning seventy and living in California, made up his mind to revise what he had done more than two decades earlier and to complete the piece. He made little progress, however, partly as a result of ill health, including worsening eyesight. In January 1945 he applied to the Guggenheim Foundation for a grant that might have enabled him to finish this and other works, or at least to make progress on them, but the foundation's grants were limited, at the time, to people under forty years of age, thus his application was rejected. Finally, in 1951, only sixteen days before his death, he wrote to the conductor Karl Rankl,

his former pupil: "I must acknowledge the possibility that I may no longer be able to compose 'Jacob's Ladder' to its completion,"[42] but he pointed out that his manuscript contained "many indications of the instrumentation I want, and these are often quite detailed."[43]

The score was eventually filled out ("completed" would be a misleading term) by the German composer Winfried Zillig, another former Schoenberg pupil, and it was in this form that the oratorio was given its world premiere at Vienna's Konzerthaus in 1961, ten years after Schoenberg's death and fifty years after he had had his first ideas for the work.* Performances of this difficult piece are rare. Like most of Schoenberg's other orchestral works, *Die Jakobsleiter* calls for a massive number of musicians: seventeen in the woodwind section; eleven brass players; celesta, piano, and harp; timpani, glockenspiel, xylophone, and enough percussionists to deal with these and six other instruments; a string section large enough to balance all of the above; two offstage instrumental groups (one "high up," the other "in the distance"); a 144-member chorus divided into twelve groups (two groups each of sopranos, mezzo-sopranos, contraltos, tenors, baritones, and basses); and

* One wonders whether Schoenberg was aware that Zillig had had "many career successes in Germany from 1933 to 1945"—that is, during the Nazi period—"including major opera premieres and a position in occupied Poland, granted as a reward for his operas' political values." This according to the article "When Classical Music Was an Alibi," by Emily Richmond Pollock and Kira Thurman, in the *New York Times*, April 15, 2022. Those operas—*Rosse* and *Das Opfer*—were successful, and Zillig was even allowed to have his twelve-tone chamber and orchestral works performed, according to Joseph Wulf's *Musik im Dritten Reich: Eine Dokumentation*, p. 367. In any case, at *Die Jakobsleiter*'s 1961 premiere, the performers were the Cologne Radio Orchestra, the Cologne and Hamburg Radio Choruses, and a first-rate group of soloists that included the American bass-baritone Thomas Stewart and the Austrian tenor Julius Patzak. Rafael Kubelik conducted. As of 2022, a fragment of that somewhat raw performance can be seen and heard on YouTube (https://www.youtube.com/watch?v=BpMjjzKznDo&t=331s). There is also an interview-conversation (in German) from that time about the work and its "completion," with Gertrud Kolisch Schoenberg and Winfried Zillig (https://www.youtube.com/watch?v=-bzecXlenGU), and it is followed by Zillig's descriptive analysis (also in German) of the work (https://www.youtube.com/watch?v=d1X9NMTSOdE).

eight solo singers, most of whom must be able to perform *Sprech-gesang* in addition to singing in the traditional way—not to mention the fact that at least one of the two soprano soloists must be capable of hitting stratospheric high notes. On the other hand, and unlike the situation in some of Schoenberg's earlier orchestral works, the instrumental textures are for the most part transparent: rarely does a singer have to strain to be heard. And much of the choral writing is exceptionally beautiful.

In Zillig's opinion, "the conclusion of the 'Jacob's Ladder' fragment is one of the most impressive endings in the whole of Occidental music. [. . .] The enchantment is complete despite the fragmentary character [. . .], for such a work, given its intellectual premise, can provide only an incomplete answer in view of mankind's limitations when facing the eternal."[44] To which one is obliged to add: "Yes, but. . . ." For this wasn't Schoenberg's original plan for an ending: it ends as it does because he never finished the piece. *"Hier endet Schönbergs Particell-Skizze"*—"Here ends Schoenberg's short-score [a score minus the orchestration] sketches," Zillig or someone else wrote under the last incomplete, single-staff bar, which trails off the final page. According to Ulrich Krämer, who has been preparing a new edition of *Die Jakobsleiter* for the Schoenberg *Gesamtausgabe* (edition of the complete works), the composer, until his death, "was thinking of ways to finish the *Jakobsleiter* [. . .], of which only the first half was completed in *particell* notation. The entire second half [. . .] had yet to be composed, although he had put down already many sketches for the music in several sketchbooks." Schoenberg meant to end the work with a prayer, *"Herrgott im Himmel"* (Lord God in Heaven).[45] But, as Schoenberg scholar Sabine Feisst has pointed out, most of the composer's subsequent religion-related texts were left incomplete, just as, for believers, God himself is without end.[46] Per-

haps, in his mind, it might have seemed dangerously blasphemous to "finish" a work that deals with the Infinite.

As for what Zillig calls *Die Jakobsleiter*'s "intellectual premise," one can only say that even the nutty libretto of *Il Trovatore* is a model of clarity in comparison with this self-flagellating and self-justifying, mystical and pseudo-mystical, philosophical and pseudo-philosophical, verbose, prayerful, doubting, prosaic-poetic lecture-sermon of a text. Indeed, comprehension of German may be more a hindrance than a help in this case: *Die Jakobsleiter* is perhaps best listened to as a forty-five-minute-long vocal-orchestral tone poem, much of it strikingly beautiful for those who care to open their ears and minds to it.

BEFORE SCHOENBERG SET ASIDE HIS WORK ON *DIE JAKOBSLEITER*, AND before he formulated his twelve-tone method, and before his work with the Society for Private Musical Performances came to an end, Holland beckoned to him. The Dutch had remained neutral during the war, although the conflict had sometimes strayed across their borders and had caused economic problems that continued to be felt during the postwar years. Still, they had been spared the military slaughter and other forms of mass destruction that the belligerent nations had wreaked upon each other. Now that international travel had again become possible, Holland was a desirable place to be. In March 1920, Schoenberg conducted his orchestral arrangement of *Verklärte Nacht* as well as two of his Five Pieces for Orchestra, Op. 16, in Amsterdam, and he returned to the city in May for a Mahler festival. He was elected president of an International Mahler League that grew out of those events, and, together

with his family, he spent the fall of 1920 and the following winter in Zandvoort, on the North Sea coast. He not only continued his work for the league but also taught several students and gave or attended performances of some of his own works: the Concertgebouw Orchestra played *Pelleas und Melisande* and the Six Songs with Orchestra, Op. 8 (with Schoenberg's cousin Hans Nachod as soloist) in both Amsterdam and The Hague; the Budapest String Quartet performed his First Quartet, Op. 7; and there were enthusiastically received performances of the *Gurrelieder.*

During the summer of 1921, following their return to Austria, the Schoenbergs traveled to the village of Mattsee, on the lake of that name, north of Salzburg, so that Arnold could work in peace, teach those of his students who had followed him there, and indulge his love of swimming. But shortly after the Schoenbergs' arrival, the local council posted a sign "suggesting" that all Jews leave. The Schoenbergs could have shown papers to prove that they all had been baptized, but Arnold, justifiably outraged, insisted that they betake themselves elsewhere. The entire group moved to Traunkirchen on the Traunsee, and from there Schoenberg wrote, half jokingly, to Berg: "Toward the end it got very ugly in Mattsee. The people there seemed to despise me as much as if they knew my music."[47] But there was no joking in a letter he wrote two years later to Kandinsky, who was anti-Semitic but who had said that although he rejected Schoenberg as a Jew, he admired him as an artist. (The Russian painter was at that time involved with the Bauhaus group, whose founder, Walter Gropius—Alma Mahler's second husband—referred to Jewish influence in the arts as "poison."[48] Later, when the Nazis came to power, the Bauhaus's leading figures, "Aryan" and otherwise, were grouped together with the Jews as perpetrators of "degenerate" art.)

The Mattsee episode, Schoenberg declared, had taught him a lesson, "and I shall not ever forget it."

> It is that I am not a German, not a European, indeed perhaps scarcely even a human being (at least, the Europeans prefer the worst of their race to me), but I am a Jew.
>
> I am content that it should be so! Today I no longer wish to be an exception; I have no objection at all to being lumped together with all the rest. For I have seen that on the other side (which is otherwise no model so far as I'm concerned, far from it) everything is also just one lump.[49]

And, in response to a conciliatory answer from Kandinsky, he wrote:

> [. . .] when I walk along the street and each person looks at me to see whether I'm a Jew or a Christian, I can't very well tell each of them that I'm the one of whom Kandinsky and some others make an exception, although of course that man Hitler is not of their opinion.* [. . .] Must not a Kandinsky have an inkling of what really happened when I had to break off my first working summer for 5 years, leave the place I had sought out for peace to work in, and afterwards couldn't regain the peace of mind to work at all? Because the Germans will not put up with Jews![50]

* Schoenberg's mention of Hitler was prescient: it not only antedated by ten years the future dictator's accession to the chancellorship of Germany but also preceded, by six months, Hitler's attempted coup d'état—the infamous Munich Beer Hall Putsch.

And yet . . . Shortly after the Mattsee incident, Schoenberg reached a decision about a new method of composition that he believed would give German music a fresh lease on life. His new music and its offshoots, he convinced himself, would show the direction in which German music was destined to go. Forget about the still highly active Richard Strauss, the up-and-coming Paul Hindemith (Schoenberg's junior by twenty-one years), and other "Aryan" composers of the day: the German musical world, Schoenberg seems to have believed, would simply have to accept the fact that the instrument of its destiny was a Jew.

Schoenberg with Alban Berg, Vienna, 1925–32.
Photograph by Dora Horowitz.

IV

BREAKTHROUGH

AND BREAKAWAY

"Whenever I think about music," Schoenberg said, "I never visualize—consciously or subconsciously—any other than German music."[1] Given his sharp awareness of the largely negative attitudes of the Germanic nations of his day toward their Jewish minorities, Schoenberg's fixation on and support for Teutonic dominance in music seems almost masochistic. "If one had a hint of common sense in Germany," he wrote,

one would understand that the fight against me means more or less the intention to break down its hegemony in music. Because through me alone and through what I produced on my own, which has not been surpassed by any nation, the hegemony of German music is secured for at least this generation. But I am a Jew! Of course, what else should I be, since I want to give something, which [society] is unable to accept?[2]

Furthermore, he said, his teachers "were primarily Bach and Mozart, and secondarily Beethoven, Brahms, and Wagner." Never mind the fact that Bach and (especially) Mozart had learned a great deal from their Italian elders and contemporaries; never mind that Schoenberg admired Tchaikovsky's mastery of orchestration,[3] or that, in later years, he kept the scores of Verdi's *Otello* and *Falstaff* in his study:[4] for him, the terms "great music" and "great German music" were virtually interchangeable. Foreigners could write perfectly competent, enjoyable, even brilliant music, but the great, deep works were German. He would have liked his works to be as popular as Tchaikovsky's, he wrote, but of course (need one even say so?) Tchaikovsky's music couldn't have been as profound as his own! Tchaikovsky was Russian; Schoenberg was German.

Apropos German music versus Russian music, let's return for a moment to the Schoenberg-Stravinsky dichotomy. The two composers grew further and further apart, aesthetically, during the post–World War I years, yet they continued to share the age-old beliefs that the construction of musical compositions requires logical procedures and that those procedures would gradually evolve and expand. Beethoven's *Missa Solemnis* contains harmonic and structural elements that Haydn would have found strange and objectionable twenty-five years earlier, when he composed *The Creation*, but that he would have had no trouble comprehending. Likewise, Berlioz's *Damnation of Faust*, composed a quarter-century after the *Missa Solemnis*, was full of expressive elements that Beethoven might have disliked but would have understood. And so on, for generations before and after the composers just named. But when we leap, for instance, from Brahms's Double Concerto and Bruckner's Eighth Symphony, both composed in 1887, to Schoenberg's *Pierrot Lunaire*

(1912) and Stravinsky's *The Rite of Spring* (1911–13), the quarter-century gap that separates the two Bs' works from those of the two Ss seems unbridgeable—an abyss between two different civilizations. Schoenberg was undoubtedly sincere when, in 1921, he complained that young composers seemed to believe that "one may write anything today," but Brahms and Bruckner, had they lived to read the scores of *Pierrot* and *The Rite*, would have thought that Schoenberg and Stravinsky were indeed writing "anything"—works that, to their ways of thinking, would have seemed to border on anarchy or madness, if not both. And the First World War, which began so soon after the appearance of those two radical works, bulldozed into oblivion any remaining sense of obligation, on the part of many contemporary exponents of all the arts, to continue the incrementally organic evolution of past generations' aesthetic precepts.

Still, the fact bears repeating: neither Schoenberg nor Stravinsky was interested in an "anything goes" approach to composition. Stravinsky, however, continued through the 1920s, '30s, and '40s to work within a highly personal version of the old tonal system, whereas Schoenberg was determined to establish a system of composition that would provide a new order of rules and formulae. As early as December 1914, or shortly thereafter, he had set down ideas for a symphony that would contain, in its scherzo movement, a theme that would make use of all twelve notes of the chromatic scale. But, he later wrote, "I was still far away from the idea to use such a basic theme as a unifying means for a whole work."[5] Then, on a summer evening in 1921, Schoenberg's student Josef Rufer went for a walk with his teacher at Traunkirchen, where the Schoenberg family and some of Arnold's disciples were staying after the upsetting Mattsee episode, and in the course of their stroll the master told the pupil:

"Today I succeeded in something by which I have assured the dominance of German music for the next century."[6] What he had created was a system that he called a "method of composition with twelve tones related only to each other."[*]

Nonmusicians who find the terms "twelve-tone," "dodecaphony," "serialism," and the like arcane or even off-putting need not worry: Schoenberg himself considered such nomenclature superfluous. He opposed analyses of twelve-tone "rows" because, he said, "this leads only to what I always fought against: the realization of how it was done, while I always aimed for the recognition of what it is!"[7] In other words, people should listen to music for its intrinsic expressive value without having to think about how it was put together. And yet, for the sake of nonmusicians who are curious about the matter, here are some very basic bits of information.

Look at the single octave (shown below) of a piano keyboard. The distance from any key, black or white, to the key nearest to it, black or white, is called a semitone or half step; thus the distance from C, the first white key on the left, to C-sharp or D-flat (C♯ or D♭), the first black key, is a semitone, as is the distance from C-sharp/D-flat to D, or from E to F, where there is no black key between the two white keys. Double that distance—from C to D or from D to E or from E to F-sharp/G-flat—and you have what is called a whole tone or whole step. What we call a major scale consists of two whole tones plus a semitone (as for example, C to D, D to E, and E to F) followed by three whole tones plus a semitone (F to G, G to A, A to B, and B to C). There are various types of minor scales, but they follow comparable patterns. A complete major or minor scale consists of seven different

[*] In the original German: "*Methode der Komposition mit zwölf nur aufeinander bezogenen Tönen.*"

notes plus a return to the original note one octave higher. Thus all the white keys played consecutively, from C to C, make a C major scale.

In what we call the key of C major, for instance, C is the central pitch—a sort of nucleus—and the other pitches revolve around it. What we call the tonal system refers precisely to this organization of notes and chords around a central tonality, or key. A "tonal" composer may wander very far from the original key but will eventually return to it.

Now, the total of black and white keys on our little keyboard, from the first C through the B, up to but not including the second C, is twelve: seven white keys and five black keys. These twelve notes recur within every octave, which is why Schoenberg described his system as "a method of composition with twelve tones related only to each other," or, simply, a twelve-tone system. In other words, the old diatonic tonal system, which had already been circumvented in atonal works, would now have another system alongside it—an alternative for composers who felt too constrained by the traditional tonal system but uncomfortable with pure atonality, which seemed, to Schoenberg and others, a form of freedom that lacked internal discipline.

To reduce the matter to its simplest terms: if you play a chord made up of the notes D, F, G, and B on a piano keyboard, it resolves

naturally—to our diatonically attuned ears—to a chord made up of C, E, G, and C. But why, Schoenberg asked himself, should it not be possible for our ears to become equally accustomed to a different system, one in which any given arrangement of the twelve notes of the chromatic scale functions as a center of gravity? He believed that forsaking the centrality of a single note as a key center was a form of emancipation from a hierarchy; it was a sort of musical egalitarianism that put all the twelve tones on an equal footing. This notion became the basis for the system that he invented, or at least co-invented and then adapted to his requirements. Any given piece could now be based on a twelve-note row or series (thus the terms "tone row" and "serialism") that could then be performed in its original order or backward (retrograde), upside-down (inversion of the note-to-note intervals) or both backward and upside-down (retrograde inversion), and in myriad combinations.

This is a grossly, not to say grotesquely, oversimplified explanation of a complex system that gradually spawned a plethora of variants, but it can perhaps give the layperson at least a basic notion of what Schoenberg was up to in the early 1920s and beyond.

(I said that Schoenberg "at least co-invented" his system or method, because other composers, including the Russian Alexander Scriabin and the Ukrainian Yefim Golyshev, had already experimented with compositions based on all twelve notes of the chromatic scale, and the Austrian musician Josef Matthias Hauer claimed the title of inventor of, and "sole expert in," what we think of as Schoenberg's system. Erwin Stein, a Schoenberg pupil and, later, a major disseminator of his teacher's works and ideas, summarized the latter issue by pointing out that Schoenberg "*invents* a new, appropriate series [note-row (or tone-row)] to be the basis of each piece, whereas Hauer's theory establishes a number of series, from among which

he then makes his choice for each work."[8] The experiments of Scriabin and Golyshev remained such, and Hauer proved to be a minor composer, whereas Schoenberg and a few of his disciples and successors brought the system to fruition and made it into an influential *modus operandi.*)

No law required that "serial" composers couldn't wander off course from time to time and depart from strict adherence to the system. Schoenberg himself, when he was asked whether he always stuck to the rules of twelve-tone composition, answered, "I do not know. I am still more a composer than a theorist. When I compose, I try to forget all theories and I continue composing only after having freed my mind of them. It seems to me urgent to warn my friends against orthodoxy. Composing with twelve tones is not nearly as forbidding and exclusive a method as is popularly believed. It is primarily a method demanding logical order and organization, of which comprehensibility should be the main result."[9]

Between 1920 and 1923, inclusive, Schoenberg composed two pieces—or, more precisely, two groups of pieces—in which he gradually began to apply his new method. These works were the Five Piano Pieces, Op. 23, and the Serenade, Op. 24, for seven instruments and low male voice. In both compositions, as in many of Schoenberg's subsequent works, the most immediately striking characteristic is their delicacy. It's true that people unaccustomed to post-tonal music will find these compositions' ongoing dissonances disorienting to a degree that may distract their attention from the delicacy, but the sense of disorientation will be greatly diminished by listening several times to each of these short pieces. The angst that typifies much of Schoenberg's work is still present, but it seems to have been internalized. Instead of screaming, it speaks. And there is great lightness, especially in the fifth of the Five Pieces—a waltz

that is generally counted as the earliest of his more or less "orthodox" twelve-tone pieces.

That lightness is present also in the Serenade, a particularly fascinating work because within some of its seven movements Schoenberg began to apply his new system to mostly traditional, short musical forms, and in so doing he made use of instrumental colors from an unusual palette. Among the winds he deployed only the mellow clarinet and bass clarinet, and the addition of mandolin and guitar to the much more common (in classical music) and potentially much more powerful string sounds of the violin, viola, and cello was also innovative—and effective. The first movement, "March," is meant to be played at "a steady march tempo throughout," Schoenberg instructed, although his fast metronome mark (half note = 100) is hard to achieve. (A recording by an ensemble conducted by Robert Craft comes closest, among the versions that I have heard.) The time signature, 2/2, never changes; dynamic marks are many and explicit; and the expressive tone varies widely: the violin, viola, and cello often have to demonstrate a sort of jaunty nonchalance through abundant *saltellato* (bouncing bow) and *col legno* (using the wooden side of the bow) passages, whereas some of the clarinets' phrasing must be lyrical, and everyone needs to produce biting attacks from time to time.

I feel certain that Schoenberg was being intentionally droll by following the "March"—a form that automatically brings to mind things military—with a "Minuet," a dance form that had ceased to be popular in Europe over a century before this work was composed. Perhaps he was thinking of Beethoven's aforementioned life-embracing "Diabelli" Variations for the piano, in which Anton Diabelli's silly waltz theme is followed by a pompous march, and in which the final variation is a minuet. In the Serenade's minuet,

Schoenberg's metronome indication (quarter note = 88–92) is not difficult to achieve, but no live or studio recording of it that I have heard approaches that tempo: most performances hover around 68–72, and this eliminates not only the "singing" quality that the composer specifically requested but also the whole notion of the minuet as a dance: at too slow a tempo, the music plods, beat by beat. Still, with a bit of imagination one can perceive the airiness that Schoenberg meant to achieve. After all, the use of guitar and mandolin provides much of this movement, and parts of the rest of the Serenade, with the lightness of the Belle Époque's *café-chantant* music—what the Viennese called *Schrammelmusik*, with which Schoenberg was familiar from his youth.

The third movement, "Variations," consists of a theme, played only by the clarinet, plus five numbered variations in shifting tempi and instrumental combinations, and a broadly paced coda within which the individual instruments play skittish figurations. Each of these seven segments is precisely eleven bars long. (Seven segments within a seven-movement piece played by seven instruments: one of Schoenberg's numerical fixations seems to have been at work here.) Schoenberg himself mentioned, in later years, that this movement is not quite a twelve-tone composition: "Its theme consists of fourteen notes, because of the omission of one note, B, and the repetition of other tones," he wrote, and he pointed out that "all the technical tools of the method are here, except the limitation to only twelve different tones."[10] Once again, most conductors ignore Schoenberg's initial tempo marking (Andante, eighth note = 96–100) and give the theme an almost dirge-like quality. (It's useful to recall Hilary Hahn's comment, quoted in this book's Prologue, about the "oft-ignored tempi printed in the score" of Schoenberg's Violin Concerto. This applies to many of his other works as well. Of course there must

be some leeway in all composers' tempo indications—Schoenberg himself inveighed against rigid tempi and literal adherence to metronome marks—but, as James Levine used to say, "There's a ballpark." If a composer's indicated tempo is altered by more than ten percent or thereabouts, the intended character of the piece in question changes beyond recognition.)

It is the fourth movement, "Sonnet No. 217 by Petrarch, for a low male voice,"* that counts as a "real twelve-tone piece," Schoenberg said. Among other examples: for the first syllable of each of the fourteen-line poem's first twelve lines, he used a different note of the chromatic scale: E, B-flat, G, F, A, F-sharp, A-flat, D-flat, C, C-flat, E-flat, and D; the thirteenth and fourteenth lines begin with E and B-flat, respectively, like the first two lines. However interesting this procedure surely is, I confess that in the case at hand I find the music to be at odds with the words, especially since this movement, as the fourth of seven and the only vocal segment, was clearly meant to be the Serenade's centerpiece. Like the other poems in the fourteenth-century *Canzoniere*, this one is addressed to Petrarch's ideal woman, Laura, whom he loves but who causes him anguish and sleeplessness, regardless of whether she has looked at him or ignored him ("hiding eyes so sweet and naughty"). He wishes that he could somehow take revenge on her by disturbing *her* sleep and making her hear his words when, at night and in tears, he imagines that he is speaking to her and embracing her. I can't help wishing that Schoenberg had lightened his approach—had thought, perhaps, about Mozart and had avoided the jerkiness and the strenuous rhythmic patterns that occur throughout so much of what is meant to be a love song. After

* Schoenberg's title is incorrect: 217 is the sonnet's number in an incomplete edition of Karl Förster's German translation of Petrarch's *Il Canzoniere*; the correct number is 256.

all, the only "revenge" that the poet seeks is to hold his beloved in his arms! Schoenberg did not speak Italian, but perhaps if he had listened to the *sound* of Petrarch's original text he would either have written this movement differently or chosen a different text to set.[*] Camille Crittenden, in a brief essay about the Serenade,[11] points out the interesting use of musical onomatopoeia on the German words *Leu* (lion), *fliegt* (flees), and *weint* (weeps), but this does not compensate for the overall clash between the verses and their setting.

"Dance Scene," the Serenade's fifth movement, is by contrast a joyful delight—a fast-paced waltz in 3/8 time, interrupted first by a gentle *ländler* (the early-nineteenth-century popular dance form that in part anticipated the waltz), also in 3/8, and then, briefly, by a *gallop*, or two-step, in 4/8 time, before the waltz returns and ends in a wild rush. Next, "Song (without Words)"—the slowest but also the shortest movement (under two-and-a-half minutes)—is a sort of expressionistic torch song in which the violin languidly tells its sad story while the other instruments comment sympathetically. The "Finale" reprises the tempo and much of the musical material of the opening "March"; toward the end, the languid torch song briefly reappears, only to be chased away by the jolly march music, which ends with all seven instruments playing *fortissimo.*

All in all, the Serenade is a work that deserves to be performed much more often than it is today. As usual, Schoenberg set up his own obstacles, in this case by including two instruments—guitar and mandolin—that are not usually included in either symphonic

[*] The original text: *Far potess'io vendetta di colei / che guardando et parlando mi distrugge, / et per più doglia poi s'asconde et fugge, / celando gli occhi a me sí dolci et rei. // Cosí li afflicti et stanchi spirti mei / a poco a poco consumando sugge, / e 'n sul cor quasi fiero leon rugge / la notte allor quand'io posar devrei. // L'alma, cui Morte del suo albergo caccia, / da me si parte, et di tal nodo sciolta, / vassene pur a lei che la minaccia. // Meravigliomi ben s'alcuna volta, / mentre le parla et piange et poi l'abbraccia, / non rompe il sonno suo, s'ella l'ascolta.*

or chamber music concerts. But the sound of those instruments is the element that gives the work its characteristic timbre.[*]

THE SERENADE WAS COMPOSED BETWEEN SEPTEMBER 1921 AND April 1923, and one can hardly help wondering whether Schoenberg's decision to make his setting of a Petrarch love sonnet the work's central movement happened purely by chance or whether its tale of unrequited love had an autobiographical basis, either in his marital situation or in some other relationship, real or otherwise. What is certain is that those years were full of significant events for Schoenberg himself and his family members. During the fall of 1921, shortly after the anti-Semitic incident at Mattsee, Arnold learned that his mother, Pauline, had died, in Berlin, at the age of seventy-three. At around the same time Arnold and Mathilde's daughter, Gertrud (Trudi), now nineteen, married his pupil Felix Greissle, who was twenty-six. Also, beginning in those years Trudi's brother, Görgi, in his mid-teens, decided that he wanted to be a composer; the younger Schoenberg would eventually write a fair amount of music, but it seems that the father was dismissive of the son's attempts, which presumably led to conflict.[12] Then, in 1923, Mathilde became ill with liver cancer and died, on October twenty-second of that year, at the age of forty-six.

Despite the fraught nature of their marriage, Arnold took his wife's death very badly. By various accounts, his daily routine during

[*] In the Serenade's score, Schoenberg used a capital H with a tiny horizontal line attached at the top right to indicate *Hauptstimme* (principal voice), a capital N with a similar line at the top right to indicate *Nebenstimme* (additional, or secondary, voice), and a small, closing bracket to indicate that these voices have moved to other instruments. This practice would be adopted also by Berg, Webern, and some other composers.

BREAKTHROUGH AND BREAKAWAY | 139

the following weeks and months included smoking sixty cigarettes, drinking three liters of black coffee, consuming much alcohol, and taking codeine and Pantopon, an injectable form of opium nearly as strong as morphine. Trudi and Felix Greissle—who by then had a six-month-old son, whom Arnold loved (and who was named after him)*—offered to live with the composer in the immediate aftermath of Mathilde's death; he welcomed their offer, but the arrangement proved disastrous. They had fights "almost every day about really minor matters," Greissle later recalled, until it became "impossible to live further with him." The Greissles moved back to their own apartment but, on the evening of the day they left, Schoenberg threw pebbles at the Greissles' upstairs window. "I opened the window and down there was Schoenberg," Greissle recounted. "He said very meekly, 'May I come up?'" He apologized: "'I'm sorry, you are of course absolutely right, you cannot live with me, that's impossible, the whole situation is impossible.'"[13] But he continued to spend time with them when he needed companionship. Then, on August 28, 1924, barely two weeks before his fiftieth birthday and ten months after Mathilde's death, Schoenberg married Gertrud Kolisch, the twenty-four-year-old sister of his pupil, the violinist Rudolf Kolisch. "I didn't know why I was allowed to be so happy,"[14] he wrote later, and this domestic happiness would last until the end of his life.

Other events of 1924 also gave Schoenberg some satisfaction. In May, he conducted the public premiere of the Serenade at a festival in Donaueschingen, Germany; in June, *Erwartung*—composed in 1909—finally received its first performance, in Prague, with Zemlinsky conducting and Marie Gutheil-Schoder as soloist; three

* Trudi and Felix Greissle's son Arnold was born in 1923; another son, Hermann, was born in 1925.

months later, in Vienna, Fritz Stiedry conducted the first, mostly negatively received performance of *Die glückliche Hand*, eleven years after its completion, with the famous baritone Alfred Jerger taking the part of The Man; and numerous concerts marking Schoenberg's fiftieth birthday, which occurred on September thirteenth, also took place during that period and in various cities.

The *Erwartung* premiere stands out among those events because, on the one hand, it was no longer considered avant-garde (it was already fifteen years old), but, on the other, it still seemed tremendously difficult for the performers. Zemlinsky reported:

> I organized my rehearsals as follows: first I divided the orchestra into very small groups, which rehearsed separately, [. . .] then full strings and harp; full wind and percussion; finally full orchestra without the soloist. After that, two so-called *sitzproben* [singer plus orchestra but minus stage action] sufficed before the actual stage/orchestra rehearsals began. Since the work lasts only half an hour, much could be achieved during the customary three-hour sessions, so that it was possible in three such stage rehearsals to achieve an absolutely clear and convincing realization of the score. To alleviate certain problems of intonation for the singer, I had a harmonium recessed into the stage, near the area where she was acting; from time to time, without disturbing the audience in the least, this was used to give her a "note." Thus we managed to perform the work at a level which betrayed nothing of its difficulties.[15]

Gutheil-Schoder, who had had the unpleasant experience of performing the Second String Quartet's solo vocal part at its contested premiere in 1908, had accepted, the following year, Schoenberg's

invitation to sing the *Erwartung* premiere; fortunately, she was still, at fifty, able to bring off the difficult task when the premiere at last took place, although, as Schoenberg later recalled, she had "very great difficulty with the music."[16]

Earlier in 1924, Alfredo Casella had helped to arrange performances of *Pierrot Lunaire*, with Schoenberg himself conducting, in Rome, Venice, Naples, Padua, Milan, Turin, and Florence. To Schoenberg's delight, Giacomo Puccini traveled from his home on the Tuscan coast to Florence in order to attend the last of those performances. As a "partial exception" to what the Italian musicologist Fiamma Nicolodi called the "general but inevitable deafness" of Italian musicians of the day toward Schoenberg and company, Puccini not only followed the performance closely, score in hand, but also paid his compliments to the composer, who, thirteen years earlier, "had included Puccini among the innovators of twentieth-century harmonic language," Nicolodi pointed out.[17] Schoenberg was flattered by Puccini's interest and courtesy, and he often referred to the incident, in later years, when he felt called upon to defend himself against attacks from conservative musicians. After the Second World War, some of Italy's most gifted composers— Luigi Dallapiccola, Luigi Nono, Bruno Maderna, Luciano Berio, and Franco Donatoni, among others—would be counted among the most significant proponents of and heirs to the achievements of Schoenberg and his disciples.

The mid-1920s were reasonably fertile years for Schoenberg, who completed the Suite for Piano, Op. 25, in 1923 (Steuermann gave its premiere in Vienna the following year); the Wind Quintet, Op. 26, in 1924; Four Pieces for Mixed Chorus, Op. 27, as well as Three Satires for Mixed Chorus, Op. 28, in 1925; and the Suite (for E-flat clarinet or flute, clarinet, bass clarinet or bassoon, violin, viola, cello,

142 | SCHOENBERG

and piano—dedicated to "my dear wife"), Op. 29, in 1926. Like the Serenade, three of these five works—that is, all of them except the choral compositions—make ample use of traditional dance forms and other classical models. Perhaps this was a counteroffensive, on Schoenberg's part, to the neoclassicism of Stravinsky and other composers of the period, who also made use of older forms but without venturing beyond some version of tonality. In his texts for the Three Satires, Schoenberg used heavy-handed humor to poke fun at the neoclassicists for having abjured Romanticism in favor of less overtly emotional forms of expression. He even wrote a foreword to these pieces—an essay that intentionally offended those who were taking what he described as "the middle way" and who "nibble at dissonances." They were "pseudotonalists," he said, and they wrote "in the same needy way that is imposed on a poor conservatoire student." And he went on to attack the "folklorists" (Bartók? Kodály?), who "apply to the naturally primitive ideas of folk music a technique suitable only to a complicated way of thinking."[18] These attacks are reminiscent of a famous anecdote about Brahms, who, upon leaving a social gathering, reportedly joked, "If there is anyone here I have forgotten to insult, I apologize." But Schoenberg wasn't joking: he could never resist making new enemies or poking a stick at old ones, real or imagined, in order to continue to see himself as a lonely truth-teller.

Schoenberg also continued to teach, out of economic necessity but also because it was a natural calling for him. In 1925, he was appointed to succeed Busoni, who had died the previous year, as professor of composition at the Prussian Academy of the Arts. Thus, toward the end of the year, following an operation for appendicitis, Schoenberg moved to Berlin for the third time, now accompanied by his young second wife but—as far as I have been able to determine—not by his nineteen-year-old son, Georg. Arnold and

Gertrud lived at first in a *pension* on the Steinplatz but later moved to Nussbaumallee 17 in the Charlottenburg district, and then to Nürnbergerplatz 3. At various times during his Berlin years, Schoenberg's pupils at the Academy included the Germans Winfried Zillig and Hans Heinz Stuckenschmidt; the German-Swiss-Catalan Roberto Gerhard; the Swiss Alfred Keller; the German (and, later, English) Walter Goehr; the Americans Marc Blitzstein and Henry Cowell; the Greek Nikos Skalkottas; and many others. Even some of Schoenberg's Vienna-based pupils followed him to Berlin from Vienna, to continue to study under his aegis; these included Josef Rufer, who became his assistant.

According to Alfred Keller, the classes often met in Schoenberg's apartment:

> We smoked heavily, and for a while Schoenberg contributed to the general haze with his large, fat cigars. Classes were entirely informal, due additionally to Schoenberg's custom of first having his students discuss and evaluate each other's compositions. This often led to loud and fierce disagreements. When things threatened to get out of hand, however, Schoenberg would calm us down. [. . .] It was not uncommon for him then to find useful ideas where the students had only found a work's insufficiencies and lacks—attempts which under his painstaking tutelage were transformed into musical thoughts and forms worth developing. [. . .]. We also discussed ideological things, especially concerning politics [. . .]. He presented his often singular opinions very decisively with the sparkling eloquence peculiar to him. [. . .] Twelve-tone music [. . .] was very rarely discussed [. . .]. Schoenberg was aware of the effect of his commanding personality and of the danger this could pose to the

individual development of his students. [. . .] He would allude to this in a humorous vein [. . .], saying, "I consider twelve-tone composition strictly a family matter."[19]

IN 1927 AND 1928 SCHOENBERG WROTE TWO JEWISH-THEMED TEXTS: an opera libretto, *Moses und Aron*, about which more anon, and a prose play, *Der biblische Weg* (The Biblical Path). Never one to underestimate himself or his work, Schoenberg was convinced that the play "would be a huge success in the theater. Produced by someone such as Reinhardt, in London, it would probably spread through all the theaters. [. . .] Although its profundities offer the superior kind plenty of food for thought, [it] is vivid and theatrical enough to fascinate the simpler sort."[20] He thought that Max Reinhardt, one of the most famous theater directors and impresarios of the day, would be fortunate to have such a text at his disposal, but I have not managed to find any indication that Reinhardt ever read the text, let alone considered staging it. The play's protagonist, Max Aruns (the name was derived from Moses and Aaron), proposes creating a "new Palestine," a homeland in Africa for all Jews, but—as David Josef Bach, Schoenberg's friend from early days, pointed out in an essay—"Aruns comes to grief because of the imperfect nature of everything human."[21] Aruns, too, is imperfect, but "his death as a martyr redeems and lifts [him] to the only level of perfection possible for humans." Moshe Lazar, a literary scholar and translator, characterized the text as an "agitprop" work as well as "a response in dramatic form to the growing anti-Jewish movements in the German-speaking world [. . .] and a deeply personal expression of [Schoenberg's] own 'Jewish identity' crisis."[22]

Music, in any case, remained Schoenberg's main concern. Within just over six weeks, early in 1927, he composed his Third String Quartet, Op. 30. When it was nearly finished, he received a commission for it from Elizabeth Sprague Coolidge, an American heiress, accomplished pianist, and chamber music devotee who, through her generosity, aided a remarkable number of the significant composers of her day. (Bartók's Fifth String Quartet, Webern's String Quartet, and Stravinsky's *Apollon musagète*—later known as *Apollo*—are among the masterpieces that her largesse helped to bring into existence.) She even traveled to Vienna that fall to attend the Kolisch Quartet's premiere of Schoenberg's new work.

Unlike the formally innovative Second String Quartet, the Third is classical in structure: it has a sonata-form first movement (Moderato), a theme-and-variations second movement (Adagio), a minuet/scherzo-form third movement (Intermezzo: Allegro moderato), and a rondo finale (Molto moderato), but its sound-world is uncompromisingly dissonant. Still, as with so many of Schoenberg's other works, repeated hearings (and study of the score, for the musically trained) can help warm listeners to what may at first seem a harshly forbidding soundscape. The tragic Adagio and the alternatingly lighthearted and fateful Intermezzo will in themselves reward the effort, and so will the combination of childlike glee and adult angst in the finale.

I disagree, however, with a statement by the pianist and writer Charles Rosen, who, in his book on Schoenberg, found "similarities between Stravinsky's *Jeu de cartes* and Schoenberg's Quartet opus 30" and "between large religious works such as *Die Jakobsleiter* (or parts of *Moses und Aron*) and [Stravinsky's] *Symphony of Psalms.*" To Rosen, these were "parallel rather than opposing movements,"[23] which is true with respect to form and chronology but not to the

146 | SCHOENBERG

actual sound of those compositions or to how most listeners seem to perceive those works' expressive content. In fact, from the 1920s until Stravinsky began to experiment with serialism in the 1950s—after Schoenberg's death—the two men remained at opposite poles in both sound and content: Schoenberg's music sounded more radical, but its mode of expression never ceased to be Romantic, whereas Stravinsky rejected Romanticism yet opted for what most listeners found to be less disconcerting sounds.

DESPITE STRONG, ONGOING OPPOSITION TO SCHOENBERG'S WORKS, increasing numbers of curious music lovers across Europe began to pay attention to them, or at least to his pre–twelve-tone and even pre-atonal compositions. In November and December 1927, the Leningrad Philharmonic, conducted by Nikolai Malko, gave enthusiastically received performances of the *Gurrelieder*; in December, Schoenberg himself conducted his *Pelleas und Melisande* and *Pierrot Lunaire* in Paris, where his audiences included applauding supporters as well as protesting detractors; and in January 1928 he conducted the *Gurrelieder* in London, with great success. Other Schoenberg compositions were presented that winter in Basel and Bern, and the German premiere of *Die glückliche Hand* took place in Berlin in March 1928. Finally, in December 1928 the illustrious Berlin Philharmonic, conducted by the equally renowned Wilhelm Furtwängler, gave the world premiere of the Variations for Orchestra, Op. 31.

Through the previous summer, which Arnold and Gertrud had spent at Roquebrune-Cap-Martin on the French Riviera, the composer had dedicated most of his working time to completing the Variations. In a letter to Furtwängler, he warned that "the

individual parts are by and large very difficult—so the quality of the performance will depend on how well the parts are learned."[24] Despite this caveat, Furtwängler gave the piece only three rehearsals, and the performance provoked hissing and whistling from a considerable portion of the audience. "Unbelievable! Completely irresponsible!"[25]—thus Webern wrote shortly afterward, referring to the event. Not until 1931, when the excellent Hans Rosbaud presented a more carefully prepared interpretation with the Frankfurt Radio Orchestra, was the work heard more or less as Schoenberg had intended; this did not make the piece popular, but it at least made it intelligible.

As in many of his earlier orchestral works, Schoenberg called for a more than substantial ensemble for the Variations: twenty-eight woodwind and brass players; a large enough body of string players to counterbalance the winds; celesta, harp, and mandolin; and timpani plus nine other percussion instruments, including the recently invented flexatone—a metal sheet with wooden strikers that create an eerie, trembling sound when the sheet is shaken. Not all the instruments are deployed all the time, however, and some segments have a chamber music–like quality. The roughly twenty-minute-long composition begins with a short, basically calm introduction that contains a violent outburst in the middle. Schoenberg made the theme itself "relatively simple," he said, because, among other reasons, "the variations gradually become more and more complex."[26] The theme's melancholy waltz tempo is often turned into a dirge by being played twenty percent slower than Schoenberg's metronome indication of quarter note = 72. (The theme is twenty-four bars long, and the bar lengths of all the variations are multiples of twelve.) Skittish rhythms within a moderate underlying tempo dominate the first variation. The second, if it is played

dolce (sweetly), as Schoenberg instructed, and at or near his tempo (quarter note = 56), should resemble a flowing siciliana; not many conductors seem to be aware of this, however, and instead give the piece a slow, stagnant, beat-by-beat feeling. Variation III alternates between playfulness and violence. The fourth variation is a fast-paced, light-footed waltz, and the fifth, marked *bewegt* (animated), actually has a granitic feel to it, although its shrill, anguished fortes and fortissimos are disrupted from time to time by gentle, waltz-like hints. Variation VI is the most lyrical and least tense of them all, and Variation VII is meant to be played "as softly as possible"; at approximately two minutes, it is longer, more mysterious, more pointillistic, and more delicate than any of its sisters, and probably also the most difficult to perform correctly without making it sound constricted. The eighth variation, in complete contrast, rushes by in a half-minute-long, frenzied outburst, and Variation IX serves as both a less frantic postlude to its predecessor and as a prelude to the Finale, which, at over five minutes, is the work's longest single segment. Beginning quietly but nervously, this last section quickly takes on a menacing tone, thanks in part to the hammering effect of the double basses playing some of their lowest notes. Frequent bipolar switches between lightness and violence occur, and some of the lighter areas contain extended fugue-like passages into which Schoenberg worked the note pattern B-flat, A, C, and B-natural, which, in German notational terminology, spells B-A-C-H. The whole work ends in a tremendous, full orchestral fortissimo outburst, with all twelve notes of the chromatic scale played simultaneously in the final chord.

The Variations' unsatisfactory and hotly contested premiere did not deter Schoenberg at all: one month after that event, and precisely, on New Year's Day 1929, he completed *Von heute auf morgen*

(which may be translated as "from today to tomorrow," "from one day to the next," or "overnight"), Op. 32, a one-act comic opera with a libretto by one Max Blonda, pen name of Gertrud Kolisch Schoenberg. The story centers on a youngish or early-middle-aged husband and wife, both unnamed, who return home from an evening on the town during which the husband has been enchanted by an unattached former schoolmate of his wife's and the wife has enjoyed the compliments of a tenor from the opera company. Shades of *Die Fledermaus*, except that Strauss's 1874 operetta treats marital infidelity as amusingly predictable, perhaps even inevitable, whereas the point of *Von heute auf morgen*'s text is that the "modern fashion" for what would today be called open marriage is precisely that—a fashion— and is worthless in comparison with a good, solid, old-fashioned monogamous marriage for life. Berg and the conductor Otto Klemperer liked Gertrud Schoenberg's libretto, but Theodor W. Adorno, the soon-to-be well-known sociologist-philosopher, who was also a thoroughly trained musician and musicologist and a Schoenberg supporter, condemned its "crassly bourgeois and arch-reactionary" subject matter. (Berg, Klemperer, and Adorno were none of them known to be models of monogamy.)

More interesting, however, is the question of why Arnold Schoenberg wanted to write a comic opera in the first place. The answer appears to be that he was angered and perhaps even offended by the popularity, in Weimar-era Germany, of musical-theatrical works like Ernst Krenek's *Jonny spielt auf* (*Jonny Strikes Up*) and Kurt Weill's *Die Dreigroschenoper* (*The Three-Penny Opera*, with text by Bertolt Brecht), both of them written by skilled composers who combined moderately modernist—but not atonal or twelve-tone— musical idioms with personalized versions of the popular music of the day. Those two works, which fall into the category of *Zeitopern*

(timely operas, operas that deal with contemporary subjects), also had distinctly left-leaning social and political thought behind them, whereas Schoenberg was opposed to corrupting the sacred art of music with such issues. ("Art is from the outset naturally not for the people," he had written just before he composed *Von heute auf morgen*. "[T]he new bliss consists of the right to speak: free speech! Oh God!")[27] Another difference is that *Jonny spielt auf*, for instance, received 421 performances in Germany and abroad during its first season alone (1927), and that its libretto was translated into fourteen languages;[28] *Von heute auf morgen*, on the contrary, was unlucky. It was performed in February 1930 at the prestigious Frankfurt Opera under the baton of Hans Wilhelm Steinberg (later known, in America, as William Steinberg), and was broadcast on the radio later that month in a performance that Schoenberg himself conducted, but it received no further hearings in its composer's lifetime.

Von heute auf morgen's central problem, however, lay in its musical inaccessibility, as far as the public at large was concerned. The fact that Schoenberg had believed otherwise—had thought that his little opera could match or even outdo the successes of Krenek and Weill—demonstrates the degree of his self-delusion with respect to the reception, especially in those early years, of his new system of composition. Even today, with all possible good will, one can hardly imagine casual music lovers grasping the humor in this opera's score (as opposed to its verbal text), because the musical idiom remains foreign to them.

Not long after having composed *Von heute auf morgen*, Schoenberg, who enjoyed the cinema (silent cinema, at the time) and thought about its artistic possibilities, composed *Begleitungsmusik zu einer Lichtspielszene* (Accompanying music for a cinematographic scene), Op. 34. The three-part score—"Threatening Danger,"

"Fear," and "Catastrophe"—interested Klemperer, who suggested that the avant-garde Hungarian artist László Moholy-Nagy produce an abstract film that would go with Schoenberg's music. Nothing came of that idea, but Klemperer—conductor, at the time, of the forward-looking Kroll Opera—did give the first performance of the nine-minute-long piece, in Berlin in November 1930.

During the same period, Schoenberg was becoming interested in another modern medium, the radio, as a means not only for transmitting new music away from the corrida-like atmosphere of public performances but also for propagandizing his own works through on-the-air conversations with music critics and others. This worked until health problems—especially asthma, either caused or exacerbated (or both) by his smoking habit—forced him, first, to spend the late spring and summer of 1931 on Lake Geneva, near Montreux, and then to take a leave of absence from his teaching position in order to exchange Berlin's cold, damp winter climate for the warmer air of Barcelona, on the recommendation of his pupil Roberto Gerhard, who lived there.

———

Erwartet die Form nicht vor dem Gedanken!
Aber gleichzeitig wird sie da sein!
(Do not anticipate the form before the idea!
But it will be there at the same time!)

—Arnold Schoenberg,
MOSES UND ARON, ACT II, SCENE 1

In October 1931, Arnold and Gertrud traveled to the Catalan capital, where Arnold hoped to complete *Moses und Aron*. He had already

written the opera's entire libretto and some of its music, but in the end he finished only the first two acts of what was to have been a three-act work. Like *Die Jakobsleiter*, another Old Testament–influenced composition, *Moses und Aron* would remain incomplete at the time of Schoenberg's death, but it is now performed as a two-act opera, when it is performed at all. Its first act takes place during the Israelites' enslavement in Egypt, Act II while they are on their forty-year trek through the wilderness to the Promised Land.

Moses und Aron seems a nearly ideal vehicle for music created within the twelve-tone system, although not for reasons that Schoenberg would necessarily have considered desirable or even valid. The pure sound of the music very effectively sets up a sense of extreme temporal distance, even alienation, from a civilization of three millennia ago; in this sense, and only in this sense, Schoenberg's achievement is comparable to what Federico Fellini would do, cinematically and through narrative, in his *Satyricon* (1969), by re-imagining Roman civilization of the first century CE. The two men's intentions, however, were diametrically opposed. Fellini was illustrating the impossibility, for people of our time, of even understanding, let alone empathizing with, the mentality of dead, pre-Christian civilizations; Schoenberg was dramatizing what he perceived as the age-old but still valid conflict between "eternal" principles—principles carved in stone (literally, in this case)—and the desire for instant gratification.

Like many of Schoenberg's previous works, *Moses und Aron* requires a massive orchestra, including an ample percussion section and two mandolins. But one of his most effective strokes involves the chorus: he gave the voice of the invisible, unknowable, inconceivable God, who speaks from the Burning Bush in the first part of the first act, to a chorus that intones a weirdly mysterious mix of cross-rhythms

and dodecaphonic sounds plus *Sprechgesang* à la *Pierrot Lunaire*. The choral part is particularly striking because it is made up of all voice ranges, from bass to soprano, with the addition of a boys' choir.

Another extraordinary idea was to make Moses himself a low-voiced speaker, not a singer: the prophet—who, according to the Bible, suffered from a speech impediment—uses only *Sprechgesang* to converse with the invisible, almighty deity, and the contrast highlights the abyss that separates plodding humanity from the incomprehensibly floating, drifting sounds of the universe. (Moses does have to sing three lines, during the second scene of Act I, but all of his other lines are done through *Sprechgesang*.) This technique also sets up a fine contrast between Moses, the angry, expostulating prophet, and his brother, smooth-singing Aaron, in their encounter in the second scene and in their subsequent dialogues. We feel immediately that Aaron is a man of the world, someone who knows how to bend with the wind, unlike Moses, who is harsh and uncompromising. The brothers often speak at cross-purposes.

Aaron's role—we should note—is made for a Tannhäuser-type tenor: not quite a heldentenor, but one with a clarion sound, a reliable high register, and considerable vocal endurance. Most important of all, however, for any opera director who wishes to present this work, is the hiring of a tenor who has perfect pitch and who thus can hit the notes correctly and not simply approximate them. (Generally speaking and from a practical point of view, one of the negative aspects of all atonal and twelve-tone vocal music is the basic, explicit difficulty of singing the right notes.)

In the third scene, in which the Israelites await the arrival of Moses and Aaron, who, they hope, will bring them a new, strong god to protect them from the cruelties inflicted on them by the Egyptian pharaoh, the music effectively seconds the give-and-take

of a crowd scene while preserving (intentionally or otherwise) the sense of alienation—the sense that we, the audience, are observing a remote tribe that we cannot entirely comprehend. This feeling extends into the nearly half-hour-long fourth scene, in which Moses and Aaron appear before the people, who at first reject the idea of worshiping a god who can't be represented in an image, but change their collective mind when Aaron shows them some magic tricks (rod into snake into rod, healthy hand into leprous hand into healthy hand, water into blood into water) to demonstrate the invisible god's power. They accept the idea of being the Chosen People who will be freed by an invisible, omniscient, omnipotent god.

The opera's Interlude serves as a remarkable, *pianissimo* introduction to Act 2: part of the chorus sings, another part uses *Sprechgesang*, with very light orchestral accompaniment, as the Israelites—who have already made their exodus from Egypt—gossip and complain about Moses's forty-day absence on Mt. Sinai. "Where is Moses? Where is our leader? We haven't seen him in a long time. We've been abandoned. He's never coming back. Where is his God? Where is the Eternal One?" This leads directly into Aaron's confrontation with the Seventy Elders, who are being threatened by the people, and to his decision to allow the people to build a Golden Calf and indulge in pagan rituals, including the sacrifice of the blood of four naked virgins and the rape of one tribe's women by another tribe's men. Moses returns from Mount Sinai carrying the tablets of the law, upbraids his brother, insists on the importance of the law over the people's primal instincts, breaks the tablets, but finally concedes that the tablets, too, were "images" of what ought to be invisible and inconceivable: "Thus all that I have thought was only madness, and can and must not

be spoken," he groans. Throughout the act, the music serves the constantly varying dramatic purposes of the text.

The completed text of the never-composed third act is much more verbose and abstract than that of its predecessors; it is a sort of theological discussion between Moses and Aaron that is hard to imagine functioning with stage action. In 1913, when Hugo von Hofmannsthal was working on the libretto for Richard Strauss's *Die Frau ohne Schatten*, he wrote to Strauss: "I must all the time strike the exact balance between too much and too little. [. . .] It is terrifying how short the libretto for *Tristan* is, for instance, and how long it takes to perform."[29] But in Schoenberg's plan for Act 3 of *Moses und Aron* the situation was reversed: the libretto is too long for whatever music could possibly have partnered it. And as a follow-up to the second act's orgasmic explosions and to Moses's outcries of frustration, it would have been catastrophically anticlimactic. This may explain, at least in part, why Schoenberg died without having set this act to music.

Hans Rosbaud conducted both the first concert performance of *Moses und Aron*, in Hamburg in 1954, three years after Schoenberg's death, and its first staged performance, in Zurich in 1957. Schoenberg's reputation was rising, posthumously, and the work received a great deal of attention, with predictable reactions: positive from the avant-garde, noncommittal from the merely curious, and negative from conservatives. Although it is not frequently produced, *Moses und Aron* has at some time or other appeared in most of the world's major opera houses. Arthur Rubinstein attended its Paris premiere, in 1962, and commented to a British journalist: "I was deeply impressed by its emotional impact. I didn't understand the music well; but 'understand' is a word one shouldn't apply to music; there's nothing to *understand*—for me, music must be *felt*."[30] But

156 | SCHOENBERG

I hope that readers who tend to be put off by Schoenberg's music will excuse me if I repeat, with respect to this opera, what I have said about some of his other works: it gains from repeated listening.

Schoenberg meant *Moses und Aron* to be seen as well as heard; as was his wont, however, he created obstacles for himself—in this case by calling for massive, complicated, frequently changing scenes that require throngs of people, herds of livestock, galloping horses, a Burning Bush, a Golden Calf that must suddenly be destroyed, naked virgins and other naked people, male as well as female ("naked to the extent that the rules and necessities of the stage allow and require," Schoenberg added, in his stage instructions), and much more. The work could perhaps function better as a film than on a stage, and in fact a cinematic version, by Jean-Marie Straub and Danièle Huillet, was issued in 1975; much of that production seems excessively static, but the basic idea was a good one.

After having read many of Schoenberg's declarations about himself and his position in music history, one may be forgiven for thinking that "God's words" to Moses, as the composer himself wrote them into his libretto, may also have carried a secondary, personal meaning:

Before their ears you will do wonders—
their eyes will recognize you:
by your rod will they hear you—
admire your wisdom; by your hand—
believe in your strength [. . .].*

* I am not quoting from a biblical translation (or at least not knowingly), but rather from Schoenberg's German text: "*Vor ihren Ohren wirst du Wunder tun*— / *ihre Augen werden sie anerkennen:* / *von deinem Stab werden sie hören*— / *deine Klugheit bewundern; von deiner Hand* — / *an deine Kraft glauben* [. . .]."

It seems legitimate to wonder, too, whether one of Schoenberg's motivations for writing this opera, beyond his increasing preoccupation with Judaism and his own Jewishness, was his perception of himself as a lonely, misunderstood prophet.

———

THE SCHOENBERGS' BARCELONA WINTER TURNED INTO AN EIGHT-month stay, toward the end of which Gertrud gave birth to their first child, Dorothea Nuria Schoenberg. (Nuria is a typical Catalan name, and it is the one by which Dorothea would always be called.) This was by far the longest period that Arnold, and presumably also Gertrud, had ever spent outside the German-speaking world, and it was a foretaste of another, much longer absence from their native environment than they could have imagined at the time.

To avoid an extremely long train ride with their new baby, they returned to Germany by plane, in June 1932; it was their first flight. Between November of that year and January 1933, Schoenberg refashioned a harpsichord concerto by the early eighteenth-century Viennese composer Georg Matthias Monn into a cello concerto, and he dedicated the piece to Pablo Casals, the most famous cellist of the time, who, however, politely refused to play it. The thematic material and overall form of the work's three movements are Monn's, and Schoenberg's arrangement is entirely tonal, but the extremely difficult solo part, the modern and at times idiosyncratic orchestration, many unusual harmonic progressions, and a number of insertions are pure Schoenberg. The great Emanuel Feuermann gave the concerto its first performance in 1935, with the BBC Symphony Orchestra under the baton of Edward Clark, a Schoenberg devotee and former pupil, but the Monn-Schoenberg concerto has never become a popular vehicle among cellists. And immediately after

having completed that piece, Schoenberg wrote Three Songs for low voice and piano, which he then forgot about and which were published only after his death, as his Op. 48.

Back in 1923, Schoenberg had been prescient about "that man Hitler," a thirty-four-year-old rabble-rousing upstart from the Austrian provinces. Ten years later, on January 30, 1933, barely seven months after Arnold and Gertrud's return to Berlin with baby Nuria, the upstart became chancellor of Germany. In February, Schoenberg went to Vienna to give a lecture, not suspecting that this would be his last visit to his native city and country. The reality of his situation in Germany, on the other hand, became apparent barely a month after the Nazi takeover. On March 1, shortly after his return to Berlin, he attended a meeting of the Senate of the Prussian Academy of the Arts, of which he was a faculty member, and heard its president, the composer and conductor Max von Schillings, proclaim that Germany's new government wanted to eliminate Jewish influence within the institution. "Schoenberg's immediate reaction," Willi Reich reported, "was to say that he never stayed where he was not wanted, and he walked out of the meeting."[31] In a letter in which he accepted his removal from the Academy while protesting its causes, he asked to have his salary paid through September 1935, as stipulated in his contract; the request was denied. One may safely presume that Schoenberg did not go into mourning when Schillings, an avowed anti-Semite, died of a pulmonary embolism at age sixty-five, less than four months after having dumped Schoenberg.

In what sort of position did Schoenberg find himself at the onset of the Nazi regime? As Bojan Bujić succinctly stated the matter, "German nationalist musicians saw him as an internationalist, the National Socialists considered him a Cultural Bolshevik, the Com-

munists rejected him as a bourgeois, the anti-Semites saw a Jew in him, yet the composers he considered closest to him were predominantly Aryan."[32] In an odd way, his case resembled that of Anton Rubinstein, the nineteenth-century Russian-born but thoroughly Europeanized piano virtuoso and composer, whose family had converted from Judaism to Christianity when he was a child, and who later lamented: "To the Jews I am a Christian, to the Christians a Jew; to the Russians a German, to the Germans a Russian; to the classicists a Wagnerite, to the Wagnerites a reactionary; and so on. Conclusion: I am neither fish nor flesh—a wretched individual!"[33] But in what was quickly becoming Hitler's Germany, the only criterion that counted, for Schoenberg and every other artist, was how they either met or didn't meet the Nazis' ideas about who was fit or unfit to function in the new society that they were intent on shaping. Major musicians of Jewish descent—conductors Bruno Walter and Otto Klemperer and pianist Artur Schnabel, among many others—were quickly escaping from Germany, and Schoenberg clearly did not meet the Nazis' standards, since he was both a Jew—despite his conversion to Lutheranism—and a "degenerate" modernist. Besides, with respect to his conversion thirty-five years earlier, Schoenberg had for some time been entertaining second thoughts. On May 17, after having received an urgent telegram from Rudolf Kolisch, Gertrud's brother, recommending a "change of air,"[34] Arnold, Gertrud, and little Nuria left Germany for Paris, and there, at one of the city's synagogues, and with Marc Chagall as a witness, he officially returned to the Jewish faith.

"This shows the true face of these liberal Jews' religious depths and metaphysical roots," reported the *Acht-Uhr-Blatt*, one of Vienna's right-wing newspapers.

For them, faith is a tool like any other, a means to an end. No more than that. What Mr. Free-thinker Schoenberg has done looks brave [. . .]. In reality it is a maneuver. The sum total of all his past views meant so little to him that he could throw them out double-quick, and by the same token his new faith will mean no more to him than a cloak thrown about his shoulders, to be blown away again by the next shift in the wind of opinion.[35]

We can see, however, that Schoenberg's reconversion to Judaism made perfect sense at that precise historical moment, when not merely the age-old undercurrents of anti-Semitism but also overt threats to all German Jews were becoming official policy. Since the Mattsee incident a dozen years earlier, he had become increasingly aware of the fact that no matter what he said or did, or didn't say or didn't do, he would always be considered a Jew above all else and only secondarily, at best, an Austrian or a German or a Viennese or an adoptive Berliner. Contemporaneously, his fascination with the Old Testament as a source of moral authority had been growing rapidly; his texts for *Der biblische Weg* and *Moses und Aron* bear irrefutable witness to this fact. Finally, Schoenberg's deep-seated need to face enemies more powerful than himself—to be, once again, David courageously facing Goliath and the whole army of Philistines— was fulfilled by the act of flaunting his now-official Jewishness, not only at the Nazis but at the entire Teutonic world, to which he had dedicated his life's work and which was now rejecting not only his work but also his person.

Yet what was he to do now, as far as sheer survival was concerned? A full year earlier, while still in Barcelona, he had written to Joseph Asch, a Jewish physician in New York whom Schoenberg

had evidently met in Europe, asking whether Asch could "get some rich Jews to provide for me so that I don't have to go back to Berlin among the swastika-swaggerers and pogromists," and so that he could stay in Barcelona, for his health. He wished that he could have a guaranteed income of $2,000 to $2,400 a year, "so that at long last I needn't do anything but create!"[36] But in the United States at the height of the Great Depression, no one felt rich enough to promise a substantial open-ended annuity to a controversial foreign composer.

At some point, however, Schoenberg began to consider actually emigrating to America, and he told his cousin Hans Nachod that he intended to found a United Jewish Party on the other side of the Atlantic and to run a newspaper in support of Jewish causes. Perhaps he would even give up music altogether. In the meantime, though, he was approached by a Russian-American cellist, Joseph Malkin, whom he had met decades earlier and who had recently organized a private conservatory in Boston as well as a student group in New York. If Schoenberg would be willing to teach at the conservatory, the job was his, Malkin informed him. Thus, on October 25, 1933, after having spent two months at the French spa of Arachon on the Atlantic coast near Bordeaux, the fifty-nine-year-old Schoenberg, his thirty-three-year-old wife, and their nineteen-month-old daughter boarded the SS *Ile de France* in Le Havre; they were bound for New York, where they arrived on the last day of the month.

Arnold Schoenberg would never again set foot in Europe.

Final page of the manuscript of Schoenberg's String Trio, Op. 45 (1946).

V

A CALIFORNIAN

FINALE

OCEAN TRAVELERS

His Excellency Paul May, Belgian Ambassador to the United States, will arrive today from Brussels on the French liner *Ile de France* accompanied by Mme. May. Other passengers include Henri Morin de Linclays, newly appointed general manager of the French Line in the United States and Canada; Carlos Palacios, Chilean delegate to the League of Nations; Artur Bodanzky, conductor of the Metropolitan Opera Company, and Mme. Bodanzky, Tito Schipa, operatic tenor, and Mme. Schipa, Arnold Schoenberg, German composer, and the following others [. . .].

—*New York Times*, Tuesday, October 31, 1933

Artur Bodanzky had been in charge of the Metropolitan Opera's German wing since 1915. As a Viennese Jew, a former Zemlinsky pupil, and a former assistant conductor to Mahler at Vienna's Court Opera, he had known Schoenberg since their youth, and he had tried, unsuccessfully, to give the pre-

164 | SCHOENBERG

miere of *Erwartung* in Mannheim before the First World War, when he was that city's music director. Arnold and Gertrud must have been comforted by the shipboard presence of someone from their own circle—someone who, moreover, already had eighteen years' familiarity with musical life in the United States—and with whom they could communicate during their hastily arranged Atlantic crossing. And upon disembarking in New York, the Bodanzkys and Schoenbergs were greeted by yet another Viennese Jewish musician of their generation: the world-famous violinist Fritz Kreisler.*

Little is known of Schoenberg's very first impressions of the United States in general and New York in particular. Franklin D. Roosevelt was in the first year of his presidency and was creating dynamic programs to try to help the country emerge from the Great Depression. Yet despite the grave economic situation, New York, with its grid-like street layout and its skyscrapers (the Chrysler Building, the Empire State Building, and the RCA Building had all been completed since 1930), was unlike any other city that Schoenberg had ever known. Not only that: the local press seemed more interested in him than had been the case in Europe: the day after his arrival, he was interviewed at the flamboyant Beaux-Arts Hotel Ansonia, on Manhattan's Upper West Side, by a reporter for the *New York Times*. The headline—SCHOENBERG SEEKS NEW TALENT HERE—in the following day's paper was followed by three subheadlines about the "Ultra-Modern Composer" and his intentions. The article proper stated that "One of the world's foremost compos-

* Kreisler (1875–1962), like so many other Viennese Jews, had been baptized—in his case, at the age of twelve—but, as we have seen, such transformations didn't count for much among the majority population.

ers and teachers" had arrived with "his wife, his eighteen-months-old daughter, Nuria, and a terrier named Witz, German for jest." He "looked forward not only to the opportunity to guide some of America's young composers to a fuller expression of themselves but to the learning of new and enriching things from the contact with them. [. . .] He is a small man, shy and extremely modest, with a sensitive face and expressive brown eyes."

Schoenberg would take up his teaching duties at the Malkin Conservatory in Boston the following Monday and would teach in New York every Friday, the interview reported; it mentioned as well that Elizabeth Sprague Coolidge—who evidently had been apprised of Schoenberg's intention to try his luck in the United States—had already arranged concerts of his music at the Library of Congress and at New York's Town Hall Club as well as concerts and receptions for him at Yale and Harvard universities and the New School for Social Research in New York, all within fifteen days of his arrival. In addition, Serge Koussevitzky, the great Boston Symphony Orchestra's well-known conductor, had invited Schoenberg to conduct some of his own music with the orchestra a few months later. The article ends with the statement that Schoenberg "plans to stay here throughout the season and perhaps longer."[1]

All in all, Schoenberg must have seen this initial reception as a remarkably auspicious start to his American adventure. A concert of his music organized by the League of American Composers during that same month of November 1933 must have reinforced the positive aspect of his situation: it was attended by, among others, George Gershwin, Edgard Varèse, Aaron Copland, Ernest Bloch, Roger Sessions, Wallingford Riegger, and Percy Grainger. But if the prospects looked good, daily life soon presented a different perspective. The Malkin Conservatory proved to be a tiny institution

founded only a year earlier in Boston's Back Bay, about two miles from the apartment that the Schoenbergs occupied at 1284 Beacon Street in Brookline. According to Jeremy Eichler, who investigated the story for the *Boston Globe* in 2009, "the school had no orchestra and only half a dozen classrooms. The students were few and underskilled, the tuition fees prohibitive, the soundproofing unacceptable. Within weeks, Schoenberg was teaching from his own apartment." Although he would become fluent in English remarkably quickly, communication was difficult at first, and his pupils felt intimidated, more by his reputation than by his behavior. Worst of all for him was the harsh New England winter, which constantly kept him either ill or on the verge of illness, and the weekly train trips to New York and back only exacerbated his condition. "He was known to teach with a giant muffler wrapped around his neck or, on one occasion, with towels stuffed into his pant legs" to counteract the effects of his having "waded through snow banks,"[2] Eichler reported. At one point he became so ill that the engagement to conduct his *Pelleas und Melisande* with the Boston Symphony had to be postponed by two months; it took place on March 16, 1934.

By the spring of 1934 Schoenberg had decided not to return to Boston—nor did Joseph Malkin wish to renew his most famous teacher's contract for the following academic year. The Schoenbergs moved, first to New York City (the Park Central Hotel and then the Ansonia), and from there to the village of Chautauqua, in western New York State, which had an important summer music program. There, Schoenberg became acquainted with Ernest Hutcheson, an Australian-born pianist who was an administrator of the Chautauqua School of Music and—more important, from Schoenberg's point of view—dean of New York City's prestigious Juilliard School. Hutcheson offered him a teaching position

at Juilliard, beginning that fall, but Schoenberg then decided that his health required him to move to a warmer climate. "I want to tell you that your offer gives me very great pleasure indeed, for it shows me that I need not feel superfluous in America," he wrote to Hutcheson. On the other hand, Schoenberg was "quite certain that I shall not be able to stand up to the New York climate before spring."[3] He considered moving somewhere in the Deep South, but in the end he opted for Southern California, where he hoped to find sufficient work to support himself and his family. Thus in September 1934, after a visit to Niagara Falls, the Schoenberg family once again traveled westward.

Their first residence in greater Los Angeles was a rented house on Canyon Cove in Hollywood, but two years later they moved into, and eventually bought, a house at 116 North Rockingham Avenue in Brentwood; this would remain Schoenberg's home for the rest of his life. His first reaction to the area was ecstatic: "You have no idea how beautiful it is here!" he wrote to Webern. "This is Switzerland, the Riviera, the Wienerwald, the Salzkammergut, Spain, and Italy—everything together in one place. There is rarely a day—supposedly also in winter—without sun."[4] To many others, he would say that he had been "driven into Paradise."

The move to the West Coast coincided approximately with Schoenberg's sixtieth birthday (September 13, 1934), for which he received congratulations, good wishes, and displays of admiration and affection from many of his friends, pupils, and colleagues in Europe. In a letter that he sent to several of them, he expressed his gratitude but couldn't refrain from making a sarcastic complaint about his position in the New World: "For here I am universally esteemed as one of the most important composers: alongside Stravinsky, Tansman, Sessions, Sibelius, Gershwin, Copland, etc., . . .

etc., . . . etc. . . ."[5] In other words, he was not treated as someone superior to all the others, as he felt was his due.

Still, his earliest weeks in sun-drenched Los Angeles may have inspired him to write the cheerful Suite in the Old Style, for strings (G major)—his return to tonal composition for the first time in several years, although he did sometimes push G major and other tonalities to extremes in the five-movement piece and did not attach enough importance to it to honor it with an opus number. It was intended at least in part as a teaching vehicle: "Without exposing students to injury from the 'poison of atonality' for the time being," he wrote, the piece "should be a preparation for modern playing technique, within a harmonic system which leads toward modern sentiments."[6] To this listener, some of the string writing in the second movement (Adagio) sounds like Sibelius and some of the melodic phrases in the trio of the third movement (Minuet) are reminiscent of Stravinsky's *Apollo*; I'm sure, however, that those similarities were unconscious on Schoenberg's part, if they aren't simply a figment of my imagination.

AS USUAL, THE NEED TO EARN MONEY BECAME A PRESSING ISSUE. Almost immediately after Schoenberg's arrival in Los Angeles, Pauline Alderman, an assistant professor of theory at the University of Southern California (USC), organized a class that she and two others took at Schoenberg's home, and the following spring he was given a flat fee of $600 to teach, at USC, a class of twenty-five to forty students, who split the cost among them; twenty-seven-year-old John Cage was one of their number, and he continued to work under Schoenberg's tutelage for several years, with many ups and downs in their teacher-pupil relationship. Schoenberg also taught a

private counterpoint class at home during the spring of 1935, and USC then made him a "visiting professor" for the summer sessions of 1935 and 1936 as well as providing him with a regular part-time position for the 1935–36 academic year, all of which gave him roughly $4,000 for a fourteen-month period—nearly three times the average annual Depression-era American income.[7] Several Hollywood film composers also came to Schoenberg for private lessons; the best known among them were Oscar Levant, whom Schoenberg considered gifted and who later became famous, not as a composer but as a pianist, wit, and cameo-role movie actor; and Alfred Newman, who would write the scores of such cinematic classics as *Wuthering Heights*, *The Hunchback of Notre Dame*, *The Song of Bernadette*, *All About Eve*, *Anastasia*, and *The Diary of Anne Frank*. Schoenberg himself was invited to write a film score, but his request for $50,000 and his insistence that his score would have to be used exactly as he wrote it made a contract impossible—"fortunately," he wrote to Alma Mahler-Werfel, "for it would have been the end of me."[8]

He became a member of the American Society of Composers, Authors, and Publishers (ASCAP) and even got to know some of the members who wrote only popular music; at first he was shocked by the informality of their conversations, so different from people's behavior in Europe, and especially in the German-speaking countries at that time, but he got used to it. At one ASCAP gathering—according to Walter H. Rubsamen, a professor of musicology at UCLA—a songwriter said to him, "You know, Arnold, I don't understand your stuff, but you must be O.K., or you wouldn't be here." Schoenberg enjoyed telling the story.[9]

On average, he found his American students less prepared than the pupils he had taught in the Old World. "Although even in Europe I was almost unfailingly very dissatisfied, I did usually find

that there was at least a certain fairly extensive knowledge of the works of the masters," he wrote to Hutcheson. "This indispensable basis for teaching appears to be in the main lacking here"—a fact that he attributed, probably incorrectly, to the relatively high costs, in America, of both printed music and concert and opera tickets.[10] On the other hand, as he told Ernst Krenek (by then a fellow exile), he believed that "American young people's intelligence is certainly remarkable. [. . .] They are extremely good at getting hold of principles, but then want to apply them too much 'on principle.' And in art that's wrong."[11]

In 1936, when the University of California at Los Angeles (UCLA) was seeking a new professor of composition, Otto Klemperer—another refugee, who had become conductor of the Los Angeles Philharmonic—strongly recommended Schoenberg to the school's administration. He was engaged as a full professor at a salary of $4,800, with an increase of $3,000 in 1939 and another in 1942, and with a guaranteed pension; he held the position for eight years, and during that time he and his family lived a reasonably comfortable, middle-class life.[12] His daughter Nuria recalled that "he enjoyed teaching very much and I think that was what saved him."

> He was also interested in less gifted pupils, always endeavoring to respond to them individually. Sometimes he would come home and say that a pupil "had seen daylight," when he had not expected it at all. In a certain sense, he did adapt to the new situation in America—but he also wanted to improve it.[13]

Nuria recalled that at UCLA her father gave individual exams to each pupil, depending on what he thought would do each of them the most good. His students there included the young composers

Leon Kirchner, Earl Kim, and Lou Harrison. But he was also happy to teach nonmusicians who were curious about music and whose general culture could be improved by studying it. One of his UCLA students was a twenty-year-old undergraduate named Jackie Robinson; Schoenberg would let him out of class when Robinson had to go to baseball practice, and Nuria said that her father felt very proud when, in 1947, Robinson famously broke the color barrier in major league baseball.[14]

Musicologist Sabine Feisst, in her book, *Schoenberg's New World: The American Years*, deflates several commonplace pronouncements about the composer's eighteen years in the United States. Far from being either a "lonely 'finished product from the old world,' disinclined to adjust to his new environment," or an "opportunist eager to compromise his European ideals," Schoenberg "found ways to come to terms with his Austrian-German, Jewish, and American identities in their social, intellectual, and cultural contexts," Feisst writes.[15] Elsewhere, she points out that the relatively modest number of performances in America of Schoenberg's post-tonal works during his American years "needs to be gauged against the background of a general musical conservatism conditioned by economically strained times, and also compared with the still smaller number of performances of progressive works by such fellow émigrés as Bartók, Krenek, and [Stefan] Wolpe," or such American-born composers as Ives, Riegger, and Sessions.[16]

Malcolm MacDonald, in his otherwise first-rate Schoenberg biography, went so far as to give the title "Wilderness" to his chapter on Schoenberg's American period, but the facts reveal a different picture. During his California years, Schoenberg produced several of his most important works, raised a growing young family (a son, Ronald, was born in 1937, and another, Lawrence, arrived

in 1941, when Arnold was sixty-seven and Gertrud forty-one), and maintained contact with his European friends and relatives—except during the war years, when correspondence with enemy and enemy-occupied countries was impossible. Worth noting is the fact that Schoenberg was already fifty-nine in 1933, when he arrived in America. At that time, the average lifespan of an Austrian male was fifty-five and that of an American male was sixty-two. By the standards of the day, at the time of his immigration he either had already surpassed or was on the verge of surpassing the average, yet he remained productive almost until the end of his eighteen-year American sojourn.

THE FIRST MAJOR WORK THAT SCHOENBERG WROTE IN THE UNITED States was his Violin Concerto, Op. 36, which he began in 1934 and completed two years later. The work is extremely hard to perform: Jascha Heifetz, whose technique was considered the most extraordinary of any violinist of his time, or possibly of any time, reportedly told Schoenberg that in order to play it he would have had to grow a sixth finger on his left hand. But Louis Krasner, who had commissioned and premiered Berg's Violin Concerto, did manage to give Schoenberg's concerto its first performance, with the Philadelphia Orchestra and Leopold Stokowski in 1940. The work is difficult for listeners, too, and I confess that I failed to grasp either its importance or its hidden beauties until I heard Hilary Hahn's extraordinary recording of it, which conveys its delicacy as well as its power. Even then, however, and after having studied the printed score, I had to listen to the piece multiple times in order to shed my initial hostility toward it. These facts—by the way—raise more general issues about

Schoenberg's music vis-à-vis the public, and I'll return to that matter in this book's Epilogue.

The concerto's first movement, marked *Poco allegro*, alternates between tragedy and fury, with the solo violin commenting on, punctuating, and embellishing the orchestra's pronouncements, which end in what I hear as quiet despair. A gentle lyricism characterizes much of the second movement, *Andante grazioso*, in which the violin is often paired with individual instruments or instrumental groups instead of playing over them or in opposition to them, as is common in concerti. Here, as in the first movement, the orchestra occasionally erupts in outbursts—sometimes playful, sometimes violent—and deeply melancholy passages occur for the violin in its low register, but for the most part the *grazioso* quality prevails. The finale, *Allegro*, contains funny-grotesque and at times satirically militaristic rhythmic patterns of a sort that would later permeate several works of Shostakovich, a composer whose music Schoenberg despised. (Bertolt Brecht, who visited Schoenberg, reported the composer saying of Shostakovich's Seventh Symphony—evidently referring to its first movement—"35 minutes, with material for 12 minutes.")[17] But Schoenberg's grotesquerie not only anticipated those of his much younger Russian colleague: it existed, and exists, within a much more complicated and (to my way of thinking) much more intense context. Was he communicating, among much else, his sense of horror at the events taking place in ever-more-Nazified Germany (and Austria, especially after the *Anschluss*, in 1938)—events that Schoenberg, an enthusiastic moviegoer, must have seen on newsreels as well as learned about from newspapers and the radio? We can't know that. All we know is that the work ends in catastrophe.

174 | SCHOENBERG

Toward the end of his life, Schoenberg described the Violin Concerto as his favorite among his orchestral works.[18] And surely it was with this composition that Schoenberg initiated the peak phase of his twelve-tone period—a period that continued immediately with the Fourth String Quartet, Op. 37, which he began after he had started writing the concerto and finished before the concerto was completed. Not counting earlier sketches, the whole piece was written in about six weeks in 1936—about the same length of time that the Third Quartet had occupied nine years earlier. For listeners unaccustomed to dodecaphony, the quartet is an even thornier work than the concerto, in the first place because it is more tightly constructed, and then because the concerto offers the vast aural variety of a full orchestra with a soaring solo part, whereas a string quartet's palette is necessarily more restricted. Still, Schoenberg makes use, sometimes to an extreme degree, of each instrument's possibilities. "I am very content with the work and think it will be much more pleasant than the third," he wrote to Elizabeth Sprague Coolidge, who commissioned the composition for $1,000. "But—I believe always so."[19]

The quartet's first movement, *Allegro molto, energico*, is a march interspersed with frantic episodes and with some lyrical and even ethereal moments. There are rhythmic reminiscences of the "fate" motif from Beethoven's Fifth Symphony, and the movement ends forcefully. Beginning as a gentle waltz, the second movement, *Comodo* (an easy, natural tempo), soon breaks into rough and extremely jittery passagework, with occasional shrieks. There are playful passages, too, but subdued sadness suddenly takes over the ending, as if to demonstrate that the playfulness was a form of laughter in the dark. In the third movement, *Largo*, somber tones prevail, and in stark slow motion; twice, the tempo picks up and the rhythms

become livelier, but the overall darkness changes little. The finale, *Allegro*, is another march, but a gloomy one; the gloom is sometimes interrupted with outbursts of frenzy and, at one point, of extreme expressionistic angst, but the ending is quiet, almost funereal.

There seems to have been nothing at all funereal, however, about Schoenberg's day-to-day life in Southern California. "I remember him as a very loving father who had a lot of time for us," Nuria Schoenberg Nono recalled.*

> We children never experienced any big variations in his mood. [. . .] I do believe he suffered a great deal, when I think of everything he had lost. [. . .] His greatest loss was his cultural milieu when he moved to America: his friends and pupils. [. . .] He could not speak English when he arrived in America; he learned it and, reading his writings and lectures, [I see that] his vocabulary was astonishing. [. . .] He was always grateful to be in America at all and that he had a position at a university. There were others who had had important positions in Germany but who never got a second chance. My mother was also very important. She was so optimistic and strong and she believed in him so much. She passed that on to us three children, too, and so we knew who our father was—and we were proud of him.[20]

Once, when Nuria was still a child, a friend's mother asked her what her father did for a living. "I said, 'He's the world's greatest composer.' She said, 'Oh, then you must be very rich.' I said, 'No, not at

* In 1955, Nuria married the Italian composer Luigi Nono.

all.' She said, 'Oh, I'm so sorry.' I told this at home and my parents laughed their heads off."[21]

Schoenberg enjoyed making toys for his children. One of the first items, Nuria recalled, was a traffic light that was set up in the garden of their house "for our tricycle and bicycle traffic." Their mother "was the electrician on the project" and also became the family driver after she and her husband bought a car; Arnold never learned to drive. "He would sit in the car and make a sketch for an opera or something musical, or he would make a little caricature of somebody or figure out some mathematical thing," according to Nuria. "He was always working and his mind just never stopped inventing things. [. . .] I remember when he explained to us about the solar system. He used all kinds of lamps in the house. The big standing lamp was the sun and he walked around with another lamp that was the earth. He was always doing things with us." She continued:

> "Make it better" is a key term for what I experienced with my father; whatever one did, one should do it as best one could [. . .]. Everyone was to be respected—every laborer or craftsman—who did his work well. [. . . At home] he had two rooms. One was his composing room—with lots and lots of books. He was lucky to be able to bring over all of his books when he left Europe. When he composed, the doors were closed and nobody bothered him—"Daddy's working and no noise." [. . .] At lunch time or dinner time you could call him and he would come out and tell us stories. [. . .] He was wonderful with us, but we knew we had to respect the times when he was working.[22]

Schoenberg also became an avid tennis player and frequented local tennis courts until he was in his mid-sixties. "He preferred doubles," according to Rubsamen, "so that he would not have to run around as much [. . .]. Toward the end of his tennis-playing activities, we learned to hit the ball directly at or close to him, so that he could participate fully. If aware of this little trick, he gave no sign."[23] One of his partners was George Gershwin, with whom he developed a friendship as well as mutual professional admiration. In 1937, when Gershwin died of a brain tumor at age thirty-eight, Schoenberg felt the loss both personally and as a tragedy for American music, and he paid tribute to his young colleague in a short radio broadcast.

Arnold, Gertrud, and Nuria all became American citizens in 1941; Nuria's younger brothers were born in the United States, thus were citizens by birth. Through the late 1930s and until the United States entered World War II in December 1941, Schoenberg devoted much time, energy, and money to helping other Jews to escape from Nazi-occupied Europe: he wrote letters of recommendation in the hope of persuading potential American employers to offer jobs to musicians who were trying to immigrate, and he signed many affidavits guaranteeing his assistance. Not all of his efforts were successful, but he did his best. One way or another, and with or without his help, several of Schoenberg's Jewish, part-Jewish, and other anti-Nazi Austrian and German friends and acquaintances did manage to reach America—among them, Alma Mahler-Werfel and her husband, the novelist Franz Werfel, both of whom escaped from German-invaded France by traveling on foot over the Pyrenees, then via Madrid to Portugal and by ship to New York; Eduard Steuermann, whose sister Salka Viertel had been screenwriting and acting in Hollywood since 1928; and Gertrud's brother, the violinist

178 | SCHOENBERG

Rudolf Kolisch, and their mother. Several of them ended up in the Los Angeles area, which must have brought at least a modicum of comfort to Arnold and Gertrud.

Naturally, not all of these relationships always went smoothly, given the touchiness—and the unusual situations—of the characters involved: there were breaks, for instance, with Otto Klemperer, who had told Schoenberg that his works had become alien to him,[24] and with Thomas Mann, whom Schoenberg had met in California but who offended him by making the main character of his novel *Doktor Faustus*—first published in 1947—a composer who had invented a twelve-tone system. After Schoenberg protested, Mann added a note to the book's subsequent editions, in which he stated that "the method of composition [. . .] known as the twelve-tone or row technique, is in truth the intellectual property of a contemporary composer and theoretician, Arnold Schoenberg, and that I have transferred it within a certain imaginary context to the person of an entirely fictitious musician, the tragic hero of my novel." And Mann acknowledged his indebtedness to Schoenberg's *Harmonielehre*. Among friends, however, Schoenberg's main complaint about Mann's book seems to have been that the novel's "tragic hero" was syphilitic.

All three of the friends who had most influenced Schoenberg during his teens and early twenties had fled the Nazis. Zemlinsky had ended up in the New York area, where he died, all but forgotten, in 1942; thanks to the efforts of the conductor James Conlon and a few others, including Zemlinsky's biographer Antony Beaumont, his reputation has been re-evaluated upward in recent decades. David Josef Bach had immigrated to England, where he died in 1947. Oskar Adler, too, went to England and remained there until his death in 1955; Schoenberg corresponded with him until the last months of his own life.

Nuria said that her parents told her and her brothers little about the past, but "what we learned about Vienna was not very positive. There was a parody of a famous song which replaced the words 'city of my dreams' with 'unforgivable disgrace.' Yet there was still a love of Vienna which somehow came through—or a love-hate feeling." Nor did her parents have much to say about their Jewish roots or anti-Semitism, especially since her mother, although three-quarters Jewish by descent, had been raised as a Catholic and raised her children as Catholics. "We knew practically nothing about the Jewish religion," Nuria said. "I was the oldest, so of course I knew what was going on in Germany, but my father never talked about it. We talked about schoolwork, not about his experiences in Vienna. He was thinking about our future; we never learned much about politics or the past."[25]

Schoenberg managed to help his and Mathilde's daughter Trudi, Trudi's husband, Felix Greissle, and their sons, Arnold and Hermann Greissle, to immigrate to the United States; he also tried to help his son Görgi to cross the Atlantic, but as there were insufficient funds for also getting Görgi's wife, Anna (née Sax), and their daughter, Susi, out of Austria, all three stayed behind.[26] Fortunately, they all survived the war, but, according to Nuria, not knowing for years whether or not Görgi was alive depressed her father. (Trudi died of cancer in New York in 1947, at the age of forty-five, four years before her father's death; Görgi died in Austria in 1974, at age sixty-seven.) Arnold Schoenberg's sister, Ottilie Schoenberg Blumauer, managed to survive the war and died in Berlin in 1954, at seventy-eight, but their brother, Heinrich, died in Salzburg in 1941, at age fifty-nine, evidently as a result of maltreatment at the hands of the Gestapo.

"And then there were the contacts he had lost," Nuria said of her father. "Alban Berg had already died," of blood poisoning, in

1935, "and [Schoenberg] was told that Webern was politically not above suspicion. That certainly took a great toll on him as well,"[27] especially because Schoenberg esteemed his former pupil as "one of the most original figures in the musical life of our time."[28] Webern, although not an anti-Semite, was ambivalent on the Nazi question, but he gave Görgi Schoenberg a place to live and hide toward the end of the war. In September 1945, a jittery American soldier—part of the Allies' army of occupation—shot and killed Webern, who was smoking outside his home in the dark, shortly before curfew.

Schoenberg's creativity seemed to wane for a while during his mid-sixties. In 1937 he orchestrated Brahms's Piano Quartet in G Minor but produced no new work of his own, and the only new composition of 1938 was *Kol Nidre*, Op. 39, a twelve-minute-long piece in G minor (like the Brahms quartet), scored for speaker, choir, and small orchestra. Rabbi Jacob Sonderling, an immigrant from Poland and Germany, had commissioned it for performance at Los Angeles's Fairfax Temple on Yom Kippur, the Jewish Day of Atonement, and Schoenberg himself conducted the first performance. And in 1939, Schoenberg produced his Chamber Symphony No. 2, in E-flat minor, Op. 38, which he had begun in 1906, taken up again several times, and now at last completed, although in only two movements instead of the three that he had originally planned. Conductor Fritz Stiedry, an old Viennese acquaintance who had in the meantime fled Germany, first to the USSR and then to the United States, had persuaded Schoenberg to finish the work so that he (Stiedry) could conduct it with the New Friends of Music Orchestra in New York. "I have been working on the second chamber symphony for a month now," Schoenberg wrote to him. "I spend most of the time trying to discover 'What did the author mean here?' My style has now become very consolidated and it is now effortful to unify what I wrote down

back then, justifiably trusting in my feeling for form, with my current extensive requirements for 'visible logic.'" Years later, however, he commented: "A longing to return to the old style was always powerful in me; and I was forced to yield to that urge from time to time. So sometimes I compose tonal music. Stylistic differences of this kind have no special importance for me. I don't know which of my compositions are better; I like them all, because I liked them when I was writing them."[29]

In its final form, the Chamber Symphony No. 2 is scored for a classical-sized orchestra (two each of flutes, oboes, clarinets, bassoons, horns, and trumpets—with the second oboe doubling on English horn—plus strings); it was quickly taken up by several major conductors, including Klemperer, Pierre Monteux, and Stokowski. Why it has not remained part of the orchestral repertoire is a mystery: its style is essentially lyrical, and its harmonic content is less radical than that of many other twentieth-century tonal pieces. The first movement is melancholy; the second begins cheerfully and ends tragically. (Most performances of the first movement are paced funereally, vastly below Schoenberg's metronome mark of eighth note = 92, and some of the piece's other tempi are also played too slowly. Schoenberg attended the premiere, which took place in New York in December 1940, and afterward he wrote to Stiedry: "As to the shaping, it was generally compelling, but it suffered much by the tempi being too slow, some of them far too slow."[30] And to Bernard Hermann, who conducted the piece on the Columbia Broadcasting System's radio network in 1949, Schoenberg wrote that "the first movement was too slow. I am sure if you would try to read this movement now in the tempo which my metronome marks indicate, that everything would fit very well to this tempo.")[31] Schoenberg also made an arrangement of the piece for two pianos and published it as Op. 38b.

No new works appeared in 1940, the horrifying and depressing year in which Nazi Germany conquered large portions of Western Europe, but he did manage to conduct a recording of *Pierrot Lunaire* for Columbia Records. And in 1941 only one new creation emerged from his pen: the complex and contrapuntal Variations (for organ) on a Recitative in D Minor, Op. 40, commissioned by William Strickland, a young conductor and organist who would eventually commission works of many other American and American-based composers. Finally, in 1942, Schoenberg returned, after nearly six years, to the twelve-tone system: *Ode to Napoleon Buonaparte*, Op. 41, is a setting—for speaker, string quartet, and piano—of Lord Byron's poem of the same name, and it is yet another *unicum* in Schoenberg's output.

President Franklin Roosevelt's "date that shall live in infamy" speech, which had marked the United States' entry into World War II in December 1941, seems to have been one of the motivations behind this work; another was the desire to set something by Byron, whom Schoenberg admired for his personal and financial support for the Greek wars of independence during the early 1820s. A commission from the League of Composers came at the right time, and the wish to attack a war-mongering, Hitler-like figure without deigning to name the Nazi dictator completed the *Ode*'s origin story. "I knew it was the moral duty of intelligentsia to take a stand against tyranny,"[32] Schoenberg wrote. Still, the pairing of Napoleon with Hitler seems ill-advised: Schoenberg surely knew that Napoleon's armies had torn down the ghettos across Germany and had liberated the Jews, whereas Hitler was enslaving and killing as many Jews as he could find. Schoenberg may even have known that Byron's violent attack was written immediately after what the poet had thought to be the French emperor's

cowardly surrender, in 1814, and that one year later Byron wrote a tribute, "Napoleon's Farewell," after what, in his opinion, had been Bonaparte's valiant albeit unsuccessful attempt to defeat the reinstated Bourbons and regain power. (About Byron's attitude toward Napoleon, Stendhal commented acidly that the poet was envious of the emperor's formerly triumphant career—which the French writer called "the despotism of glory"—and would have been kinder to him had Napoleon had the "dull" look of a George Washington, whom Byron had initially held up as the heroic antithesis of Napoleon.)

In any case, Schoenberg's aims were very different from Byron's, and he seems to have had little interest in the poetic merits of the poem's nineteen nine-line verses—such as their intricate rhyme scheme: ABABCCBDD. Schoenberg's intention, with respect to the text, seems to have been the seconding of verbal meaning through motivic, dynamic, and rhythmic variety. (Among other motives, there are references to the *Marseillaise* and the opening notes of Beethoven's Fifth Symphony.) The work begins with harsh piano chords and violently whirling passages for the strings but ends, strikingly, on a triumphant E-flat major chord. ("I don't know why I did it," Schoenberg later wrote about the tonal ending. "Maybe I was wrong.")[33] For the speaker, Schoenberg created a different form of *Sprechgesang* than he had used in previous vocal works: instead of writing notes on a five-line staff with x's through their stems, he set normal notes—some of them with sharp and flat signs—above and below a single line, to indicate the desired tone-level for each syllable. These indications are extremely detailed: Schoenberg wanted the speaker to achieve "the number of shades, essential to express one hundred and seventy kinds of derision, sarcasm, hatred, ridicule, contempt, condemnation, etc., which I tried to portray in my music,"[34] he said. And indeed Leonard

Stein, who played the piano part in a performance of the work that Schoenberg helped to prepare in Los Angeles, recalled that "in a special coaching session with the speaker, Schoenberg, his dark eyes flashing expressively while he recited lines from the work, emphasized, above all, their dramatic and expressive values." But, Stein added, the "inflections of pitch, marked so carefully in the score, were treated in a secondary manner."[35]

After having completed the *Ode*, Schoenberg decided to withhold it from the League of Composers, which had wanted to engage the Budapest Quartet for the premiere; Schoenberg preferred the Kolisch Quartet, which was already familiar with his chamber works. In the end, the premiere was given in an effective version for string orchestra, instead of string quartet, by the New York Philharmonic conducted by Artur Rodzinski, and with bass-baritone Mack Harrell as the speaker, at Carnegie Hall on November 23, 1944; a recording of that performance is available in various formats. The pianist on that occasion was Edward Steuermann, Schoenberg's former pupil and longtime supporter, who, on February 6 of that year, had realized a much more substantial project for his teacher by giving the world premiere of Schoenberg's Concerto for Piano and Orchestra, Op. 42, with Stokowski and the NBC Symphony Orchestra, in a concert broadcast from Studio 8H in the RCA Building, Rockefeller Center, New York.

Like the Violin Concerto, the Piano Concerto—written during the latter half of 1942, after the *Ode*—presents such extreme technical difficulties for the soloist that more than one virtuoso has given up the attempt to play it; to be fair, however, some have given it up because they didn't or don't like it. The original commission

for a "piece" for piano had come from Oscar Levant, who had sent Schoenberg $100 or $200 but had balked when Schoenberg asked for $1,500 for an entire concerto. Levant vehemently withdrew the commission, but into the breach stepped one Henry Clay Shriver, who had studied counterpoint with Schoenberg but had opted to become a lawyer instead of a musician. Shriver gave $1,000 to his former teacher and became the work's dedicatee.

The twelve-tone piece is scored for large orchestra and is organized in four connected movements; it lasts only about twenty minutes altogether. In the manuscript, Schoenberg wrote a phrase at the beginning of each movement: Andante—"Life was so easy"; Molto allegro—"Suddenly hatred broke out"; Adagio—"A grave situation was created"; Giocoso (moderato)—"But life goes on." We don't know whether he invented these indications while the concerto was a work in progress or inserted them after he had completed it and was perhaps thinking about having them published; in the end, the descriptive phrases were not published. The first movement does indeed begin with a gentle, nostalgia-provoking waltz, but gradually builds in power until, at the start of the second movement, violence erupts. Harsh-voiced anguish continues until the third movement begins somberly, even lugubriously. The piano has a substantial cadenza that alternates between high drama and gentleness, and the orchestra is similarly of two minds, or two basic emotions, when it re-enters the proceedings; the movement's ending is at first sinister, then cataclysmic. A light-textured solo passage for the piano leads into the lilting opening of the finale; the atmosphere remains mostly playful and graceful but is punctuated here and there by more dramatic passages. Roughly a minute and a half before the end, a menacing march destroys

186 | SCHOENBERG

the peace, then becomes a headlong rush, and the concerto ends brutally.*

The premieres of both the *Ode to Napoleon Buonaparte* and the Piano Concerto occurred in 1944, the year of Schoenberg's seventieth birthday, which was the occasion for celebration but also preoccupation. For one thing, his health was declining: the asthma that had diminished since his move to California was beginning to worsen again; problems with his eyesight meant that he had to compose on special paper designed with broad spaces between the lines; and he was diagnosed with diabetes. There were financial problems, too. UCLA's administration, which generally required its professors to retire at sixty-five but had made an exception for Schoenberg, now insisted that he stop, and his pension, based on only eight years of employment, was meager: an average of $40 a month—insufficient to insure the survival of his family and himself. An alarmed Franz Werfel—presumably prompted by his wife, Alma—wrote to several friends and acquaintances, including Arthur Rubinstein (another Los Angeles area resident), to ask them to sign a petition that requested ASCAP to "double the customary sum of his royalties for the balance of his life," since "the material rewards for Schoenberg's accomplishments have not been at all commensurate with their cultural importance."[36] Rubinstein probably signed it, although in his memoirs he mentioned only having been

* In my opinion, the two most convincing recordings of the Piano Concerto, among those I have heard, are those performed by Alfred Brendel with the SWF Sinfonieorchester Baden-Baden conducted by Michael Gielen (1996) and by Emanuel Ax with the Philharmonia Orchestra conducted by Esa-Pekka Salonen (1992). Other worthwhile versions include an off-the-air recording by Steuermann himself with the Frankfurt Radio Orchestra conducted by Hermann Scherchen (1954) and a rhapsodic, live concert performance with Glenn Gould and the Cleveland Orchestra conducted by Louis Lane (1959). Mitsuko Uchida's recording with the amazingly virtuosic Cleveland Orchestra and Pierre Boulez seems to me a little too low on angst for the work in question.

one of a "group of musicians who decided to help" the composer.[37] (During that period, the Schoenbergs attended at least one chamber music party at the Rubinsteins' home; Monika Mann, Thomas Mann's daughter, was present with her parents, and many years later she wrote to Rubinstein that she had sat "next to Schoenberg, who ate an enormous amount while you played chamber music!!")[38]

About Schoenberg's economic situation after his retirement from UCLA, Sabine Feisst has convincingly disproven the allegations made by some of his European biographers that he was on the verge of starvation. He did have to "teach private students, sell manuscripts to the Library of Congress, and accept lucrative commissions, but he never came close to starving," she writes. Antony Tudor's *The Pillar of Fire*, a choreographed version of *Verklärte Nacht*, brought him decent annual royalties beginning in 1942, and, Feisst says, "ASCAP granted him an annual allowance of $1,500 in addition to royalties, friends raised money for him, and the National Institute of Arts and Letters awarded him $1,000 in 1947."[39]

Still, the fact that at seventy Schoenberg had children who were twelve, seven, and three years old meant that his financial responsibilities were considerable. The previous year, at a suggestion from Carl Engel, who headed the G. Schirmer music publishing house in New York, he composed the Theme and Variations for Wind Band, in B-flat major, Op. 43a: Engel's idea had been that, given the popularity of bands in America, such a piece could have been a commercial success. What emerged, however, was a work that, although only eleven or twelve minutes long, was far beyond most bands' musical and technical abilities. It did not receive its first performance until 1946, with the New York–based Goldman Band conducted by Richard Franko Goldman, but in the meantime Schoenberg created a version for full orchestra, published as Op. 43b, which Koussevitzky

188 | SCHOENBERG

premiered with the Boston Symphony in 1944. In its orchestral form, the Theme and Variations could be performed today by any professional orchestra and would make an effective showpiece, similar to Hindemith's once-frequently-heard Symphonic Metamorphosis of a Theme of Carl Maria von Weber—which was likewise written in 1943 and by an émigré from Nazi Germany.

During those years, Schoenberg was also working on several books: *Fundamentals of Musical Composition* (begun in 1937 and published posthumously in 1967), *Models for Beginners in Composition* (written and published in 1942), and *Structural Functions of Harmony* (begun in 1945 and published posthumously in 1954). In 1950, Dika Newlin, one of Schoenberg's former students, published a collection of his essays under the title *Style and Idea.**

He resumed work on *Die Jakobsleiter* in 1944 but then set it aside again, and the following year—the year in which Germany and Japan were at last defeated—he composed only one, short piece: the Prelude to the *Genesis Suite*. This multi-composer-created potpourri—meant to be an interpretation through music of the early chapters of the first book of the Bible—was the brainchild of the conductor-composer-clarinetist Nathaniel Shilkret, who engaged several well-known composers for the task; all but one of them were Jewish, and all of them except himself were refugees from Europe and no doubt appreciative of the generous flat fee of $1,500 that each would be paid for five to ten minutes of music. Whether or not Shilkret so intended, the seven composers represented six different countries of origin: Schoenberg (Austria) wrote the Prelude (to which Shilkret, not Schoenberg, gave the title "Earth was

* Newlin later published a book of her own: *Schoenberg Remembered: Diaries and Recollections, 1938–1976*; see my Bibliography.

without form"); Shilkret (USA, but with Ukrainian-born parents) composed "Creation"; Alexandre Tansman (Poland) wrote "Adam and Eve;" Darius Milhaud (France) was responsible for "Cain and Abel"; Mario Castelnuovo-Tedesco (Italy) wrote "The Flood—Noah's Ark"; Ernst Toch (Austria) composed "The Covenant—The Rainbow"; and Stravinsky (Russia), the only non-Jew, concluded the suite with "Babel." Schoenberg's six-minute-long Prelude, scored for orchestra and a wordless chorus that enters only during the last minute-and-a-half, is a twelve-tone work but with tonal references, and it ends on a unison C.

The whole suite was first performed in November 1945 by Werner Janssen and his orchestra, with the actor Edward Arnold as narrator; RCA Victor recorded it during the same period. Schoenberg and Stravinsky, after having lobbed long-distance put-downs at each other for over two decades, managed to avoid a face-to-face encounter, even though, as Stravinsky later reported, "we were in the recording studios on the same day and we sat on opposite sides of the Wilshire Ebell Theater at the premiere."[40] Open conflict was avoided!

SCHOENBERG TRAVELED EAST IN MAY 1946 TO LECTURE AT THE UNIversity of Chicago, and after his return home he began to think about writing a string trio that had been commissioned by Harvard University's Music Department for a fee of $750. On August 2, however, he suffered a near-fatal heart attack. As he later recalled:

I began to feel fierce pains throughout my body, particularly in the chest and around the heart. After trying for half an hour to find a doctor, a friend sent Dr. Lloyd-Jones, our present house-doctor, who then saved my life. He gave me an injection of

190 | SCHOENBERG

Dilaudid, to reduce the pains. This immediately helped; but ten minutes later I lost consciousness, and my heart-beat and pulse stopped. In other words, I was practically dead. [. . .] Dr. Jones made an injection directly into my heart. It was three weeks before I recovered. I had about 160 penicillin injections [. . .].[41]

The resulting medical expenses were onerous, but Schoenberg was able to cover them thanks to a generous gift of $1,000 from Stokowski, who had learned of the composer's straitened circumstances. Remarkably, by August 20 Schoenberg was working "from bed and armchair," Feisst reports, and he finished the trio on September 23.

The String Trio, Op. 45, may well be the strangest piece of music that Schoenberg ever wrote, but also the most astonishing and the most intimately personal one. In addition, it is a strong contender for the title of Most Physiological Musical Composition in Western Art Music. It's true that the first movement of Berlioz's *Symphonie Fantastique* contains indications of irregular heartbeats and explosive orgasms, but this entire, nineteen- or twenty-minute-long trio is a drama that unfolds inside and outside Arnold Schoenberg's diseased body as it undergoes a near-death experience, is revived, and is then heaved around like a piece of meat—a tenderly cared-for piece of meat, certainly, but a piece of meat nevertheless. Nor is this mere speculation: Schoenberg told several friends and other visitors that he had "musically depicted his illness and specific medical procedures," including even a recollection of the hypodermic needle, and that he had paid musical tribute, in the trio, "to his American physician, Dr. [Owen or Orren] Lloyd Jones, and his heavyweight nurse, [. . .] 'an enormous person, a former boxer, who could pick me up and put me down again like a sofa cushion,'" Schoenberg said.[42]

The twelve-tone work's two hundred ninety-three bars are

A CALIFORNIAN FINALE | 191

divided into five segments of uneven lengths: Part One (approximately two minutes), is filled with high drama, but the extraordinary First Episode (approximately six minutes) opens with otherworldly sounds, then becomes mournful, with harmonics that sound like weeping. There are moments of stabbing anguish, like jolts to the heart, but there are also recitatives that distantly recall some of those composed by Beethoven in his late instrumental works—in particular, the Cavatina of the B-flat Major String Quartet, Op. 130. These give way to nostalgia in the form of a waltz, another recitative, another waltz fragment, and then an ebbing away, as if of life itself. Much of Part Two (approximately three minutes) is also waltz-like, but the setting is now warm and consolatory, despite energetic outbursts and passages of eerie harmonics that seem to come from "elsewhere," as if that ebbing life force were struggling to flow back into a dying body. The Second Episode (approximately three minutes) also waltzes at times, but at one point the violin and viola alternate slow, blood-curdling *glissandi* over agitated rhythms; the pace then slows down drastically, becomes agitated again, and slows down again, leading into Part Three (approximately five-and-a-half minutes). Substantial portions of this last segment constitute a partial recapitulation of elements from the preceding segments, especially from Part One and the First Episode. And the entire trio ends not with a bang but a whimper—a gradually unfolding, sometimes almost tonal whimper that concludes on a lonely, low D-sharp from the violin.

Once again, I caution readers who are not already familiar with Schoenberg's twelve-tone idiom—and even some of those who are—that this trio may not captivate them on a first or perhaps even a second or third listening. But it is well worth whatever effort is put into it—and anyone who is musically literate will learn a lot

192 | SCHOENBERG

from studying the piece's complex score, too. Malcolm MacDonald described it, with good reason, as "one of the most expressive and most concentrated of all his works,"[43] and Schoenberg himself, in his last years, declared that it was his favorite among all of his chamber music compositions.*[44]

———

DURING THE REMAINING MONTHS OF 1946, SCHOENBERG'S HEALTH began to improve, and he regained some of his strength. When, in April 1947, he was elected to the American Academy of Arts and Letters, he recorded a message of thanks, the key sentence of which was: "I have perhaps only one merit: I never gave up." But he concluded with a typical slap at those he perceived as his enemies: "Please do not call it false modesty if I say: Maybe something has been achieved but it was not I who deserves the credit for that. The credit must be given to my opponents. They were the ones who really helped me."[45] He was, in short, as combative as ever.

In August, exactly a year after his heart attack, he composed *A Survivor from Warsaw*, Op. 46, a seven-minute-long, twelve-tone work for narrator, men's chorus, and orchestra, commissioned by the Koussevitzky Foundation and dedicated to the memory of Natalie Koussevitzky, the conductor's first wife. Vision problems caused Schoenberg to write the piece only in short score; the Polish-French conductor René Leibowitz, who had come to Los Angeles specifically to meet and work with Schoenberg, transcribed *Survivor* into full score, under the composer's supervision.

Inspired by an event related to him by Corinne Chochem, a

* My favorite recording of the piece is by the Leopold String Trio (Marianne Thorsen, violin; Lawrence Power, viola; Kate Gould, cello), but there are other good ones as well.

Russian-American exponent of Jewish and Israeli modern dance, Schoenberg himself wrote *Survivor*'s text, using a mixture of English, German, and Hebrew. The narrator, employing *Sprechgesang*, recounts in English his experience of a German roundup and beating of Jews, presumably in the Warsaw Ghetto—the infamous site where, between 1940 and 1943, nearly half a million Jews were walled in by Poland's German occupiers until they were either slaughtered right there or shipped off to the death camps. The sergeant shouts orders in German: he has to know how many of the beaten are still alive and must therefore be sent to be gassed. As the survivors begin to realize that they, too, are about to die, they begin to sing, with great force, the *Shema Yisrael* and the *V'ahavta*—the Hebrew declarations of faith. In a letter to Kurt List, a Vienna-born American conductor and musicologist who had studied with Berg, Schoenberg wrote that the *Survivor* text was meant as "a warning to all Jews, never to forget what has been done to us, never to forget that even people who did not do it themselves, agreed with [the perpetrators] and many of them found it necessary to treat us this way."[46]

Nineteen-forty-seven was also the year of the publication of *Doktor Faustus*, which unleashed the previously mentioned break between Schoenberg and Mann, and which, according to Feisst, "exposed the vulnerabilities, hypersensitivity, and feelings of neglect and persecution that marked Schoenberg's last few years."[47] These states of mind were illustrated in a letter to Rudolf Kolisch, in which Schoenberg complained about musical life in America as a "commercial racket" dominated by "American composers, [Nadia] Boulanger's pupils, the imitators of Stravinsky, Hindemith, and now Bartók as well." (Boulanger, who taught many of the foremost twentieth-century American composers and was a friend of Stravinsky, did not admire Schoenbergian serialism.) He also predicted that

these people would likewise easily conquer "the colony that Europe amounts to for them."[48]

And what about Europe? On Schoenberg's seventy-fifth birthday, on September 13, 1949, the mayor of Vienna made him an honorary citizen of his native city and invited him to return there, and in both 1950 and 1951 Schoenberg was asked to participate in summer courses in Darmstadt, Germany. But, according to Nuria Schoenberg Nono, "by then he was already ill, and secondly, he was unsure whether anti-Semitism still existed [there]—which it did, of course."[49] Indeed, with respect to that issue and in connection with his native city during the immediate postwar years, Schoenberg wrote: "I have the impression that in Vienna racial issues are still more important than artistic merit for judging artwork." On another occasion he declared, "I would like it best if performances of my music in Vienna were banned completely and forever. I have never been treated as badly as I was there."[50] Despite his misgivings, he planned a trip to Europe with his family in the spring of 1949, but, as he wrote to Josef Rufer, he was suffering from asthma, giddiness, and stomach troubles, and in the end he decided not to take the risk.[51]

And yet, he continued to work as best he could. A year earlier, Schoenberg had made modal arrangements of fifteenth- and sixteenth-century German folksongs and had published them as Three Folksongs, Op. 49, for mixed chorus *a cappella*. Now, between early March and mid-April 1949, he composed the short but complex Phantasy, Op. 47, for violin and piano, and *Dreimal tausend Jahre*, Op. 50a, a three-minute-long piece, which, like his Op. 49, was scored for mixed chorus *a cappella* but, unlike the earlier work, makes use of the twelve-tone system. Through the text, by the Austrian-American philosopher and writer Dagobert D. Runes,

Schoenberg commemorates the birth of the State of Israel: "Three times a thousand years since I've seen you, / Temple in Jerusalem, Temple of my woes!"* This was followed, in 1950, by Op. 50b, a five-minute-long, six-part choral setting of the Hebrew text of Psalm 130 (commonly known by its Latin name, *De profundis*), and then by Op. 50c, *Moderner Psalm* (Modern Psalm), for speaker, six-part chorus, and orchestra. Schoenberg had begun to write psalm texts of his own, with the intention of setting them to music, but the first of them—"O, du mein Gott: alle Völker preisen dich" (O, thou my God: all peoples praise thee)—is the only one that he managed to compose, and that one only in part: it trails off as he left it at the time of his death.

ROBERT CRAFT VISITED SCHOENBERG SEVERAL TIMES DURING THE composer's last years, although at the time the young American was becoming an amanuensis to Stravinsky. Craft went to see Schoenberg on July 5, 1950, and wrote in his diary that the composer had entered the living room "walking slowly and with the help of his wife."

> He is stooped and wizened, but sun-tanned like an athlete. He seems thinner than last time—that pained, too sensitive face, difficult to look into and impossible not to look into— and the bulging veins in his right temple are more prominent. Perhaps from the same cause his ears appear to have grown larger [. . .]. He seats himself [. . .] on the edge of the cushion

* *"Dreimal tausend Jahre seit ich dich gesehn, / Tempel in Jerusalem, Tempel meiner Wehn!"*

and without repose; and seated he seems even smaller, and older than his years. Then, as we begin to talk, he adjusts caster-thick eye-glasses heretofore dangling from his neck by a ribbon and rubber bands. The voice is soft, but as pained and sensitive as the face, and at moments it is almost embarrassingly intense.

Craft was stunned by Schoenberg's amazement that this twenty-six-year-old American was familiar with his works: "the fact of these reactions is also shocking evidence of the neglect of his music," Craft wrote. When Craft left the house, his "feeling of lightness outdoors is a measure of the almost unbearable intensity of the man, as well as of the strain created by the danger of crossing the circle of his pride, for though his humility is fathomless it is also plated all the way down with a hubris of stainless steel."[52]

Early in 1951, Schoenberg was elected honorary president of the Israel Academy of Music, and in his letter of thanks he declared that for over forty years his "dearest wish" had been "to see the establishment of a separate, independent State of Israel" and even "to become a citizen of that State and to reside there." Unfortunately, he said, he no longer had the strength to realize these personal hopes, but had he been able to be in charge of the Academy he would have set it in opposition to "amoral, success-ridden materialism."

For just as God chose Israel to be the people whose task it is to maintain the pure, true, Mosaic monotheism despite all persecution, despite all affliction, so too it is the task of Israeli musicians to set the world an example of the old kind that can make our souls function again as they must if mankind is to evolve any higher.[53]

He was still working on the *Modern Psalms* in the spring and early summer of 1951, but by then his physical strength had waned dramatically. In addition, his triskaidekaphobia, and especially his fear of "thirteenths" that fell on Fridays, made him dread the approach of Friday, July 13, 1951, the more so because it would occur while he was still seventy-six years old: 7 + 6 = 13. Robert Craft came to visit on July 7 and wrote in his diary: "He is unwell today, and unable to come downstairs, but his voice is audible from the bedroom." Gertrud Schoenberg showed Craft her husband's studio,

> as small and crowded as [Stravinsky]'s, but without [Stravinsky]'s finicky aesthetic arrangement of working paraphernalia [. . .]. The desk is tinted with red, yellow, and blue light from a stained-glass window, which is eery, though not more so than the self-portraits, obsessive about eyes. Manuscripts and papers cover the desk, a table, and an old harmonium, and every bit of shelf space is stuffed with music (I notice orchestra scores of *Otello* and *Falstaff*) or bound sets of books (Strindberg, Ibsen, Byron). A mandolin, wistful reminder of the Serenade and *Pierrot*, hangs from a peg on the wall.[54]

Six days later, on the thirteenth, Schoenberg was very weak and slept most of the time. As Gertrud later described the situation in a letter to Ottilie, Arnold's sister, she had also feared the thirteenth and longed for the day to be over.

> He insisted that I should get a sitter-in for the night. He was a German doctor who was not allowed to practice here. I was very tired, but woke up every hour and we had the light on. Arnold slept restlessly, but he slept. About a quarter to twelve

198 | SCHOENBERG

I looked at the clock and said to myself: another quarter of an hour and then the worst is over. Then the doctor called me. Arnold's throat rattled twice, his heart gave a powerful beat and that was the end. But I couldn't believe it for a long time afterwards. His face was so relaxed and calm as if he were sleeping. No convulsions, no death struggle. I had always prayed for this end. Only not to grieve![55]

Edgar Magnin, a Reform Jewish rabbi, officiated at Schoenberg's funeral at the nonsectarian Wayside Chapel in West Los Angeles. The music consisted of chorale preludes by Bach, a Lutheran, performed by the organist Alexander Schreiner, a Mormon. Twenty-three years later, at the time of the centenary of Schoenberg's birth, his ashes—together with those of Gertrud, who had died in 1968—were reinterred, in Vienna's Zentralfriedhof (Central Cemetery), not far from the graves of Beethoven, Schubert, Brahms, and Johann Strauss II. The boy from Matzah Island had returned, and the city of Vienna had made its peace with Arnold Schoenberg, although Arnold Schoenberg had never made his peace with Vienna.

IN A FRONT-PAGE OBITUARY FOR SCHOENBERG, THE *NEW YORK TIMES* of July 15, 1951, declared that "the wildest storms of twentieth-century music [had] raged" around the composer, yet "at his death there were few—no matter how little they warmed to his music itself—who could deny either the importance of his influence or that he was a great musical theorist and teacher. And there were many voices who predicted that the Austrian composer's music would finally be accepted in much the same way as the later work of Stravinsky and the compositions of Béla Bartók." This last sentence would have

displeased Schoenberg immensely, but the anonymous journalist's well-intentioned prediction has in fact proven to be overly generous.

In 1962, the pianist Glenn Gould, a Schoenberg enthusiast, wrote: "I think it's most unlikely that we can expect to clarify all the confusion surrounding the work of Arnold Schoenberg for many years to come." And I, writing six decades after Gould, am obliged to say that those words remain valid. However archaic, even absurd, his thoughts about preserving Germanic hegemony in the world of music may seem today, the controversy that he ignited is still with us.

Epilogue

WHAT NOW?

Although I was an avid reader by my early teens, I went through a phase during which I wouldn't allow any words to be visible on any surfaces in my bedroom—my little kingdom. I turned all of my books' spines toward the wall and removed all labels and word-mongering posters from view, with the impossible goal of looking at words only when I specifically wanted to read them. Words, I had decided, destroyed what I called the "purity of thought." Or, as I explained that brief life-phase to myself long after I had moved on to other follies, language had seemed to me to limit abstraction.

I hadn't heard of Karl Kraus, who had greatly influenced Arnold Schoenberg, and who had referred to language as the mother of thought, but I'm reasonably sure that even as a thirteen- or fourteen-year-old I understood that among human beings the formulation and communication of ideas requires some sort of language, be it verbal or numerical or pictorial or some combination thereof, and I certainly didn't believe that I, a kid in Cleveland, Ohio, could come up with an alternative. Besides, like most other members of our spe-

cies, I had learned to talk long before I was able to have an opinion about thought processes or any other subject, and there was nothing I could do to alter my "impurity." I suppose that I merely wanted to make a statement, namely, that language makes thought possible but also limits it. Perhaps that's why I had already gravitated, unpremeditatedly, toward music as my primary expressive love. As one great writer said, great music—he was referring specifically to Mozart's music—speaks to us "deeply . . . beyond words."[1]

Many years later, I came across Hugo von Hofmannsthal's short story, "Ein Brief," known in English as "The Lord Chandos Letter," which contains statements like the following: "the abstract words which the tongue must enlist as a matter of course in order to bring out an opinion disintegrated in my mouth like rotten mushrooms [. . .]. Even in simple, informal conversation, all the opinions which are ordinarily offered casually and with the sureness of a sleepwalker became so fraught with difficulties that I had to stop participating in these conversations at all." In reading Seneca and Cicero, whom he had loved, the fictional English Lord Chandos—writing, supposedly, in the early seventeenth century—now felt "like someone locked in a garden full of eyeless statuary [. . .]." He had discovered in himself a previously untapped empathy with the creatures and objects of our world, but, he said, "I can no more express in rational language what made up this harmony permeating me and the entire world, or how it made itself perceptible to me, than I can describe with any precision the inner movements of my intestines or the engorgement of my veins." And, he concluded, "the language in which I might have been granted the opportunity not only to write but also to think is not Latin or English, or Italian, or Spanish, but a language of which I know not one word, a language in which mute things speak to me."[2]

EPILOGUE: WHAT NOW? | 203

Hofmannsthal—who, like Arnold Schoenberg, was born in Vienna in 1874, but into a well-to-do ennobled family of only part-Jewish origin—wrote this story in 1902 and seemed to be on the verge of analyzing an apparent breakdown in traditional, ordered, verbal language, just as Schoenberg was contemporaneously on the verge of analyzing an apparent breakdown in traditional, ordered, Western harmonic language. But Hofmannsthal, whom music lovers know today mainly as the librettist of some of Richard Strauss's most important operas, was fundamentally an artistic conservative who had posed Lord Chandos's dilemma for the sake of argument, without foreseeing that other writers—James Joyce's name springs immediately to mind—would soon bring the issue into the front lines of modern intellectual debate. Schoenberg, on the contrary, turned himself into music's principal regenerator or nuisance, depending on one's point of view.

Closer to Schoenberg than Hofmannsthal, in some respects, was Franz Kafka, their junior by nine years. As Cynthia Ozick has written, Kafka understood "the unbridgeable fissure between words and the spells they cast. Always for Kafka, behind meaning there shivers an intractable darkness or (rarely) an impenetrable radiance."[3] Kafka investigated the fissure without resorting to linguistic experimentation *per se*, although there is no knowing what direction he might have taken had he lived beyond his forty-first year or perhaps received a smidgen of recognition during his lifetime.

Not by coincidence did the questions posed or the experiments carried out by Hofmannsthal, Kafka, Joyce, and Schoenberg, not to mention Stravinsky, Kandinsky, Picasso, and so many other practitioners of the arts, take place during the first quarter of the twentieth century—in other words, in the years leading up to, during, and immediately after the First World War, that cataclysmic divide

in the history of Western civilization. Many of those creators' results were brilliant and have endured, but the aftereffects necessarily varied from one art form to another. An author publishes a book and a potential reader may or may not read it; a painter paints a canvas and a potential viewer may or may not focus on it; but a composer requires intermediaries—performers—to make his or her music available to listeners, who generally have to gather together at a specific venue and listen, over a stretch of time, to what may or may not be an acceptable rendering of the work in question. This was especially true in pre-long-playing record days—the era in which Schoenberg lived nearly all his life—when the recording process was expensive and not much avant-garde music was being committed to commercial discs.

Still, the main problem with the music of Schoenberg and his disciples lay in the chasm that their system opened up between composers and listeners. For seven hundred years, from the time of Guillaume de Machaut, most European and European-influenced composers, including Schoenberg himself in his pre-atonal compositions, worked within a slowly evolving musical language that became familiar to audiences across the continent and, eventually, in many parts of the rest of the world. Originality, for most of these musicians, meant fresh melodic invention and incremental amounts of harmonic and structural innovation. Beethoven, in his astonishing later works, was to some extent an exception (his big guns were aimed at the future), and so was Wagner, yet even they were more "evolutionists" than "revolutionists" in developing their personal harmonic languages. Schoenberg saw himself as an evolutionist when he began to write in an idiom that abolished tonality, and then when he invented a new, externally imposed system, and many other intelligent musicians were likewise convinced that this was

true. "Today we know that this process was not only subjectively justified by Schoenberg's genius," wrote the respected German musicologist and critic Hans Heinz Stuckenschmidt, circa 1950, "but that it was a historical necessity, that since the introduction of the tempered system about 1700 the development of harmony was resolutely striving towards the results which Schoenberg had the courage to present to the world."[4]

And yet Schoenberg's post-tonal music struck many listeners as pure artifice rather than an example of natural evolution. (Let's set aside, for our purposes, the larger fact that all art, and indeed all human communication, is artifice.) Just as *Finnegans Wake* and its epigones appeal to a small percentage of literary specialists and aficionados, atonality and serialism continue to fascinate some practitioners of the art of music and a small fragment of the public. But for the public at large they have proven to be an evolutionary dead end. I, as a musically trained person, can look at the printed scores of atonal or dodecaphonic works by Schoenberg and others and appreciate their appeal, and I can listen to those works while I follow the scores or after having studied them, and hear the brilliance of the writing. But Schoenberg, like most other composers before and since, did not want to write music only for those who could read it. He wanted his music to be heard and enjoyed by the same people who listen to and enjoy Bach, Beethoven, and Brahms, whether or not they can read a musical score. For the most part, this has not happened.

I touched upon this issue in the previous chapter, in discussing Schoenberg's Violin Concerto and Hilary Hahn's magnificent recording of it, which she made after having whittled away at the concerto's technical and musical problems over a two-year period. In parallel, I, who have devoted much of my life to trying to understand music and musicians, required multiple listenings and much

score-study to get through (perhaps) to the essence of some of that score and to several of Schoenberg's other compositions, and to grasp and appreciate and enjoy them. Can casual music lovers, then, legitimately be criticized for finding his music off-putting and for not having the ability and/or the time and/or the desire to make the necessary effort to approach his works? And let's not forget that Schoenberg himself was of two minds on the subject. On the one hand, we have his previously quoted statement of contempt for popular taste: "Art is from the outset naturally not for the people."[5] And on the other, we scratch our heads in wonderment at his declaration, in a letter to the conductor Hans Rosbaud: "I, however, wish nothing more ardently, if I wish anything at all, than that people would look upon me as a better version of Tchaikovsky—a little better, for God's sake, but that is really all I ask for. Or at most, that people would know and whistle my melodies."[6] Again: this hasn't happened, and it seems unlikely to happen in the future.

But what is the attitude of present-day composers to Schoenberg's system? A reading of the Preface to the second English-language edition (1959) of Stuckenschmidt's *Arnold Schoenberg*, a biography, is in some ways comparable to picking up a shard from an archaeological excavation: it seems to belong to a bygone age. Stuckenschmidt, a former Schoenberg pupil, wrote that the "elements in [Schoenberg's] music which break new ground and those which create form have increased in power year by year," and that the "most recent European school of composition [. . .] would neither exist nor be thinkable without Schoenberg's work."[7] Even as late as the mid-1970s, Josef Rufer, another former Schoenberg disciple, was able to declare that his teacher's self-prophecy had been correct: "Today, after more than fifty years, the entire musical world knows how right he was with this prediction: this concept of composition

with twelve notes has become the central moving force, the unceasing and still operative impulse of twentieth-century music."[8]

To say that this is no longer the case is to understate entirely the current situation in European music and its myriad worldwide progeny. Today, composers can and do choose among a multiplicity of musical idioms: serialism and its offshoots, of course, but also minimalism and its epigones, fusions among the "musics" of various cultures, neoclassical and neo-romantic musical languages, post-Cagean experimentation, mixtures of classical music with rock or pop or folk or jazz genres that in themselves are greatly varied (think, for instance, of the "Schoenbergian" jazzman Ornette Coleman as opposed to the "traditional" Louis Armstrong), combinations of any of the above, plus much else. The array of possibilities seems exciting, but no one—not the individual composers, not the performers, not the academics and critics and other professional observers, and certainly not casually curious members of the public—can keep up with all of the constantly expanding modes of musical expression. This rich but discombobulating plethora of sound-worlds has left much of the public either reeling in confusion or giving up altogether on the art music of the late twentieth and early twenty-first centuries.

Is Arnold Schoenberg to blame for the mess in the musical world? That certainly wasn't his intention, and the breakdown in traditional tonality was in any case beginning to happen in the post-Wagnerian German musical world of his youth. Schoenberg truly believed that his twelve-tone system would become as natural to our ears as music written in C major or any other key; he persuaded himself that he was taking German art music (and therefore, from his perspective, European art music in general) one step farther along its natural evolutionary path. Nor was he alone: for more than

fifty years after the appearance in print of his first partly or wholly dodecaphonic compositions, a large number of European and European-influenced creative musicians, especially in the Americas, either believed what Schoenberg had believed or persuaded themselves that if they ignored serialism they would not be taken seriously. Even Stravinsky, who had for decades rejected serialism, and who outlived Schoenberg by twenty years, became fascinated by the still relatively new technique during the last phase of his career, and wrote some of the most compelling works in the genre when he was in his seventies and eighties. For many younger musicians, like Pierre Boulez in his blow-up-the-opera-houses early phase, any composer who did not adopt some form of serialism would automatically end up on the trash-heap of music history.

Something similar happened in the visual arts: from the mid-twentieth century onward, painters and sculptors who did not adopt some form or other of abstraction were either viewed with contempt or simply ignored by many of their colleagues and by large swaths of the critical confraternity. Tellingly, however, this did not happen in the realm of literature, probably because reading a book requires much more time than looking superficially at a painting or listening once to a piece of music.

There were, of course, dissenters, among musicians as among practitioners of the visual arts. Take, for instance, the Swiss conductor Ernest Ansermet (1883–1969), who had given pioneering performances of works by many of the avant-garde composers of his generation, including not only the likes of Bartók, Hindemith, and Stravinsky but also members of Schoenberg's "school." In addition, he had been among the first European musicians to predict, in 1919, that through jazz and its offshoots Black American musicians would open "a highway that the world may rush down tomorrow."[9]

In 1961, Ansermet published a two-volume anti-atonal and anti-twelve-tone thesis, *Les fondements de la musique dans la conscience humaine* (Music's Basis in Human Consciousness), derived from his training as a mathematician and from his studies of phenomenology; the tract explained Ansermet's belief that only a phenomenological approach to auditory consciousness can provide a real understanding of what he called the "phenomenon of music," and he concluded that serialism and even atonality were aberrations. At the time, he was reviled as a traitor to The New, an arch-conservative, or simply an old fogey who would take his rightful place on the abovementioned trash-heap. In more recent times, however, his ideas regarding what the human ear and brain can and cannot make sense of have received some serious attention.[10]

I refer to this tale not to support Ansermet's thesis (most of which I don't understand, as a result of my insouciance, during my school-days, toward subjects mathematical), but rather to illustrate the contempt shown by many serialists, through most of the second half of the twentieth century, toward all a-serialists or anti-serialists or anyone else who opposed their way of thinking. I recall attending a new music event in Toronto, circa 1970, during which a not-well-known middle-aged composer referred to the works of Shostakovich—all of them tonal—as "floor washers' music." His comment was welcomed with cheers and applause and no audible dissent.

A subtler but more cutting attack appeared in a 1958 article in *High Fidelity*, a magazine that at the time was widely read by music lovers in the United States and beyond. The American composer Milton Babbitt (1916–2011), the article's author, had given it the bland title, "The Composer as Specialist," but the magazine's editors had changed it to something much more provocative: "Who Cares If You Listen?" Babbitt later claimed that the transformed

headline was misleading, but his protest was somewhat disingenuous. In essence, he had declared that natural musical evolution had led to serialism; if average listeners liked to hear only tunes that they could whistle (or so Babbitt contemptuously lumped together all those who disagreed with his point of view) and were not interested in new, advanced music, so much the worse for them. Composers would continue to compose whatever they wished and would survive by finding teaching positions in academia, as he had done. Babbitt wasn't opposed to having people listen to his music; he was, he said, simply doing his part to continue the evolution of Western art music, and if few people wanted to listen to post-tonal music the problem was theirs, not his.

It's true that many, perhaps most, of the best-remembered composers of the past also taught music, but there is a vast difference between former times, when Mozart and Beethoven, for instance, gave piano lessons to their wealthy patrons or their patrons' children, and more recent developments. Schoenberg, as we have seen, survived *mostly* on income from teaching, because his compositions did not "sell" abundantly enough to allow him to survive by them alone. With the wonderful gift of hindsight, we can see that his dilemma, and its solution, seemed to initiate a trend. By Babbitt's day, many composers were depending on regular salaries, often in tenured positions, in a variety of institutions of higher learning; this allowed them to compose in their free time—sometimes during sabbaticals and/or with the support of foundation grants—while being reasonably sure that they would be able to provide food, shelter, and clothing for themselves and their families without having to depend on the proliferation of their music. Such secure positions are fewer and farther between today than they were in the latter half of the twentieth century, and yet many aspiring composers

EPILOGUE: WHAT NOW? | 211

continue to look upon conservatories, colleges, and universities as lifeboats in a sea of musical uncertainty. Their compositions bring them little or no income—many composers even have to pay to have their works published or recorded—whereas Mozart, Beethoven, and many other composers of the past—including hordes of now-forgotten composers—survived mainly by performing their own music or by selling it to publishers. When opera house impresarios complimented Verdi on the beauty of his latest opera, he usually replied by asking about the box-office receipts: he didn't need others to tell him whether his works were good or bad; he wanted to know whether those works were attracting substantial numbers of ticket-buyers—because if people stopped going to hear his operas he wouldn't be offered contracts to write others, and his main source of income would dry up.

I wish to be clear: There is nothing immoral, illegitimate, or even ill-conceived about composers trying to survive economically through teaching or other reasonable means. I have composer friends who have resorted to tenured teaching positions for their survival, and had I had a talent for composing I probably would have done the same. As the world of classical music is presently set up, teaching is the only path open to many people in the field. But let's at least admit the possibility that job security can, and sometimes does, lead to a state of affairs along the lines of Babbitt's who-cares-if-you-listen? attitude, or at least to an attitude of resignation on the part of some creative musicians. And let's also admit the possibility that this factor has contributed to the rift between creative musicians and their potential audiences.

Nor is the split only between composers and the public. I knew a young conductor who had a fine musical memory—not a visual, photographic memory, but an aural memory. You could wake him

up in the middle of the night and ask, "What's the second theme of the finale of Mendelssohn's 'Scottish' Symphony?"—or any theme in a hundred other repertoire pieces—and he would sing it for you and then go back to sleep. On one occasion, he studied Webern's atonal Five Pieces for Orchestra, Op. 10, for a conducting competition offered by a European orchestra; the piece fascinated him, he enjoyed learning it, enjoyed even more rehearsing it with the orchestra in question, and was thrilled afterward when the concertmaster told him that this was the best his ensemble had played the work since Boulez had performed it with them. Not more than two or three years later, this conductor was driving somewhere in his car and, upon turning on the car's radio, found himself listening to the middle of what was clearly an atonal orchestral work that he couldn't identify. Imagine his shock—and his feeling of shame—when, at the end, an announcer identified the composition as Webern's Five Pieces for Orchestra, Op. 10.

Now, if a musician with a fine aural memory—a musician who had studied these pieces thoroughly, liked them, and conducted them himself—could not remember their actual *sound*, is it fair to criticize non-professional listeners who enjoy Bach and Mozart and maybe even Stravinsky and Bartók but who do not want to hear music that, as a result of the lack of a tonal center, leaves no strong, lasting impression on them? Many of them find atonal and twelve-tone music not so much incomprehensible as unlovable—and this is the crux of the crisis provoked by Schoenberg, his disciples, and the generations of musicians who followed along their path. Those artists' post-tonal music continues to be admired by many music professionals and even by some non-professionals, but the public at large doesn't want to hear it. Some of us musically trained folks would rather hear a good performance of *Wozzeck* or *Lulu* than a

comparably good performance of *Carmen* or *Tosca*, but major opera companies' attendance records demonstrate that "some of us" are a small minority.

Here, though, we run into an aesthetic dilemma. In a previous book, I quoted the Italian conductor Gianandrea Gavazzeni on the issue of what makes some pieces of music endure and others fall by the wayside. The question isn't one of "good" or "bad" music, Gavazzeni said, but rather of which works have the "life force"— *élan vital*—and which do not. Thus *Pagliacci*, for instance, may not be "great" music, but it is bursting with life and has survived the test of time, whereas some more brilliantly constructed works may lack vitality and have therefore been forgotten.

With Schoenberg, however, the problem is a different one: The two chamber symphonies, *Pierrot Lunaire*, the various piano pieces, *Moses und Aron*, the Violin Concerto, the Piano Concerto, the String Trio, and many of his other compositions are absolutely chock-a-block with life and character and are marked with artistic integrity and individuality; they seem almost to demand to be heard. The difficulty, once again, lies in the *sound*, in the musical language itself. Schoenberg's post-tonal musical structures tend to be fascinatingly inventive takes on traditional forms, but his sound-language has alienated and continues to alienate the majority of listeners. It is foreign to their senses; they can't decipher its emotional content, thus it remains, to most twenty-first-century listeners, what it was to listeners in the twentieth: something arcane and best left to the specialists.

There is, of course, the question of basic musical education. Nearly a century ago, Richard Strauss wondered what "the majority of listeners" mean when they talk about the "enjoyment" of music; he believed that for most audience members, listening to music is "a purely sensual aural feast, unmitigated by any mental activity."

He deplored self-proclaimed music lovers, whom he considered presumptuous to believe that they understood music better than some obscure foreign language, and he suggested that the situation be remedied by making the study of music "an essential element of all higher education, at least to the extent of learning sufficient harmony and counterpoint for the appreciation of a Bach fugue and sufficient orchestration to understand fully the psychological and contrapuntal struggles in the third act of *Tristan*, or the structure and development of subjects in a movement of a Beethoven symphony."

I strongly agree with Strauss about the desirability of instruction in music as part of a standard educational program, but I just as strongly dissent on the matter of an untrained but musically sensitive person's capacity to grasp the deepest essence of a Bach fugue or *Tristan* or a Beethoven symphony. Those of us, myself included, who did not grow up in musical families (unlike Strauss, whose father was a respected professional horn player and who received competent musical training from childhood onward) were initially attracted to great music specifically because something in its essence affected us deeply. Nor do I think that Bach, Wagner, or Beethoven would have agreed with Strauss on this subject: with few exceptions, they wanted their works to touch anyone who was receptive to the language of music as that language existed in their milieus. And so did Schoenberg! As mentioned elsewhere in this book, he did not want concertgoers to be concerned with tone rows and the like, because, he said, "this leads only to what I always fought against: the realization of how it was done, while I always aimed for the recognition of what it is!"[11] He wanted people to listen to his music for its intrinsic expressive value, without having to think about how it was put together.

Just as most of us who use computers, cell phones, cars, and

EPILOGUE: WHAT NOW? | 215

household appliances expect those objects to do what we want them to do without our having to spend the time necessary to learn how they actually function, so most people who listen to music expect it to affect them, or at least hope that it will affect them, without their having to understand its internal workings. This is perfectly reasonable. The problem with post-tonal music is that it has not created this effect (or affect) in most listeners and does not seem likely to do so in the future. For the time being, at least, it must be considered a cultural artifact.

So . . . now what? Most of the *post*-post-tonal music that I have heard—and I have listened to a lot of it, and continue to do so—reminds me of the Italian expression, *lascia il tempo che trova*, which means, more or less, that it lasts the amount of time that it occupies, and no more. It doesn't stick. I would be delighted to believe that I react this way because I am a septuagenarian and unreceptive to the new, but I hear similar reactions from people—musicians as well as casual listeners—one-half or one-third my age. And the result is that most new pieces of art music are performed once or a few times, in some cases preceded by great fanfare, and then disappear from circulation. This was also the case one and two centuries ago, and yet there is no counterbalance today—nothing like the widespread enthusiasm, a hundred years ago, for the new works engendered by Diaghilev's Ballets-Russes or for the latest operas of Puccini and Richard Strauss, and no equivalent of the Europe-wide "Rossini Fever" of the 1820s. Those works were not—as some have falsely claimed—the popular music of their day, but they were enjoyed and loved by enough people to allow composers at least the hope that other complex, highly accomplished works would find similar, and similarly enduring, love. This is not happening today, nor has it been happening in many, many decades.

There are cycles in the arts. Perhaps we have reached the end of one great, centuries-long cycle of individualistic European art music and its global offshoots. We cannot know. But, in the unlikely case that the subspecies *Homo sapiens sapiens* doesn't destroy itself in the meantime, there is good reason to expect that sooner or later a new cycle will begin. And for now, we have an enormous treasure of outstanding creations that continue to speak to anyone who is willing to listen to them.

———

I SAID, IN THE PROLOGUE TO THIS BOOK, THAT I HAVE NEVER BEEN either a Schoenbergian or an anti-Schoenbergian. Now that I am completing this project, I confess that on days during which I had spent many hours with Schoenberg's music I often needed to listen to some Mozart in the evening, as a sort of head-clearing operation. And yet, in studying, listening repeatedly to, and generally paying much closer attention to his compositions than I had previously done, I found that increased familiarity brought me closer to the Schoenbergians than to their opponents. To my tastes—which, like most other people's, are in many ways severely limited—some of his early works seem emotionally (and instrumentally) overblown; some of his attempts at depicting psychological or philosophical concepts in his large, atonal musical canvases seem wrongheaded; and some of his twelve-tone works seem doomed to remain outliers as far as the general public for Western classical music is concerned, for the simple reason that they *do* require repeated hearings and a great deal of focus, which most listeners haven't the time or the desire to dedicate to them. And yet within each segment of his oeuvre and from each of his periods—tonal, atonal, and serial—there are gems that deserve the attention of any serious music lover.

EPILOGUE: WHAT NOW? | 217

I doubt that I can provide a better ending for this book than by re-quoting the two sentences that serve as its motto, and that were drawn from a letter that Schoenberg had sent to someone who was showing signs of interest in him and his music:

"You can see it isn't easy to get on with me. But don't lose heart because of that."

Acknowledgments

My grateful thanks go to the following:

Dr. Therese Muxender and Dr. Angelika Möser of the Arnold Schönberg Center, Vienna, for answering my questions on many "Schoenbergian" issues and for granting permission to use of all the images that are reproduced in this book. I also thank Dr. Ulrich Krämer of the Arnold Schönberg Gesamtausgabe, Berlin, for his explanations regarding *Die Jakobsleiter*; Prof. Deborah Burton of Boston University, for her suggestions regarding my very basic explanation of the twelve-tone system; my friends Jeffrey Karp and Jeffrey Siegel for reading my chapter drafts and offering useful suggestions; my son, Julian Sachs, for putting up with my pitiful computer-related whining; both Julian and my daughter, Lyuba Sachs, for putting up with me in general; and Michelle Beacham and Libby Rice, archivists of, respectively, the Los Angeles Philharmonic Association and the London Symphony Orchestra, for providing programming information.

I offer my thanks also to my excellent editor, Robert Weil, at

Liveright, and his equally excellent assistant, Haley Bracken, as well as to my wonderful literary agent, Denise Shannon.

Most of all, I thank my partner, Eve Wolf, for having persuaded me to take on this project and for having encouraged me all along the way. She is not to blame, however, for any defects in the finished product.

Notes

PROLOGUE: A WARNING

1. H. Hahn, pp. 4 and 5 in the liner notes for her recording of the Schoenberg and Sibelius violin concerti (with the Swedish Radio Orchestra conducted by Esa-Pekka Salonen); Deutsche Grammophon CD B0010858-02, recorded in 2007 and published in 2008.

I. A BOY FROM MATZAH ISLAND

1. Ivar Oxaal et al. (eds.), *Jews, Antisemitism and Culture in Vienna* (Abingdon, UK: Routledge 1987).
2. George E. Berkley, *Vienna and Its Jews: The Tragedy of Success, 1880s–1980s* (Cambridge, MA: Abt Books 1988), pp. 34–35.
3. Cited in Allen Shawn, *Arnold Schoenberg's Journey* (New York: Farrar, Straus and Giroux, 2002), p. 7.
4. Stephen J. Cahn, "Schoenberg, the Viennese-Jewish Experience and Its Aftermath," in J. Shaw and J. Auner (eds.), *The Cambridge Companion to Schoenberg* (Cambridge: Cambridge University Press, 2010), p. 197.
5. In Urs Liska and Olaf Wilhelmer, liner notes for CD set, *Arnold Schönberg: Sämtliche Lieder—Complete Songs* (Deutschland Radio Capriccio 7120, 2011), p. 15.
6. B. Bujić, *Arnold Schoenberg* (London and New York: Phaidon Press, 2011), p. 18. See also Cahn, "Schoenberg, the Viennese-Jewish Experience and Its Aftermath," in Shaw and Auner, *Cambridge Companion to Schoenberg*, p. 198.
7. David Josef Bach, quoted in W. Reich, *Schoenberg: A Critical Biography* (New York and Washington: Praeger 1968), p. 4.
8. From A. Schoenberg, "My Evolution," an essay written in 1949, in Schoenberg's somewhat awkward English, but first published in Spanish translation in *Nuestra*

222 | NOTES

Musica (Mexico), then delivered as a lecture by Schoenberg at Royce Hall, University of California at Los Angeles, and finally published in the American *Musical Quarterly* in 1952. It is quoted here and at other points in this book from a reprint in *Musical Quarterly*, vol. 75, no. 4 (Winter 1991), pp. 144–57.

9. Liska and Wilhelmer, *Arnold Schönberg: Sämtliche Lieder*, p. 16.
10. Schoenberg, "My Evolution."
11. Schoenberg, "My Evolution."
12. Schoenberg, "My Evolution."
13. Schoenberg, "My Evolution."
14. Reich, *Schoenberg,* pp. 4–5.
15. Cited in Liska and Wilhelmer, *Arnold Schönberg: Sämtliche Lieder*, p. 17.
16. Dennis Gerlach, "Zwei Gesänge [etc.]," in Arnold Schönberg Center, https://www.schoenberg.at/index.php/en/joomla-license-3/zwei-gesaenge-fuer-eine-baritonstimme-und-klavier-op-1-1898.
17. Mark Berry, *Arnold Schoenberg* (London: Reaktion Books, 2019), p. 46.
18. Cahn, "Schoenberg, the Viennese-Jewish Experience," pp. 202–3.
19. Schoenberg, "My Evolution."
20. Lona Truding, quoted in J. A. Smith, *Schoenberg and His Circle: A Viennese Portrait*, New York and London: Schirmer Books, 1986, p. 13.

II. FORMING THE BATTLE LINES

1. Arnold Schönberg Center, https://www.schoenberg.at/index.php/en/typography-2/brettl-lieder: "kleiner Gestalt, harten Gesichtszügen und dunkler Hautfarbe."
2. Shawn, *Arnold Schoenberg's Journey*, pp. 38 and 42.
3. Arnold Schönberg Center, "ein ganz großartiger, warmherziger Mensch"; letter of April 1, 1903, to Karl and Josephine Redlich.
4. Leonard Stein, https://www.laphil.com/musicdb/pieces/1909/gurrelieder.
5. Gertrud Kolisch Schoenberg in a Canadian Broadcasting Corporation radio interview by Glenn Gould (1962?), https://www.youtube.com/watch?v=Y_6b_oY5C20.
6. Cited in Reich, *Schoenberg*, p. 12.
7. P. Boulez, *Notes of an Apprenticeship* (New York, Alfred A. Knopf, 1968), p. 359.
8. See Frisch, *The Early Works of Arnold Schoenberg*, pp. 158 *et seq.*
9. Arnold Schönberg Center, "Biography—1900–1904."
10. Reich, *Schoenberg*, p. 13.
11. H. de la Grange, G. Weiss, K. Martner, and A. Beaumont (eds.), *Gustav Mahler: Letters to His Wife* (London: Faber and Faber, 2004), p. 193.
12. A. Mahler (D. Mitchell, ed.), *Gustav Mahler: Memories and Letters* (New York: Viking Press 1969), p. 78.
13. A. Mahler, *Gustav Mahler*, p. 198.
14. Wellesz, quoted in Reich, *Schoenberg*, p. 25.
15. E. Wellesz, *Arnold Schönberg* (New York: Da Capo, 1969), p. 20.
16. Reich, *Schoenberg*, p. 27.
17. H. H. Stuckenschmidt, *Schoenberg* (New York: Grove Press, 1959), p. 77.
18. Wellesz, *Arnold Schönberg,* p. 21.
19. Berry, *Arnold Schoenberg*, p. 46.

NOTES | 223

20. Berry, *Arnold Schoenberg.*
21. Quoted in S. Lehmann and M. Faber, *Rudolf Serkin: A Life* (Oxford and New York: Oxford University Press, 2003), p. 34.
22. Schoenberg, "Notes to My Four String Quartets," Arnold Schönberg Center.
23. Reich, *Schoenberg,* p. 30.
24. A. Mahler, *Gustav Mahler,* p. 112.
25. Boulez, *Notes of an Apprenticeship,* p. 360.
26. I. Stravinsky and R. Craft, *Dialogues and a Diary* (London: Faber, 1961), p. 106n.
27. Schoenberg, "My Evolution," emphasis added.
28. Schoenberg, "My Evolution."
29. Coffer, *Richard Gerstl,* www.richardgerstl.com.
30. A. Beaumont, *Zemlinsky* (London: Faber & Faber, 2000), p. 166.
31. Coffer, *Richard Gerstl,* www.richardgerstl.com.
32. Unpublished letter from Schoenberg to Alma Mahler, November 16, 1910, quoted in Beaumont, *Zemlinsky,* p. 323.
33. Schoenberg letter. to Hermann Scherchen, June 23, 1923, in E. Stein (ed.), *Arnold Schoenberg: Letters* (London: Faber & Faber, 1964), p. 96.
34. Schoenberg, "My Evolution."
35. Schoenberg, "My Evolution."
36. Quoted by Michael Stegemann in his notes (trans. Stewart Spencer) to the LaSalle Quartet's recording of the complete string quartets of Schoenberg, Berg, Webern, and Zemlinsky, Deutsche Grammophon six-CD set 00289 479 1976, 2013.
37. M. MacDonald, *Schoenberg* (Oxford, New York: Oxford University Press, 2008), p. 2.
38. Reich, *Schoenberg,* p. 36.
39. Bujić, *Arnold Schoenberg,* pp. 63–64.
40. Bujić, *Arnold Schoenberg.*
41. A. Schoenberg, *Theory of Harmony* (Berkeley: University of California Press, 1978), p. 432.
42. P. Lansky and G. Perle, "Atonality," in *The New Grove Dictionary of Music and Musicians* (S. Sadie, ed., London: Macmillan, 1980), vol. 1, pp. 669–73.
43. Arnold Schönberg Center, http://www.schoenberg.at/index.php/en/joomla -license-3/15-gedichte-aus-rdas-buch-der-haengenden-gaertenl-op-15-1908 -1909.
44. "Saget mir, auf welchem plade / Heute sie vorüberschreite— / Dass ich aus der reichsten lade / Zarte seidenweben hole, / Rose pflücke und viole, / Dass ich meine wange breite, / Schemel unter ihrer sohle."
45. Stuckenschmidt, *Arnold Schoenberg,* p. 45.
46. Schoenberg, "My Evolution."
47. Ethan Haimo, "The Rise and Fall of Radical Athematicism," in Jennifer Shaw and Joseph Auner (eds.), *Cambridge Companion to Schoenberg,* p. 94.
48. Arnold Schönberg Center, http://www.schoenberg.at/index.php/en/joomla -license-3/fuenf-orchesterstuecke-op-16-1909rev-1922.
49. Boulez, *Notes of an Apprenticeship,* p. 363.
50. Arnold Schönberg Center, http://www.schoenberg.at/index.php/en/joomla-license -3/fuenf-orchesterstuecke-op-16-1909rev-1922.
51. MacDonald, *Schoenberg,* p. 10.

224 | NOTES

52. Arnold Schönberg Center, http://www.schoenberg.at/index.php/en/joomla-license
-3/rerwartungl-op-17-1909.
53. Undated letter cited by Bryan R. Simms in "Whose Idea Was *Erwartung?*," in
J. Brand and C. Hailey (eds.), *Constructive Dissonance: Arnold Schoenberg and the
Transformations of Twentieth-Century Culture* (Berkeley: University of California
Press, 1997), p. 100. http://ark.cdlib.org/ark:/13030/ft52900620/.
54. Boulez, *Notes of an Apprenticeship*, p. 365.
55. Quoted by Elizabeth I. Keathley in "Interpreting *Erwartung*," in Shaw and
Auner, *Cambridge Companion to Schoenberg*, p. 82.
56. Simms, "Whose Idea Was *Erwartung?*," in Brand and Hailey, *Constructive Dis-
sonance*, p. 103.
57. Schoenberg letter of February 14, 1910, in E. Stein (ed.), *Arnold Schoenberg: Let-
ters*, pp. 24–25.
58. Schoenberg letter of November 21, 1913, in Stein, *Arnold Schoenberg: Letters,* p. 42.
59. Bujić, *Arnold Schoenberg*, p. 75.
60. Bujić, *Arnold Schoenberg*, p. 75.
61. Schoenberg, *Theory of Harmony*, p. 1.
62. Schoenberg, *Theory of Harmony*, p. 433.
63. A. Ross, *The Rest Is Noise* (New York: Farrar, Straus and Giroux, 2007), p. 64.
64. G. Adler letter to AS, September 3, 1912, in E. Ennulat (ed.), *Arnold Schoenberg
Correspondence* (Metuchen, NJ, and London: Scarecrow Press, 1991), pp. 92–93.
65. Boulez, *Notes of an Apprenticeship*, p. 365.
66. Quoted in Smith, *Schoenberg and His Circle*, p. 174.
67. Stein, *Arnold Schoenberg: Letters*, p. 297.
68. "*Stadt der Lieder von umgebrachten Künstler,*" in a letter to Guido Adler, in
Ennulat, *Schoenberg Correspondence*, pp. 90–91.
69. J. Brand, C. Hailey, and D. Harris, *The Berg-Schoenberg Correspondence: Selected
Letters* (New York and London: W. W. Norton, 1987), pp. 12–13.
70. Reich, *Schoenberg*, p. 60.
71. Ennulat, *Schoenberg Correspondence*, p. 87.
72. Stein, *Arnold Schoenberg: Letters*, p. 33.

III. WAR, INTERNAL AND EXTERNAL

1. Entry on Albertine Zehme, https://www.leipzig.de/jugend-familie-und-soziales/
frauen/1000-jahre-leipzig-100-frauenportraets/detailseite-frauenportraets/
projekt/zehme-albertine-geborene-aman.
2. MacDonald, *Schoenberg*, p. 18.
3. Boulez, *Notes of an Apprenticeship*, pp. 365–67.
4. Boulez, *Notes of an Apprenticeship*.
5. Stuckenschmidt, *Arnold Schoenberg*, pp. 61–62.
6. G. Adler letter to Schoenberg, March 9, 1913, in Ennulat, *Schoenberg Correspon-
dence,* pp. 98–99.
7. S. Walsh, *Stravinsky: A Creative Spring* (New York: Knopf, 1999), p. 189.
8. Stravinsky and Craft, *Dialogues and a Diary*, pp. 104–5.
9. I. Stravinsky and R. Craft, *Expositions and Developments* (London: Faber, 1961),
p. 78.

NOTES | 225

10. S. Walsh, *Debussy: A Painter in Sound* (New York: Knopf, 2018), pp. 243–44.

11. Walsh, *Stravinsky*, p. 190.

12. Cited in Reich, *Schoenberg*, p. 63, from *Kleine Journal*, Berlin, February 26, 1912.

13. Schoenberg letter to "Herr Dr. K.", April 28, 1913, in Stein, *Arnold Schoenberg: Letters*, p. 39.

14. Shaw and Auner, *Cambridge Companion to Schoenberg*, p. 2.

15. J. Rufer, "Hommage à Schoenberg," in *Arnold Schoenberg. Berliner Tagebuch*, Frankfurf a.M. etc., Propyläen, 1974, translated in E. M. Ennulat, *Schoenberg Correspondence*, pp. 15–16.

16. Wellesz, *Arnold Schönberg,* pp. 34–35.

17. Nuria Schoenberg Nono, interviewed by Wolfgang Schaufler in the Universal Edition's publication, *Musiksalon*; https://musiksalon.universaledition.com/en/article/he-knew-who-he-was, n.d.

18. Ernest Newman, "The Case of Arnold Schoenberg," *The Nation*, September 7, 1912, p. 830.

19. Reprinted in Wellesz, *Arnold Schönberg*, p. 18.

20. Brand et al., *The Berg-Schoenberg Correspondence*, pp. 202–3.

21. Cited in MacDonald, *Schoenberg*, p. 21, from a contribution from Schoenberg to *Homage to Henry Wood, a World Symposium* (L.P.O. Booklets No. 1, London, 1944, Miron Grindea, ed.).

22. Letter of Schoenberg to A. Nikisch, January 31, 1914, in Stein, *Arnold Schoenberg: Letters*, p. 45.

23. A. Schoenberg letter, October 1914, to A. Zemlinsky, quoted in MacDonald, *Schoenberg*, p. 55.

24. A. Schoenberg letter in the Mahler-Werfel Papers, University of Pennsylvania, cited by Ross, *The Rest Is Noise*, p. 72.

25. MacDonald, *Schoenberg*, p. 55.

26. Quoted in H. Deichmann (ed.), *Leben mit provisorischer Genehmigung* (Berlin: Guthmann-Petersen, 1988), pp. 110–11.

27. Wellesz, *Arnold Schönberg*, p. 76.

28. Quoted in Deichmann, *Leben mit provisorischer Genehmigung*, p. 112.

29. Lehmann and Faber, *Rudolf Serkin: A Life*, pp. 36–37.

30. Arnold Schönberg Center, http://www.schoenberg.at/index.php/en/schoenberg-2/biographie.

31. Reich, *Schoenberg*, p. 123.

32. Smith, *Schoenberg and His Circle*, pp. 90–91.

33. K. Popper, *Unended Quest: An Intellectual Autobiography* (LaSalle, IL: Open Court, 1976), p. 54; quoted in Smith, *Schoenberg and His Circle*, pp. 85–86.

34. Reich, *Schoenberg*, p. 126.

35. Reich, *Schoenberg*, p. 126.

36. Shaw and Auner, *Cambridge Companion to Schoenberg*, p. 9.

37. Schoenberg, *Theory of Harmony*, p. 433.

38. A. Strindberg, *Legends: Autobiographical Sketches*, mcallistereditions@gmail.com 2015, pp. 59, 61–62, 69, 71–73, 94.

39. H. de Balzac, *Séraphîta*, my translation of these excerpts.

40. Translation by Lionel Salter (1993), kindly provided by the Arnold Schönberg Center, Vienna.

226 | NOTES

41. Arnold Schönberg Center, http://www.schoenberg.at/index.php/en/schoenberg-2/biographie.
42. Arnold Schönberg Center, http://www.schoenberg.at/index.php/en/typography-2/die-jakobsleiter.
43. Rudolf Stephan, Preface to A. Schoenberg, *Die Jakobsleiter*, full score ([New York]: Belmont Music Publishers, 1980).
44. Stephan, Preface to A. Schoenberg, *Die Jakobsleiter.*
45. Ulrich Krämer, email to the author, March 8, 2022.
46. Sabine Feisst, *Schoenberg's New World: The American Years* (New York: Oxford University Press, 2011), pp. 111–12.
47. Schoenberg to Alban Berg, July 16, 2021, in Brand et al. (eds.), *The Berg-Schoenberg Correspondence*, p. 308.
48. Benjamin Ivry, "A Bauhausful of Antisemites," in *Forward*, November 10, 2009.
49. Schoenberg letter to Wassily Kandinsky, April 20, 1923, in Stein, *Arnold Schoenberg: Letters*, p. 88.
50. Schoenberg letter to W. Kandinsky, May 4, 1923, in Stein, *Arnold Schoenberg: Letters*, p. 89.

IV. BREAKTHROUGH AND BREAKAWAY

1. Rufer, "Hommage à Schoenberg," in Ennulat, *Schoenberg Correspondence*, p. 3.
2. A. Schoenberg, "Ich und die Hegemonie der Musik," unpublished manuscript in the Arnold Schönberg Center, quoted in Feisst, *Schoenberg's New World*, p. 38.
3. Smith, *Schoenberg and His Circle*, p. 90.
4. I. Stravinsky and R. Craft, *Themes and Episodes*, p. 176.
5. Schoenberg letter to Nicholas Slonimsky, June 3, 1937, quoted in Reich, *Schoenberg*, p. 96.
6. Rufer, "Hommage à Schoenberg," p. 33.
7. Rufer, "Hommage à Schoenberg," p. 2.
8. Stein, *Arnold Schoenberg: Letters*, p. 103n.
9. Schoenberg, "My Evolution."
10. Schoenberg, "My Evolution."
11. Arnold Schönberg Center, http://www.schoenberg.at/index.php/en/joomla-license-3/serenade-op-24-1920-1923.
12. Richard Brooks, "The 'Other' Schoenberg," in *The SCI Newsletter*, Society of Composers, Inc., XLI/6, November-December 2011.
13. Smith, *Schoenberg and His Circle*, p. 175.
14. Arnold Schönberg Center, http://www.schoenberg.at/index.php/en/schoenberg-2/biographie.
15. A. Zemlinsky, "Einige Worte über das Studium von Schönbergs *Erwartung*," in *Pult und Taktstock*, IV, 1927, pp. 44–45, as cited in Beaumont, *Zemlinsky,* p. 323.
16. Schoenberg to Ingeborg Ruvina, November 22, 1948, in Stein, *Arnold Schoenberg: Letters*, p. 258.
17. F. Nicolodi, *Novecento in musica* (Milan: Il Saggiatore, 2018), pp. 57–58.
18. W. Reich, *Schoenberg*, pp. 153–54.
19. Smith, *Schoenberg and His Circle*, pp. 227–28.
20. Reich, *Schoenberg*, pp. 159–60.

NOTES | 227

21. Reich, *Schoenberg*, p. 160.
22. M. Lazar, "Schoenberg's Journey to His Roots," in the liner notes to Deutsche Grammophon's compact disc release of Schoenberg's *Moses und Aron*, DG 449 174-2, 1996.
23. C. Rosen, *Arnold Schoenberg* (Chicago and London: University of Chicago Press, 1996), p. 72.
24. T. Muxeneder, "Variationen für Orchester," Arnold Schönberg Center, http://www.schoenberg.at/index.php/en/joomla-license-sp-1943310036/variationen-fuer-orchester-op-31-1926-1928.
25. Muxeneder, "Variationen für Orchester."
26. Muxeneder, "Variationen für Orchester."
27. J. Auner, *A Schoenberg Reader* (New Haven: Yale University Press, 2003), p. 212.
28. "*Jonny spielt auf*," https://en.wikipedia.org/wiki/Jonny_spielt_auf (accessed March 15, 2022).
29. R. Strauss and H. von Hofmannsthal (H. Hammelmann and E. Osers, trans.), *A Working Friendship: The Correspondence between Richard Strauss and Hugo von Hofmannsthal* (New York: Random House, 1961), p. 168.
30. *Sunday Times*, London, February 11, 1962; cited in H. Sachs, *Rubinstein: A Life* (New York: Grove Press, 1995), p. 332.
31. Reich, *Schoenberg*, p. 187.
32. Bujić, *Arnold Schoenberg*, p. 162.
33. From *Anton Rubinsteins Gedenkenkorb* (Leipzig, 1897); cited in H. Sachs, *Virtuoso* (London and New York: Thames and Hudson, 1982), p. 65.
34. Arnold Schönberg Center, https://www.schoenberg.at/index.php/en/schoenberg-2/biographie.
35. Stein, *Arnold Schoenberg: Letters*, p. 190.
36. Schoenberg letter to Joseph Asch, May 24, 1932, in Stein, *Arnold Schoenberg: Letters*, pp. 163–64.

V. A CALIFORNIAN FINALE

1. *New York Times*, November 2, 1933, p. 19.
2. J. Eichler, "Revolutionary on Beacon Street," in the *Boston Globe*, November 1, 2009.
3. Schoenberg letter of October 3, 1934, in Stein, *Arnold Schoenberg: Letters*, p. 190.
4. Schoenberg letter of November 13, 1934, to Anton Webern, cited in Feisst, *Schoenberg's New World*, p. 49.
5. Schoenberg letter of October 1934, in Feisst, *Schoenberg's New World*, p. 192.
6. Arnold Schönberg Center, https://www.schoenberg.at/index.php/en/the-news-2/suite-im-alten-stile.
7. Feisst, *Schoenberg's New World*, pp. 205–8.
8. Schoenberg to Alma Mahler-Werfel, January 23, 1936, in Stein, *Arnold Schoenberg: Letters*, p. 197.
9. W. H. Rubsamen, "Schoenberg in America," in *Musical Quarterly*, October 1951, cited in W. Reich, *Schoenberg*, p. 199.
10. Schoenberg letter to Ernest Hutcheson, March 28, 1935, in Stein, *Arnold Schoenberg: Letters*, p. 193.

NOTES

11. Schoenberg letter to Ernst Krenek, December 1, 1939, in Stein, *Arnold Schoenberg: Letters*, p. 210.

12. Feisst, *Schoenberg's New World*, p. 209.

13. Wolfgang Schaufler, "He Knew Who He Was," interview with Nuria Schoenberg Nono.

14. Robert von Bernewitz, "Nuria Schoenberg Nono Reminisces about a Life in Music with Her Father Arnold Schoenberg and Her Husband Luigi Nono," July 6, 2016, https://musicguy247.typepad.com/my-blog/2016/07/nuria-schoenberg-nono-reminisces-about-arnold-schoenberg-and-luigi-nono-interview-12-tone-classical-music-avant-garde-atonal.html.

15. Feisst, *Schoenberg's New World*, p. 44.

16. Sabine Feisst, "Schoenberg Reception in America, 1933–51," in Shaw and Auner, *Cambridge Companion to Schoenberg*, p. 257.

17. Cited in Feisst, *Schoenberg's New World,* p. 56.

18. Stravinsky and Craft, *Themes and Episodes*, p. 176.

19. Schoenberg letter to Elizabeth Sprague Coolidge, August 3, 1936, in Stein, *Arnold Schoenberg: Letters*, p. 200.

20. Schaufler, "He Knew Who He Was."

21. Robert von Bernewitz, "Nuria Schoenberg Nono Reminisces."

22. Bernewitz, "Nuria Schoenberg Nono Reminisces," and Schaufler, "He Knew Who He Was."

23. W. H. Rubsamen, in Reich, *Schoenberg*, p. 203.

24. Schoenberg letter to Otto Klemperer, September 25, 1940, in Stein, *Arnold Schoenberg: Letters*, p. 211.

25. Schaufler, "He Knew Who He Was."

26. Richard Brooks, "The 'Other' Schoenberg," in *The SCI [Society of Composer, Inc.] Newsletter*, XLI/6, November-December 2011, pp. 1 and 4.

27. Schaufler, "He Knew Who He Was."

28. Schoenberg letter to Hermann Scherchen, March 16, 1936, in Stein, *Arnold Schoenberg: Letters*, p. 198.

29. Arnold Schönberg Center, https://www.schoenberg.at/index.php/en/joomla-license-sp-1943310036/kammersymphonie-nr-2-op-38-a-38b-1906-1939.

30. MacDonald, *Schoenberg,* p. 193.

31. Stein, *Arnold Schoenberg: Letters*, pp. 276–77.

32. Arnold Schönberg Center, https://www.schoenberg.at/index.php/en/joomla-license-sp-1943310036/ode-to-napoleon-op-41-1942.

33. Schoenberg letter to René Leibowitz, July 4, 1947, Stein, *Arnold Schoenberg: Letters,* p. 248.

34. Arnold Schönberg Center, https://www.schoenberg.at/index.php/en/joomla-license-sp-1943310036/ode-to-napoleon-op-41-1942.

35. "Note by Leonard Stein," LA Phil, https://www.laphil.com/musicdb/pieces/2517/ode-to-napoleon.

36. F. Werfel, letter to Arthur Rubinstein, August 11, 1944; cited in Sachs, *Rubinstein: A Life*, p. 282.

37. A. Rubinstein, *My Many Years*, p. 493.

38. M. Mann, letter to Arthur Rubinstein, November 21, 1973; cited in Sachs, *Rubinstein: A Life*, p. 282.

39. Feisst, *Schoenberg's New World*, p. 6.
40. Stravinsky and Craft, *Dialogues and a Diary*, p. 106.
41. Reich, *Schoenberg*, p. 219.
42. Feisst, *Schoenberg's New World*, pp. 78–79.
43. MacDonald, *Schoenberg,* p. 84.
44. Stravinsky and Craft, *Themes and Episodes*, p. 176.
45. Letter to the National Institute of Arts and Letters, May 22, 1947, Stein, *Arnold Schoenberg: Letters,* pp. 245–46.
46. Schoenberg letter to Kurt List, November 1, 1948, cited in https://www.schoenberg .at/index.php/en/joomla-license-sp-1943310036/a-survivor-from-warsaw-op-46 -1947.
47. Feisst, *Schoenberg's New World* , p. 66.
48. Stein, *Arnold Schoenberg: Letters,* p. 270.
49. Schaufler, "He Knew Who He Was."
50. Statements cited in "When Classical Music Was an Alibi," by Emily Richmond Pollock and Kira Thurman, in the *New York Times*, April 15, 2022.
51. Stein, *Arnold Schoenberg: Letters*, p. 271.
52. Stravinsky and Craft, *Themes and Episodes*, pp. 166–68.
53. Stein, *Arnold Schoenberg: Letters*, pp. 286–87.
54. Stravinsky and Craft, *Dialogues and a Diary*, p. 171.
55. G. Schoenberg letter to OSB, cited in D. Newlin, *Schoenberg Remembered: Diaries and Recollections, 1938–1976* (New York: Pendragon Press, 1980), p. 341.

EPILOGUE: WHAT NOW?

1. See Saul Bellow, "Mozart: An Overture," in *It All Adds Up* (New York: Viking Penguin, 1994), pp. 12 and 14.
2. See Hugo von Hofmannsthal, "A Letter," in *The Lord Chandos Letter and Other Writings* (trans. and ed. Joel Rotenberg; New York: New York Review Books, 2005), pp. 117–28.
3. Cynthia Ozick, "The Impossibility of Being Kafka," in *The New Yorker*, January 11, 1999.
4. Stuckenschmidt, *Schoenberg*, p. 49.
5. Auner, *A Schoenberg Reader*, p. 212.
6. Quoted by Rufer, "Hommage à Schoenberg," in Ennulat, *Schoenberg Correspondence*, p. 14.
7. Stuckenschmidt, *Arnold Schoenberg*, p. 13.
8. J. Rufer, "Hommage à Schoenberg," p. 2.
9. Cited in Ross, *The Rest Is Noise*, p. 139.
10. See *Les fondements de la musique dans la conscience humaine* (Neuchâtel: La Baconnière 1961). See also the online explanatory article, "Les fondements de la musique dans la conscience humaine," https://fr.wikipedia.org/wiki/Les_Fondements_ de_la_musique_dans_la_conscience_humaine (accessed November 15, 2021).
11. J. Rufer, "Hommage à Schoenberg," p. 33.

Bibliography

Ansermet, Ernest. *Les fondements de la musique dans la conscience humaine*. Neuchâtel: La Baconnière, 1961.

Arnold Schoenberg, 1874–1951: Una mostra interattiva multimediale. Venice: Marsilio, 1996.

Arnold Schönberg Center. https://www.schoenberg.at/index.php/de/ (or https://www.schoenberg.at/index.php/en/).

Auner, Joseph. *A Schoenberg Reader*. New Haven: Yale University Press, 2003.

Balzac, Honoré de. *Séraphîta*. North Haven, CT, 2022.

Beaumont, Antony. *Zemlinsky*. London: Faber and Faber, 2000.

Bernewitz, Robert von. "Nuria Schoenberg Nono Reminisces about a Life in Music with Her Father Arnold Schoenberg and Her Husband Luigi Nono." July 6, 2016. https://musicguy247.typepad.com/my-blog/2016/07/nuria-schoenberg-nono-reminisces-about-arnold-schoenberg-and-luigi-nono-interview-12-tone-classical-music-avant-garde-atonal.html.

Berkley, George E. *Vienna and Its Jews: The Tragedy of Success, 1880s–1980s*. Cambridge, MA: Abt Books, 1988.

Berry, Mark. *Arnold Schoenberg*. London: Reaktion Books, 2019.

Bischof, Günter, Fritz Plasser, and Eva Maltschnig (eds.). *Austrian Lives*. New Orleans: University of New Orleans Press, 2012.

Boulez, Pierre. *Notes of an Apprenticeship* (trans. Herbert Weinstock). New York: Alfred A. Knopf, 1968.

Brand, Juliane, Christopher Hailey, and Donald Harris. *The Berg-Schoenberg Correspondence: Selected Letters*. New York and London: W. W. Norton, 1987.

Brand, Juliane, and Christopher Hailey (eds.). *Constructive Dissonance: Arnold Schoenberg and the Transformations of Twentieth-Century Culture*. Berkeley: University of California Press, 1997, http://ark.cdlib.org/ark:/13030/ft52900620/.

Brinkmann, Reinhold, and Christoph Wolff (eds.). *Driven into Paradise: The Musical Migration from Nazi Germany to the United States*. Berkeley: University of California Press, 1999.

232 | BIBLIOGRAPHY

Bujić, Bojan. *Arnold Schoenberg.* London and New York: Phaidon Press, 2011.

Cahn, Stephen J., "Schoenberg, the Viennese-Jewish Experience and Its Aftermath." In Jennifer Shaw and Joseph Auner (eds.), *The Cambridge Companion to Schoenberg.* Cambridge: Cambridge University Press, 2010.

Coffer, Raymond. *Richard Gerstl (1883–1908).* www.richardgerstl.com.

Deichmann, Hans (ed.). *Leben mit provisorischer Genehmigung: Leben, Werk und Exil von Dr. Eugenie Schwarzwald (1872–1940).* Berlin and Vienna: Guthmann-Petersen, 1988.

De la Grange, Henry Louis, Günter Weiss, Knud Martner, and Antony Beaumont (eds.). *Gustav Mahler: Letters to his Wife.* London: Faber and Faber, 2004.

Ennulat, Egbert (ed.). *Arnold Schoenberg Correspondence.* Metuchen, NJ, and London: Scarecrow Press, 1991.

Feisst, Sabine. *Schoenberg's New World: The American Years.* New York: Oxford University Press, 2011.

Frisch, Walter. *The Early Works of Arnold Schoenberg, 1893–1908.* Berkeley: University of California Press, 1993.

Frisch, Walter (ed.). *Schoenberg and His World.* Princeton: Princeton University Press, 1999.

Gay, Peter. *Freud, A Life for Our Time.* New York and London: W. W. Norton, 1988.

Gay, Peter. *Schnitzler's Century: The Making of Middle-Class Culture, 1815–1914.* London: Allen Lane—The Penguin Press, 2001.

Gilliam, Bryan (ed.). *Music and Performance during the Weimar Republic.* Cambridge: Cambridge University Press, 1994.

Griffiths, Paul (ed.). *The Thames and Hudson Encyclopaedia of 20th-Century Music.* London and New York: Thames and Hudson, 1986.

Hahl-Koch, Jelena (ed.). *Arnold Schönberg, Wassily Kandinsky: Briefe, Bilder und Dokumente einer aussergewöhnlichen Begegnung.* Salzburg and Vienna: Residenz Verlag 1980.

Harrison, Thomas. *1910: The Emancipation of Dissonance.* Berkeley: University of California Press, 1996.

Hartog, Howard (ed.). *European Music in the Twentieth Century.* Harmondsworth, Middlesex: Penguin Books, 1961.

Heister, Hanns-Werner, Claudia Maurer Zenck, and Peter Petersen (eds.). *Musik im Exil: Folgen des Nazismus für die international Musikkultur.* Frankfurt am Main: Fischer, 1993.

Hofmannsthal, Hugo von (Joel Rotenberg, ed. and trans.). *The Lord Chandos Letter and Other Writings.* New York: New York Review Books, 2005.

Lehmann, Stephen, and Marion Faber. *Rudolf Serkin: A Life.* Oxford: Oxford University Press, 2003.

Liska, Urs, and Olaf Wilhelmer. *Arnold Schönberg: Sämtliche Lieder—Complete Songs,* liner notes. Deutschland Radio Capriccio 7120, 2011.

MacDonald, Malcolm. *Schoenberg.* Oxford, New York: Oxford University Press, 2008.

Mahler, Alma (Donald Mitchell, ed.). *Gustav Mahler: Memories and Letters.* New York: Viking Press, 1969.

Mann, Thomas. *Doktor Faustus* (trans. John E. Woods). New York: Alfred A. Knopf, 1997.

Neighbour, O. W. "Schoenberg [Schönberg], Arnold (Franz Walter)," entry in *The New Grove Dictionary of Music and Musicians* (S. Sadie, ed.). London: Macmillan, 1980.

BIBLIOGRAPHY | 233

Neue Wiener Schule: Alban Berg, Arnold Schönberg, Anton Webern. Musikfest Basel, 1973.

Newlin, Dika. *Schoenberg Remembered: Diaries and Recollections, 1938–1976.* New York: Pendragon Press, 1980.

Nicolodi, Fiamma. *Novecento in musica.* Milan: Il Saggiatore, 2018.

Oxaal, Ivar, et al. (eds.). *Jews, Antisemitism and Culture in Vienna.* Abingdon, UK: Routledge, 1987.

Payne, Anthony. *Schoenberg.* London: Oxford University Press, 1968.

Reich, Willi. *Schoenberg: A Critical Biography* (trans. Leo Black). New York: Praeger, 1971.

Restagno, Enzo. *Schönberg e Stravinsky: Storia di un'impossibile amicizia.* Milan: Il Saggiatore, 2014.

Rosen, Charles. *Arnold Schoenberg.* Chicago and London: University of Chicago Press, 1975.

Ross, Alex. *The Rest Is Noise.* New York: Farrar, Straus and Giroux, 2007.

Sachs, Harvey. *Music in Fascist Italy.* London: Weidenfeld & Nicolson, 1987.

Sachs, Harvey. *Rubinstein: A Life.* New York: Grove Press, 1995.

Sachs, Harvey. *Virtuoso.* London and New York: Thames and Hudson, 1982.

Schaufler, Wolfgang. "He Knew Who He Was." Interview with Nuria Schoenberg Nono. *Musiksalon*, https://musiksalon.universaledition.com/en/article/he-knew-who -he-was, n.d.

Schoenberg, Arnold. "My Evolution." *Musical Quarterly*, vol. 75, no. 4 (Winter 1991), pp. 144–57.

Schoenberg, Arnold. *Theory of Harmony.* Los Angeles and Berkeley: University of California Press, 1978.

Shaw, Jennifer, and Joseph Auner (eds.). *The Cambridge Companion to Schoenberg.* Cambridge: Cambridge University Press, 2010.

Shawn, Allen. *Arnold Schoenberg's Journey.* New York: Farrar, Straus and Giroux, 2002.

Stein, Erwin (ed.). *Arnold Schoenberg: Letters.* London: Faber & Faber, 1964.

Stravinsky, Igor, and Robert Craft. *Dialogues and a Diary.* London: Faber & Faber, 1961.

Stravinsky, Igor, and Robert Craft. *Expositions and Developments.* London: Faber & Faber, 1959.

Stravinsky, Igor, and Robert Craft. *Themes and Episodes.* New York: Alfred A. Knopf, 1967.

Strindberg, August. *Legends: Autobiographical Sketches* (trans.?). ?: McAllister Editions, 2015.

Stuckenschmidt, Hans Heinz (trans. Edith Temple Roberts and Humphrey Searle). *Arnold Schoenberg.* New York: Grove Press, 1959.

Viertel, Salka. *Das unbelehrbare Herz. Erinnerungen an ein Leben mit Künstlern des 20. Jahrhunderts.* Hamburg and Düsseldorf: Eichhorn Verlag, 1970.

Walsh, Stephen. *Debussy: A Painter in Sound.* New York: Knopf, 2018.

Walsh, Stephen. *Stravinsky: A Creative Spring.* New York: Knopf, 1999.

Wellesz, Egon. *Arnold Schönberg* (trans. W. H. Kerridge). New York: Da Capo Press, 1969 (reprint of London: J. M. Dent, 1925).

Wulf, Joseph. *Musik im Dritten Reich: Eine Dokumentation.* Frankfurt am Main: Ullstein/Zeitgeschichte, 1983.

Wynberg, Simon, et al. *Music in Exile: Émigré Composers of the 1930s.* Museum of Jewish Heritage, New York, and Royal Conservatory of Music, Toronto, 2008.

Index

Page numbers in *italics* refer to illustrations.

"Abschied" (Schoenberg), 14
Academy of Music and Fine
 Arts (Vienna), 81–82
Adler, Guido, 78, 91
Adler, Oskar, 8, 9, 178
Adorno, Theodor W., 149
Aimard, Pierre-Laurent, 88
Alderman, Pauline, 168
Also sprach Zarathustra
 (Strauss), 29
"Altenberg" Lieder (Berg), 97
American Academy of Arts
 and Letters, 192
Ansermet, Ernest, 208
anti-Semitism
 Bildung and, 17–18
 Gravina and, 94n
 postwar, 194
 Vienna, 1, 2, 3, 17, 194
 Wagner and, 26, 35
 See also Nazi regime;
 Schoenberg, Arnold,
 ANTI-SEMITISM AND
Apollo (Stravinsky), 145, 168
Armstrong, Louis, 207
Arnold, Edward, 189
Arnold Schoenberg (Stucken-
 schmidt), 206

Arnold Schönberg (Wellesz),
 94, 103
"Arrangement in Grey and
 Black" (Whistler), 69
Asch, Joseph, 160–61
Austro-Hungarian Empire,
 1–2, 4, 17, 25, 101, 110
 See also Viennese Jewish
 community
Austro-Prussian War (1866),
 25
Ax, Emanuel, 186n

Babbitt, Milton, 209–10
Bach, David Josef, 8, 9, 14–15,
 144, 178
Bach, Johann Sebastian, 128
Ballets Russes, 91
Balzac, Honoré de, 113,
 114–16
Bartók, Béla, 77, 108, 142,
 145, 208
Baudelaire, Charles, 55
Bauhaus, 123
Beaumont, Antony, 178
Beethoven, Ludwig van
 creative struggles, 111–13
 emotion and, 65–66

Fourth String Quartet
 and, 174
human voice and, 55
motivic fragments and, 67
*Ode to Napoleon Buon-
 aparte* and, 183
Schoenberg's conducting
 of, 102
Serenade, Op. 24 and, 134
String Quartet No. 1, in D
 minor and, 45–46
String Trio, Op. 45 and,
 191
Western musical evolution
 and, 128, 204
*Begleitungsmusik zu einer
 Lichtspielszene*, Op. 34
 (Schoenberg), 150–51
Berg, Alban, *126*
 atonality and, 64
 death of, 179–80
 Hauptstimme/Nebenstimme
 notations and, 138n
 Krasner and, 172
 on *Pelleas und Melisande,*
 37
 on Mathilde Schoen-
 berg, 54

236 | INDEX

Berg, Alban (*continued*)
 Schoenberg's influence on,
 44, 80
 Schoenberg's move to Berlin (1911) and, 83
 Skandalkonzert and, 97
 Steinakirchen vacation
 and, 71
 Verein für Musikalische
 Privataufführungen
 and, 107, 108–9
 Von heute auf morgen and,
 149
Bergman, Ingmar, 96
Berio, Luciano, 141
Berlin, 25–26
 See also Schoenberg,
 Arnold, BERLIN
 SOJOURN (1901–1903),
 BERLIN SOJOURN
 (1911–15), *and* BERLIN
 SOJOURN (1925–33)
Berlioz, Hector, 20, 30–31,
 128, 190
Berry, Mark, 15
B-flat Major String Quartet,
 Op. 130 (Beethoven),
 191
Bienenfeld, Elsa, 40
Bierbaum, Otto Julius, 27, 28
Bildung, 17–18
Bismarck, Otto von, 25
Bizet, Georges, 102
Black American musicians,
 208
Blitzstein, Marc, 143
Bloch, Ernest, 165
Blonda, Max. *See* Schoenberg,
 Gertrud Kolisch
Blumauer, Ottilie Schoenberg
 (Schoenberg's sister),
 xxii, 6n, 19, 42n, 179
Bodanzky, Artur, 74, 75,
 163–64
Boruttan, Alfred, 95
Boulanger, Nadia, 193
Boulez, Pierre
 Concerto for Piano and
 Orchestra and, 186n
 on *Erwartung,* 72, 73

Five Pieces for Orchestra
 and, 68
 on *Die glückliche Hand,* 79
 Gurrelieder and, 33
 Kammersymphonie and, 49
 on *Pelleas und Melisande,*
 37
 Pierrot Lunaire and, 87,
 88, 89, 92
 twelve-tone system and,
 208
Brahms, Johannes
 early influence on Schoenberg, 10
 Kammersymphonie and, 50
 motivic fragments and, 67
 polyphony and, 50n
 Schoenberg's early musical
 environment and, 7
 Schoenberg's lieder and,
 12–13
 Verklärte Nacht and, 21
 vs. Wagner, 8–9, 13–14
 Western musical evolution
 and, 128, 129
 "Brahms the Progressive"
 (Schoenberg), 13
Brecht, Bertolt, 105, 149–50,
 173
Brendel, Alfred, 186n
Brettl-Lieder (Schoenberg),
 28–29
Breuer, Hugo, 54
Breuer, Josef, 73
Bruckner, Anton, 7, 9, 10, 60,
 128, 129
Bujić, Bojan, 5–6, 61, 158–59
Bülow, Hans von, 94n
Buntes Theater (Berlin),
 27, 29
Busoni, Ferruccio, 67, 89,
 108, 142
Byron, Lord (George Gordon), 182–83

Cage, John, 168
Cahn, Steven J., 17–18
Canzoniere (Petrarch), 136,
 137, 138
Casella, Alfredo, 108

Castelnuovo-Tedesco, Mario,
 189
Chagall, Marc, 159
Chamber Symphony No.
 1, Op. 9, in E major
 (*Kammersymphonie*)
 (Schoenberg), 46–51,
 65, 97, 100–101, 109
Chamber Symphony No. 2,
 Op. 38 (Schoenberg),
 50, 180–81
Chochem, Corinne, 192–93
Christen, Ada, 12
Clark, Edward, 157
Coblenz, Ida, 55n
Coffer, Raymond, 51n
Coleman, Ornette, 207
commedia dell'arte, 86
Concerto for Piano and
 Orchestra, Op. 42
 (Schoenberg), xvi,
 184–86
Conlon, James, 178
Coolidge, Elizabeth Sprague,
 145, 165, 174
Copland, Aaron, 165
Cowell, Henry, 143
Craft, Robert, 87n, 134, 195–
 96, 197
Creation, The (Haydn), 128
Crittenden, Camille, 137

Dahl, Ingolf, 87n
Dahms, Walter, 94
Dallapiccola, Luigi, 141
Damnation de Faust, La (Berlioz), 30–31, 128
"Dank" (Schoenberg), 14
*Das Buch der hängenden
 Gärten* (Schoenberg),
 62–64, 67, 70
Das Rheingold (Wagner), 32
Debussy, Claude, 36–37, 68,
 72, 77, 92–93, 108
"Deckel des Sarges klappert
 und klappt" (*Gurrelieder*) (Schoenberg), 34
Dehmel, Richard, 16–17,
 19–20, 21–22, 28, 55,
 116

INDEX 237

Der biblische Weg (Schoenberg), 144, 160
Der Blaue Reiter, 75–76, 82
"Der Pflanze, die dort über dem Abgrund schweb" (Schoenberg), 13
Der siebente Ring (George), 55–56
Des knaben Wunderhorn (folk collection), 18
Des knaben Wunderhorn (Mahler), 44
"Des Sommerwindes wilde Jagd" (*Gurrelieder*) (Schoenberg), 35
Deutsch, Max, 104
Deutsche Chansons (Bierbaum), 27
"Diabelli" Variations (Beethoven), 65, 112, 134
Diaghilev, Sergei, 91, 92, 93
Die Bücher der Hirten-und Preisgedichte, der Sagen und Sänge, und der hängenden Gärten (George), 62–63
Die Dreigroschenoper (*The Three-Penny Opera*) (Brecht and Weill), 105, 149–50
Die Fledermaus (Strauss), 149
Die Frau ohne Schatten (Strauss), 155
Die glückliche Hand (Schoenberg), 78–81, 87, 111, 140, 146
Die Jakobsleiter (Schoenberg), 111, 113–22
　libretto, 116–19, 122
　orchestration of, 120–21
　premiere of (1961), 120
　religion in, 119, 121–22
　Rosen on similarities to Stravinsky, 145
　Schoenberg's inability to finish, 119–20, 121
　sources for, 113–16
　U.S. work on, 188

Die Meistersinger (Wagner), 34–35
Die Seejungfrau (Zemlinsky), 44
Die Walküre (Wagner), 32, 34
Doktor Faustus (Mann), 178, 193
Donatoni, Franco, 141
Don Juan (Strauss), 20, 29
Don Quixote (Strauss), 29
Double Concerto (Brahms), 7, 128
Dowson, Ernest, 111
Dreimal tausend Jahre, Op. 50a (Schoenberg), 194–95
"Drüben geht die Sonne scheiden" (Schoenberg), 13
Duffy, Kiera, 88
Dukas, Paul, 108
"Du sendest mir" (*Gurrelieder*) (Schoenberg), 32
Dvořák, Antonín, 10–11, 22

Eichler, Jeremy, 166
Eighth Symphony (Bruckner), 7, 128
Eighth Symphony (Mahler), 40–41, 47–48, 55
Eight Songs, Op. 6 (Schoenberg), 42
"Ein Brief" ("The Lord Chandos Letter") (Hofmannsthal), 202–3
Ein Heldenleben (Strauss), 29
"Ein seltsamer Vogel" (*Gurrelieder*) (Schoenberg), 34
Eisler, Hanns, 28, 104
Elektra (Strauss), 32, 70
Endell, August, 27
Engel, Carl, 187
"Entrückung" (George), 56
Erdgeist (Wedekind), 28
"Erhebung" (Schoenberg), 15
"Eroica" Symphony (Beethoven), 45–46, 65–66
"Erwacht, König Waldemars

Mannen wert" (*Gurrelieder*) (Schoenberg), 34
Erwartung, Op. 17 (Schoenberg), 71, 72–75, 80, 87, 139, 140–41
"Erwartung" (lied) (Schoenberg), 15
"Es ist Mitternacht" (*Gurrelieder*) (Schoenberg), 32
Existentialism, 86
Expressionism, 72, 75–76

Falstaff (Verdi), 128
Feininger, Lyonel, 75
Feisst, Sabine, 121, 171, 187
Fellini, Federico, 152
Feuermann, Emanuel, 157
Feuersnot (Strauss), 29
"Feuillage du coeur" (Maeterlinck), 82
Fifth String Quartet (Bartók), 145
Fifth Symphony (Beethoven), 174, 183
Finnegans Wake (Joyce), 205
Five Piano Pieces, Op. 23 (Schoenberg), 65, 133–34
Five Pieces for Orchestra, Op. 10 (Webern), 212
Five Pieces for Orchestra, Op. 16 (Schoenberg), 67–70, 71, 98, 99–100, 122
Four Lieder, Op. 2 (Schoenberg), 13, 15–17, 21, 42
Four Orchestral Songs, Op. 22 (Schoenberg), 111
Four Pieces for Mixed Chorus, Op. 27 (Schoenberg), 141
Fourth String Quartet, Op. 37 (Schoenberg), 174–75
Fourth Symphony (Mahler), 40–41, 55
Franco-Prussian War (1870), 25
Franz Josef (Austro-Hungarian emperor), 25
Freud, Sigmund, 38–39, 73

238 | INDEX

Freund, Marya, 53–54, 95
Fried, Oskar, 82
Friede auf Erden, Op. 13
 (Schoenberg), xiv, 55
Frühlings Erwachen (Wede-
 kind), 28
Fuchs, Robert, 8
*Fundamentals of Musical
 Composition* (Schoen-
 berg), 188
Furtwängler, Wilhelm,
 146–47

Gärtner, Eduard, 14
Gavazzeni, Gianandrea, 213
"Gegrüsst, o König, an
 Gurre-Sees Strand"
 (*Gurrelieder*) (Schoen-
 berg), 34
Geibel, Emanuel, 12
Genesis Suite, 188–89
George, Stefan, 55, 62–64, 111
George Lieder. *See Das Buch
 der hängenden Gärten*
Gerhard, Roberto, 143, 151
German Empire, 25
Gershwin, George, 165, 177
Gerstl, Richard, 51–53, 55, 72,
 75, 78–79, 80
"Geübtes Herz" (Schoen-
 berg), 19
Gielen, Josef, 89n
Gielen, Michael, 89n, 186n
Gielen, Rose Steuermann,
 89n
Giraud, Albert, 85–86, 87, 88
Goehr, Walter, 143
Gold, Alfred, 12
Goldman, Richard Franko,
 187
Goldmark, Karl, 81
Goldschmied, Malvina, 19
Golyshev, Yefim, 132, 133
Gould, Glenn, 86, 186n, 199
Gould, Kate, 192n
Graf, Herbert, 39n
Graf, Max, 39n
Grainger, Percy, 165
Gravina, Gilberto, 94n
Greif, Martin, 12

Greissle, Arnold (Schoen-
 berg's grandson), 139,
 179
Greissle, Felix, 104, 138, 139,
 179
Greissle, Gertrud (Trudi)
 Schoenberg (Schoen-
 berg's daughter), 22, 38,
 83, 138, 139, 179
Greissle, Hermann (Schoen-
 berg's grandson), 139n,
 179
Gropius, Walter, 123
Guntram (Strauss), 29n
Gurrelieder (Schoenberg),
 30–36
 critical reception of, 99
 delay in completion, 35–36
 differences within, 33
 individual songs in, 32
 orchestration of, 31, 36, 42,
 43, 82
 performances of, xiv, 95,
 96, 97, 100, 110, 123, 146
 Schoenberg's opposi-
 tional psychology and,
 35–36, 96
 Schoenberg's turn away
 from, 47
 sound platforms in, 33
 Richard Strauss and,
 30–33
 Wagner and, 32, 33–35
Gurresange (Jacobsen), 30
Gutheil-Schoder, Marie, 59,
 139, 141–42
Gutmann, Emil, 91

Hába, Alois, 64
Hahn, Hilary, xvi, 135, 172
Hanslick, Eduard, 11
*Harmonielehre (Theory of
 Harmony)* (Schoen-
 berg), 76–78, 82n, 105,
 112, 178
Harrell, Mack, 184
Harrison, Lou, 171
Hartleben, Otto Erich, 85,
 87, 88
Haskil, Clara, 106

Hauer, Josef Matthias, 132–33
Haydn, Joseph, 128
Heifetz, Jascha, 172
Hermann, Bernard, 181
"Herr Gänsefuss" (*Gurrelie-
 der*) (Schoenberg), 35
"Herrgott, weisst du, was
 du tatest" (*Gurrelieder*)
 (Schoenberg), 34
Herzgewächse, Op. 20
 (Schoenberg), 82
Heyse, Paul, 12
Hindemith, Paul, 125, 188,
 208
Hitler, Adolf, 2, 124n, 158,
 182
 See also Nazi regime
Hofmannsthal, Hugo von,
 155, 202–3
Holocaust, 40n, 104n
Horwitz, Karl, 43
Huillet, Danièle, 156
Hutcheson, Ernest, 166–67

Ibert, Jacques, 71
Il Trovatore (Verdi), 122

Jacobsen, Jens Peter, 30
Jalowetz, Heinrich, 43, 44
Janssen, Werner, 189
Jerger, Alfred, 140
Jeu de cartes (Stravinsky), 145
Jonny spielt auf (Krenek),
 149–50
Joyce, James, 203, 205
Jugendstil, 92

Kafka, Franz, 203
Kalbeck, Max, 60
Kammersymphonie (Chamber
 Symphony) No. 1, in E
 Major, Op. 9 (Schoen-
 berg), 46–51, 65, 97,
 100–101, 109
Kandinsky, Wassily, 75–76,
 123, 124
Karpath, Joseph, 60
Keller, Alfred, 143
Keller, Gottfried, 19
Kerber, Erwin, 17n

INDEX | 239

Kerr, Alfred, 90
Kim, Earl, 171
Kindertotenlieder (Mahler), 44, 97
Kirchner, Leon, 171
Klee, Paul, 75
Klemperer, Otto, 149, 151, 159, 170, 178, 181
Klimt, Gustav, 51
Kodály, Zoltán, 142
Kokoschka, Oskar, 39
Kolisch, Rudolf, 104, 139, 159, 177–78
Kol Nidre, Op. 39 (Schoenberg), 180
Koussevitzky, Natalie, 192
Koussevitzky, Serge, 165, 187–88
Krämer, Ulrich, 121
Krasner, Louis, 172
Kraus, Karl, 39, 60–61, 71, 201
Kreisler, Fritz, 164
Krenek, Ernst, 149–50, 170
Kubelik, Rafael, 120n

Lane, Louis, 186n
Lansky, Paul, 61
LaSalle Quartet, 62n
Lazar, Moshe, 144
League of Composers, 182, 184
Legends (Strindberg), 113–14
Leibowitz, René, 192
Leinsdorf, Erich, 17n
Lempel, Blume, 54n
Lenau, Nikolaus, 12
Leoncavallo, Ruggero, 115n, 213
Lepcke, Ferdinand, 85
Les fleurs du mal (Baudelaire), 55
Les fondements de la musique dans la conscience humaine (Ansermet), 209
Levant, Oscar, 169, 185
Levetzow, Karl von, 14, 27–28
Levine, James, 136

liberalism/radicalism, 16, 28, 110
See also Schoenberg, Arnold, OPPOSITIONAL PSYCHOLOGY OF
Lieser, Lilly, 102
Liszt, Franz, 9, 10, 20
"Litanei" (George), 56
Loos, Adolf, 39, 46, 60–61, 106
Lueger, Karl, 2
Lulu (Berg), 80

MacDonald, Malcolm, 87, 171
Macelaru, Cristian, 88
Macke, August, 75, 76n
Madama Butterfly (Puccini), 118
Maderna, Bruno, 141
Maeterlinck, Maurice, 36, 37, 82
Magnin, Edgar, 198
Mahler, Alma. *See* Mahler-Werfel, Alma
Mahler, Gustav
 Brahms vs. Wagner controversy and, 13–14
 death of, 41–42, 82
 financial assistance to Schoenberg, 41, 76, 81
 Fuchs and, 8
 on Gutheil-Schoder, 59
 Harmonielehre on, 77
 human voice and, 55
 Kammersymphonie and, 47–48, 50
 Schoenberg's admiration for music of, 40–41
 Skandalkonzert and, 97
 Verein für Musikalische Privataufführungen and, 108
 Vereinigung schaffender Tonkünstler and, 44
 Western musical evolution and, xiii
Mahler-Werfel, Alma, 41, 47, 54, 123, 177
Malkin, Joseph, 161

Malkin Conservatory (Boston), 165–66
Malko, Nikolai, 146
Mallarmé, Stéphane, 55, 62
Mann, Monika, 187
Mann, Thomas, 178, 193
Marc, Franz, 75, 76n
Marseillaise, 183
Milhaud, Darius, 71, 108, 189
Missa Solemnis (Beethoven), 112, 128
Models for Beginners in Composition (Schoenberg), 188
Moderner Psalm, Op. 50c (Schoenberg), 195
Moholy-Nagy, László, 151
Monn, Georg Matthias, 157
Monn-Schoenberg cello concerto, 157
Monteux, Pierre, 181
Morgenstern, Christian, 28
Moses und Aron (Schoenberg), 144, 145, 151–57, 160
Mozart, Wolfgang Amadeus, xvi, 128, 136, 202, 216
Münter, Gabriele, 75–76
My Youth in Vienna (Schnitzler), 3–4

Nachod, Hans (Schoenberg's cousin), 5, 95, 123, 161
"Nachtwandler" (Schoenberg), 28
Nahowski, Helene, 544
Napoleon Bonaparte, 182–83
Naturalism, 16n
Nazi regime
 Anschluss, 173
 Bauhaus and, 123
 Gerstl and, 52
 refugees from, 71–72, 104n, 177–78, 179, 188–89
 Schoenberg's creative responses to, 173, 182, 192–93
 Schoenberg's experience during, 158–61
 Zillig and, 120n

240 | INDEX

neoclassicism, 48, 93, 142
Newlin, Dika, 188
Newman, Alfred, 169
Newman, Ernest, 98–99
New World Symphony
 (Dvořák), 22
Nicolodi, Fiamma, 141
Nietzsche, Friedrich, 26,
 55, 66
Nikisch, Arthur, 100–101
Ninth Symphony
 (Beethoven), 55, 102,
 112
Ninth Symphony (Bruck-
 ner), 7
Nono, Luigi, 141
Nono, Nuria Schoenberg
 (Schoenberg's daugh-
 ter), 98, 157, 161, 170,
 171, 175–76, 179, 194
"Nun dämpft die Däm-
 merung" (Gurrelieder)
 (Schoenberg), 32
"Nun sag ich Dir" (Gurrelie-
 der) (Schoenberg), 34

Ode to Napoleon Buonaparte,
 Op. 41 (Schoenberg),
 182–84, 186
"Ode to Napoleon
 Buonaparte" (Byron),
 182–83
"Oh, wenn des Mondes
 Strahlen leise
 gleiten" (Gurrelieder)
 (Schoenberg), 32
Oppenheimer, Max, 71
Otello (Verdi), 128
Ozick, Cynthia, 203

Pagliacci (Leoncavallo), 213
Pappenheim, Marie (Mizzi),
 71–72, 73, 75, 116
Patzak, Julius, 120n
Pelléas et Mélisande (Debussy),
 36–37, 72
Pelléas et Mélisande (Maeter-
 linck), 36, 37
Pelleas und Melisande, Op. 5
 (Schoenberg)

audience acclaim for, 90,
 91, 109–10
critical reception of, 44–45
orchestration of, 36–38, 47
performances of, 82, 94,
 109–10, 123, 146, 166
Perle, George, 50
Petrarch, 136, 137, 138
Petrushka (Stravinsky), 91
Pfau, Ludwig, 12, 13
Pfitzner, Hans, 108
Phantasy, Op. 47 (Schoen-
 berg), 194
Piano Concerto (Con-
 certo for Piano and
 Orchestra, Op. 42)
 (Schoenberg), xvi,
 184–86
Piano Quartet in G Minor
 (Brahms), 180
Pierrot Lunaire, Op. 21
 (Schoenberg), 85–93
 audience acclaim for, 90,
 91, 101
 critical reception of, 90–91,
 101
 lightheartedness in, 65
 orchestration of, 85
 performances of, 87n,
 89–92, 94, 141, 146
 Popper on, 109
 recordings of, 182
 Sprechgesang in, 86
 Western musical evolution
 and, 128–29
Pierrot lunaire: Rondels ber-
 gamasques (Giraud),
 85–86, 87, 88
Pillar of Fire, The (Tudor),
 187
Pisk, Paul, 104, 109
Polyhymnia, 9
Popper, Karl, 109
post-Romantic Expression-
 ism, 48
Poulenc, Francis, 108
Power, Lawrence, 192n
Prelude to the Genesis Suite
 (Schoenberg), 188, 189
Price, Margaret, 62n

Prometheus: Poem of Fire
 (Scriabin), 69
Psalm 130, Op. 50b (Schoen-
 berg), 195
Puccini, Giacomo, 77, 118,
 141

Rankl, Karl, 104, 119–20
Ratz, Erwin, 104
Ravel, Maurice, 92, 102, 108
Redwitz, Oskar von, 12
Reger, Max, 13–14, 108
Reich, Wilhelm, 71
Reich, Willi, 38, 110, 158
Reinhardt, Max, 144
Reinick, Robert, 12
Riegger, Wallingford, 165
Rilke, Rainer Maria, 111
Rise and Fall of the City of
 Mahagonny (Brecht and
 Weill), 105
Rite of Spring, The (Stravin-
 sky), 70, 93, 98, 129
Robert, Richard, 106
Robinson, Jackie, 171
Rodzinski, Artur, 184
Romanticism
 Brahms vs. Wagner con-
 troversy and, 14
 neoclassicism and, 142
 See also Schoenberg's
 music, ROMANTICISM
 AND
Roosevelt, Franklin D., 164,
 182
Rosbaud, Hans, 147, 155, 206
Rosé, Arnold, 40
Rosen, Charles, 145–46
Ross, Alex, 77–78
"Ross! Mein Ross" (Gur-
 relieder) (Schoenberg),
 32, 34
Rubinstein, Anton, 159
Rubinstein, Arthur, 155,
 186–87
Rubsamen, Walter H., 169,
 177
Rufer, Josef, 104, 129–30, 143,
 206–7
Runes, Dagobert D., 194–95

INDEX | 241

Salome (Strauss), 32, 43
Salonen, Esa-Pekka, 186n
Satie, Erik, 108
Satyricon (Fellini), 152
"Schenk mir deinen goldenen
Kamm" (Schoenberg),
15
Scherchen, Hermann, 91,
94, 186n
Schillings, Max von, 158
Schlaf, Johannes, 16n
Schnabel, Artur, 159
Schnitzler, Arthur, 3–4, 16,
28, 60, 75
Schoenberg, Anna Sax, 179
Schoenberg, Arnold, *24,
84, 126*
American Academy
of Arts and Letters
election, 192
Barcelona sojourn (1931–
32), 151, 157, 160–61
belief in German musical
dominance, 93, 102,
125, 127–28, 199
birth of, 4–5
books by, 76–78, 82n, 105,
112, 178, 188
childhood of, *xxii*, 5–7
children of, 22, 46, 83
conducting weaknesses,
74–75, 102
conversion to Christianity,
16–17
death of, 197–98
experience under Nazi
regime, 158–61
family background, 4
health problems, 151, 166,
186, 189–90, 194, 197
Holland sojourn (1920–
21), 122–23
misogyny of, 79, 117
musical education of, 5–6,
10, 11
numerical superstitions of,
86, 197
as painter, 75, 76
U.S. immigration, 161,
163–65

—ANTI-SEMITISM AND
conversion and, 17
creative responses to,
144
German music and,
125, 127–28
Mattsee incident, 123–
24, 160
Nazi regime and,
158–61
—BERLIN SOJOURN
(1901–1903)
Gurrelieder orchestra-
tion, 31
move to, 22–23, 26
Pelleas und Melisande
composition,
36–38
Stern Conservatory
position, 30, 38
Strauss assistance,
29–30
Überbrettl position,
22–23, 26–29
—BERLIN SOJOURN
(1911–15)
move from Vienna, 83
Stern Conservatory
position, 94–95
Stravinsky encounter,
91–93
—BERLIN SOJOURN
(1925–33)
*Begleitungsmusik zu
einer Lichtspielszene*
composition, 150–51
Der biblische Weg com-
position, 144
move to Berlin, 142–43
Prussian Academy of
the Arts position,
142, 143–44, 158
Third String Quartet,
Op. 30 composition,
145–46
Variations for Orches-
tra composition,
146–48
Von heute auf morgen
composition, 148–50

—INCOME SOURCES
Liszt Foundation
grant, 30
Mahler financial assis-
tance, 41, 76, 81
orchestrating/de-
orchestrating, 11–12
Überbrettl musical
director position,
22–23, 26–29
See also TEACHING *below*
—JUDAISM AND
conversion to Christi-
anity, 16–17
Israel and, 194–95, 196
musical education and,
5–6
Old Testament texts
and, 119, 144, 160
parenting and, 179
Psalm 130, Op. 50b, 195
reconversion, 159–60
societal critique and,
9–10
*A Survivor from War-
saw,* 193
—OPPOSITIONAL PSYCHOL-
OGY OF
American Academy
of Arts and Letters
election and, 192
atonality and, 57–58
attacks on neoclassi-
cism and, 93, 142
audiences and, 96–97
conversion to Christi-
anity and, 18
education and, 10
Gurrelieder and, 35–36,
96
reconversion to
Judaism and, 160
—PERSONALITY OF
Craft on, 196
late-life hypersensitivity,
193–94
marriage to Mathilde
and, 53–54
relationship with
Mahler and, 41

Schoenberg, Arnold
(*continued*)
teaching and, 105
Verein für Musikalische Privataufführungen and, 109
See also OPPOSITIONAL PSYCHOLOGY OF *above*
—TEACHING
Malkin Conservatory, 165–66
as necessary for financial support, 210
private students, 43–44, 95–96
Prussian Academy of the Arts, 142, 143–44, 158
Schwarzwald school, 39–40, 42–43, 103–6
Stern Conservatory, 30, 38, 85, 94–95
Suite in the Old Style and, 168
UCLA, 170–71, 186
University of Southern California, 168–70
Viennese private students, 43–44, 95–96
—U.S. YEARS (1933–51)
ASCAP membership, 169, 186, 187
books, 188
California move, 166–68
Craft on, 195–96
daily life and parenting, 175–76
embarkation, 161, 163
Fourth String Quartet composition, 174–75
Genesis Suite and, 188–89
health problems, 166, 186, 189–90, 194, 197
Jewish escape assistance, 177–78
late-life compositions, 194–95

Malkin Conservatory teaching, 165–66
productivity during, 171–72
reception, 163–65
retirement, 186–87
String Trio composition, 189, 190–92
Theme and Variations composition, 187–88
UCLA teaching, 170–71, 186
USC teaching, 168–70
Vienna honorary citizenship, 194
Violin Concerto composition, 172–74
wartime compositions, 180–85
—VIENNA SOJOURN (1903–11), 38–84
Das Buch der hängenden Gärten, 62–64
creative paralysis (1910), 81
Erwartung composition, 71, 72–75
Five Pieces for Orchestra, 67–70, 71, 99–100
Freud and, 38–39
Gerstl affair, 51–53, 55, 72, 78–79, 80
Die glückliche Hand composition, 78–81
Harmonielehre publication, 76–78, 82n
Kammersymphonie, 46–51
Mahler and, 40–42, 44
oppositional psychology and, 96, 97
private students, 43–44, 95–96
Schwarzwald school teaching, 39–40, 42–43
Steinakirchen vacation, 71
String Quartet No. 1,

in D minor composition, 45–46
String Quartet No. 2 composition, 54–62
Vereinigung schaffender Tonkünstler, 44–45, 107
—VIENNA SOJOURN (1915–25)
compositions (mid-1920s), 141–42
creative struggles, 110–13
death of wife Mathilde, 138–39
marriage to Gertrud Kolisch, 139
military service, 102–3, 110
performances of Schoenberg's music, 109–10, 139–41
Schwarzwald school teaching, 103–6
twelve-tone compositions, 133–38
Verein für Musikalische Privataufführungen, 106–9, 111
Schoenberg, E. Randol, 51n
Schoenberg, Georg (Görgi) (Schoenberg's son), 46, 83, 138, 179, 180
Schoenberg, Gertrud Kolisch (Schoenberg's wife)
children of, 157, 171–72
on *Die Jakobsleiter,* 120n
as librettist, 149
marriage of, 139
move to Berlin (1925), 142–43
Schoenberg's death and, 197–98
U.S. immigration, 161, 163–64
Schoenberg, Heinrich (Schoenberg's brother), 5, 6n, 19, 179

INDEX | 243

Schoenberg, Lawrence
 (Schoenberg's son),
 171–72
Schoenberg, Mathilde von
 Zemlinsky (Schoen-
 berg's wife), *24*
 children of, 22, 46, 83
 death of, 138–39
 Gerstl affair, 52, 53, 55, 72,
 78–79, 80
 marriage of, 19
 move to Berlin (1911), 83
 Schoenberg's personality
 and, 53–54
Schoenberg, Pauline Nachod
 (Schoenberg's mother),
 xxii, 4, 5–6, 138
Schoenberg, Ronald (Schoen-
 berg's son), 171
Schoenberg, Samuel (Schoen-
 berg's father), 4, 6
Schoenberg, Susi (Schoen-
 berg's granddaughter),
 179
*Schoenberg Remembered: Dia-
 ries and Recollections,
 1938–1976* (Newlin),
 188n
Schoenberg's music
 audience acclaim for,
 90, 91, 95, 96, 97, 101,
 109–10
 audience distaste for,
 xiii–xv, 47, 59–60, 205,
 212–13, 214–15
 childhood compositions,
 6–7
 cinematic productions, 156
 density of, 15, 34
 dissonance in, 21, 133, 145
 dodecaphony in, 174
 human voice in, 55
 impact on Western music,
 xiii–xiv, 58, 198–99
 Italian appreciation of, 141
 lieder, 12–16, 64
 lightheartedness in, 65
 polyphony in, 50
 post-Romantic Expres-
 sionism and, 48

 publishing of, 68
 radio and, 151
 recordings of, 62n, 88, 172,
 182, 184, 186n, 192n
 repeated listening as
 worthwhile, 133, 155–
 56, 172–73, 191–92,
 205–6, 216
 Schrammelmusik and, 135
 Sprechgesang in, 86, 89,
 154, 183–84, 193
 tempo indications, 87–88,
 134, 135–36, 181
 titles, 68–69
 —ATONALITY
 as emancipation of the
 dissonance, 50
 emotional tone and, 63
 Kammersymphonie
 and, 50
 lyrics and, 62–63, 64, 88
 Schoenberg's exhilara-
 tion about, 64–65
 Schoenberg's opposi-
 tional psychology
 and, 57–58
 String Quartet No. 2
 and, 56–59, 61–62
 term, 61–62
 Two Songs for voice
 and piano, Op. 14
 and, 57n
 vocal difficulty of, 153
 —CRITICAL RECEPTION OF
 Gurrelieder, 99
 Pelleas und Melisande,
 44–45
 Pierrot Lunaire, 90–91,
 101
 String Quartet No. 2,
 59–61
 —DIFFICULTY OF
 dissonance and, 21, 133
 emotion and, 64–66
 lack of resolution and,
 63–64
 repeated listening as
 worthwhile, 133,
 155–56, 172–73,
 191–92, 205–6, 216

 Romanticism and, 15
 Schoenberg's conduct-
 ing and, 74–75
 Schoenberg's self-
 delusion about, 150
 sound-language and,
 213
 technical performance
 challenges, xvi, 49,
 59, 140–41, 153, 172,
 184–85, 187
 twelve-tone system
 and, 150, 153, 174
 See also public distaste
 for *above*
 —INFLUENCES ON
 early career, 6–11
 lieder and, 12–14
 Verklärte Nacht, 21
 Vienna sojourn (1903–
 11), 45–46
 *See also specific
 composers*
 —ORCHESTRATION OF
 Chamber Symphony
 No. 2, 181
 Erwartung, 73, 111
 Five Pieces for Orches-
 tra, 67–70
 Four Orchestral Songs,
 Op. 22, 111
 Gurrelieder, 31, 36, 42,
 43, 82
 *Hauptstimme/Neben-
 stimme* notations,
 138n
 Die Jakobsleiter, 120–21
 Kammersymphonie, 48
 Moses und Aron, 152
 Pelleas und Melisande,
 36–38, 47
 Pierrot Lunaire, 85
 twelve-tone system
 and, 134, 137–38
 Variations for Orches-
 tra, Op. 31, 147–48
 —PERFORMANCES OF
 *Begleitungsmusik zu
 einer Lichtspielszene,*
 151

244 | INDEX

Schoenberg's music
(*continued*)
Chamber Symphony,
Op. 9, 97
Chamber Symphony
No. 2, 181
Concerto for Piano and
Orchestra, 186
current rarity of, xiv
Erwartung, 139, 140–41
Five Pieces for
Orchestra, 98,
99–100, 122
Die glückliche Hand,
140, 146
Gurrelieder, xiv, 95, 96,
97, 100, 110, 123, 146
Die Jakobsleiter, 120
Kammersymphonie, 47,
100–101
lieder, 14–15
Monn-Schoenberg cello
concerto, 157
Moses und Aron, 155
*Ode to Napoleon Buon-
aparte,* 184, 186
Pelleas und Melisande,
82, 94, 109–10, 123,
146, 166
Pierrot Lunaire, 87n,
89–92, 94, 141, 146
Serenade, Op. 24, 40
String Quartet No. 2,
58, 59–60
U.S. years, 165, 171, 180
Variations for Orches-
tra, 146–47
Verklärte Nacht, 40, 122
Von heute auf morgen,
150
—ROMANTICISM AND
creativity ideals, 112
difficulty and, 15
early works, 12, 15, 46,
50, 87
Die Jakobsleiter,
118–19
Kammersymphonie, 48
Pelleas und Melisande
and, 37

vs. Stravinsky, 146
Verklärte Nacht, 21, 22
—TONALITY
Chamber Symphony
No. 2, 181
Die Jakobsleiter, 118
Kammersymphonie,
48–49, 50
String Quartet in D
Major, 49
Suite in the Old Style,
168
Verklärte Nacht, 20–21
—TWELVE-TONE SYSTEM
announcement of,
129–30
attacks on, 208–9
choral symphony
sketches (1914)
and, 111
co-inventors of,
132–33
Concerto for Piano
and Orchestra and,
184–86
difficulty of, 150, 153,
174
Dreimal tausend Jahre
and, 194–95
early compositions
using, 133–38
Fourth String Quartet
and, 174–75
Mann on, 178
modern performance
scarcity and, xiv
Moses und Aron and,
152
overview, 130–32, *131*
Schoenberg's belief in,
207–8
sound-language and,
213
String Trio, Op. 45 and,
190–92
Violin Concerto, Op. 36
and, xiv, 172–74
Western musical evo-
lution continuity
and, 204–5, 209–10

—WESTERN MUSICAL EVO-
LUTION AND
composers' income and,
210–11
continuity and, 58–59,
204–5, 206–8
current multiplicity,
207
discontinuity and, xiii,
xv, 128–29, 205,
208–9
Italian appreciation
and, 141
musical education and,
213–15
Schoenberg as destruc-
tive of, xv–xvi
—WORKS
"Abschied," 14
*Begleitungsmusik zu
einer Lichtspielszene,*
Op. 34, 150–51
Der biblische Weg, 144,
160
Brettl-Lieder, 28–29
*Das Buch der hängenden
Gärten,* 62–64, 67, 70
Chamber Symphony
No. 2, Op. 38, 50,
180–81
Concerto for Piano and
Orchestra, Op. 42,
xvi, 184–86
"Dank," 14
"Deckel des Sarges
klappert und
klappt" (*Gurrelie-
der*), 34
"Des Sommerwindes
wilde Jagd" (*Gurre-
lieder*), 35
Dreimal tausend Jahre,
Op. 50a, 194–95
"Drüben geht die
Sonne scheiden," 13
"Du sendest mir" (*Gur-
relieder*), 32
Eight Songs, Op. 6, 42
"Erhebung," 15
"Erwacht, König

INDEX | 245

Waldemars Mannen
wert" (*Gurrelieder*)
(Schoenberg), 34
Erwartung, Op. 17, 71,
72–75, 80, 87, 139,
140–41
"Erwartung" (lied), 15
"Es ist Mitternacht"
(*Gurrelieder*), 32
Five Piano Pieces, Op.
23, 65, 133–34
Five Pieces for Orches-
tra, Op. 16, 67–70,
71, 98, 99–100, 122
Four Lieder, Op. 2, 13,
15–17, 21, 42
Four Orchestral Songs,
Op. 22, 111
Four Pieces for Mixed
Chorus, Op. 27, 141
Fourth String Quartet,
Op. 37, 174–75
Friede auf Erden, Op.
13, xiv, 55
"Gegrüsst, o König, an
Gurre-Sees Strand"
(*Gurrelieder*), 34
"Geübtes Herz," 19
Die glückliche Hand,
78–81, 87, 111, 140,
146
"Herr Gänsefuss"
(*Gurrelieder*), 35
"Herrgott, weisst du,
was du tatest" (*Gur-
relieder*), 34
Herzgewächse, Op.
20, 82
Kammersymphonie
(Chamber Sym-
phony) No. 1, in E
Major, Op. 9, 46–51,
65, 97, 100–101, 109
Kol Nidre, Op. 39, 180
Moderner Psalm, Op.,
50c, 195
Monn-Schoenberg cello
concerto, 157
Moses und Aron, 144,
145, 151–57, 160

"Nachtwandler," 28
"Nun dämpft die
Dämmerung" (*Gur-
relieder*), 32
"Nun sag ich Dir"
(*Gurrelieder*), 34
*Ode to Napoleon Buon-
aparte*, Op. 41,
182–84, 186
"Oh, wenn des Mondes
Strahlen leise glei-
ten" (*Gurrelieder*), 32
"Der Pflanze, die dort
über dem Abgrund
schweb," 13
Phantasy, Op. 47, 194
Prelude to the *Genesis
Suite*, 188, 189
"Ross! Mein Ross"
(*Gurrelieder*), 32, 34
"Schenk mir deinen
goldenen Kamm,"
15
"Seht die Sonne" (*Gur-
relieder*), 35
"Ein seltsamer Vogel"
(*Gurrelieder*), 34
Serenade, Op. 24, 111,
133, 134–38
Six Lieder, Op. 3, 13,
18–19, 21, 42
Six Little Piano Pieces,
Op. 19, 82
Six Songs for voice and
orchestra, Op. 8, 42,
45, 123
"So tanzen die Engel"
(*Gurrelieder*), 34
"Sterne jubeln" (*Gur-
relieder*), 32
String Quartet in D
Major, 10–11, 12,
45, 49
String Quartet No. 1,
in D minor, Op. 7,
45, 123
String Quartet No. 2,
Op. 10, 54–62, 140
String Trio, Op. 45,
162, 189, 190–92

Suite, Op. 29, 141–42
Suite for Piano, Op.
25, 141
Suite in the Old Style,
168
*A Survivor from War-
saw*, Op. 46, 192–93
Theme and Variations
for full orchestra in
B-flat major, Op.
43b, 187–88
Theme and Variations
for Wind Band, in
B-flat major, Op.
43a, 187
Third String Quartet,
Op. 30, 145–46
Three Folksongs, Op.
49, 194
Three Piano Pieces,
Op. 11, 67, 73
Three Pieces for
Chamber Orchestra
(unfinished), 81
Three Satires for
Mixed Chorus, Op.
28, 141, 142
Three Songs for low
voice and piano, Op.
48, 158
Two Ballads for voice
and piano, Op.
12, 55
Two Songs for bari-
tone, Op. 1, 13, 14,
21, 42
Two Songs for voice
and piano, Op. 14,
57n
Variations for
Orchestra, Op. 31,
146–48
Variations (for organ)
on a Recitative in D
Minor, Op. 40, 182
Verklärte Nacht, Op.
4, A Sextet for two
violins, two violas,
and two cellos,
19–22, 40, 122, 187

246 | INDEX

Schoenberg's music
(*continued*)
Violin Concerto, Op.
36, xiv, xvi, 135,
172–74
Von heute auf morgen,
Op. 32, 39n, 148–50
"Waldsonne," 15, 16n
"Wie Georg von
Frundsberg von sich
selber sang," 18
Wind Quintet, Op.
26, 141
*See also Die Jakobsleiter;
Gurrelieder; Pelleas
und Melisande; Pier-
rot Lunaire*
*Schoenberg's New World: The
American Years* (Feisst),
171
Schrammelmusik, 135
Schreiner, Alexander, 198
Schreker, Franz, 72, 83, 95
Schumann, Robert, 12
Schwarzwald, Eugenie Nuss-
baum ("Frau Doktor"),
39, 103–4, 105–6
See also Schwarzwald
school
Schwarzwald, Hermann,
39–40, 105–6
Schwarzwald school, 40,
42–43, 103–6
Scriabin, Alexander, 69, 108,
132, 133
Second String Quartet. *See*
String Quartet No. 2
Second Symphony (Mahler),
55
"Seht die Sonne" (*Gurrelieder*)
(Schoenberg), 35
Séraphîta (Balzac), 113,
114–16
Serenade, Op. 24
(Schoenberg), 111,
133, 134–38
serialism. *See* Schoenberg's
music, TWELVE-TONE
SYSTEM
Serkin, Rudolf, 104, 106–7

Serres chaudes (Maeterlinck),
82
Sessions, Roger, 165
Seventh Symphony (Shosta-
kovich), 173
Shawn, Allen, 28
Shilkret, Nathaniel, 188–89
Shostakovich, Dmitri, 173,
209
Shriver, Henry Clay, 185
Sibelius, Jean, 8, 44, 168
Siegfried (Wagner), 79
Silja, Anja, 88
Simms, Bryan R., 73
Sinfonia Domestica (Strauss),
44, 47
Six Lieder, Op. 3 (Schoen-
berg), 13, 18–19, 21, 42
Six Little Piano Pieces, Op. 19
(Schoenberg), 82
Six Pieces for Orchestra, Op.
6 (Webern), 97
Six Songs for voice and
orchestra, Op. 8
(Schoenberg), 42, 45,
123
Skalkottas, Nikos, 143
Skandalkonzert, 97–98
"Snowstorm in Summerland,
A" (Lempel), 54n
Sonderling, Jacob, 180
"So tanzen die Engel" (*Gurre-
lieder*) (Schoenberg), 34
Specht, Richard, 60
Sprechgesang, 86, 89, 154,
183–84, 193
Stefan, Paul, 45
Stein, Erwin, 43, 132–33
Stein, Leonard, 33, 35, 183–84
Steinberg, Hans Wilhelm
(William), 150
Stendhal, 183
Stern Conservatory (Berlin),
30, 38, 85, 94–95
"Sterne jubeln" (*Gurrelieder*)
(Schoenberg), 32
Steuermann, Eduard, 89, 104,
107, 141, 177, 184, 186n
Stewart, Thomas, 120n
Stiedry, Fritz, 140, 180

*Stilpe, Ein Roman aus der
Frosch Prospektive*
(Bierbaum), 27
Stock, Frederick, 100
Stokowski, Leopold, 172, 181,
184, 190
Straub, Jean-Marie, 156
Straus, Oscar, 26–27, 29
Strauss, Johann, II, 7, 12,
70, 149
Strauss, Richard
Brahms-vs.-Wagner con-
troversy and, 13–14
Five Pieces for Orchestra
and, 70
German music and, 125
Gurrelieder and, 30–33
Harmonielehre on, 77
Hofmannsthal and, 203
Die Jakobsleiter and, 118
Kammersymphonie and, 50
libretti of, 155
on musical education,
213–14
Pelleas und Melisande
and, 36
Schoenberg's first Berlin
sojourn and, 29–30
Schoenberg's study of, 43
Schoenberg's teaching
positions and, 85
Schoenberg's turn away
from, 47
unvoiced stories and, 20
Verein für Musikalische
Privataufführungen
and, 108
Vereinigung schaffender
Tonkünstler and, 44
Stravinsky, Igor
audience reactions to, 98
Coolidge and, 145
Five Pieces for Orchestra
and, 70
Genesis Suite and, 189
interest in twelve-tone
system, 208
neoclassicism and, 48,
93, 142
on *Pierrot Lunaire,* 91–93

INDEX | 247

relationship with Schoenberg, 93–94, 189
Rosen on similarities to Schoenberg, 145–46
Schoenberg's belief in German musical dominance and, 102
Schoenberg's late-life hypersensitivity and, 193
Suite in the Old Style and, 168
Verein für Musikalische Privataufführungen and, 108
Vereinigung schaffender Tonkünstler and, 108
Western musical evolution and, 59, 93, 128–29
Strickland, William, 182
Strindberg, August, 79, 113–14
String Quartet (Webern), 145
String Quartet in D Major (Schoenberg), 10–11, 12, 45, 49
String Quartet No. 1, in D minor, Op. 7 (Schoenberg), 45, 123
String Quartet No. 2, Op. 10 (Schoenberg), 54–62, 140
String Trio, Op. 45 (Schoenberg), *162*, 189, 190–92
Structural Functions of Harmony (Schoenberg), 188
Stuckenschmidt, Hans H., 64, 90, 143, 205, 206
Style and Idea (Schoenberg), 188
Suite, Op. 29 (Schoenberg), 141–42
Suite in the Old Style (Schoenberg), 168
Suite for Piano, Op. 25 (Schoenberg), 141
Suk, Josef, 108
Survivor from Warsaw, A, Op. 46 (Schoenberg), 192–93

Swedenborg, Emanuel, 113
Symbolism, 36, 56, 62, 85–86
Symphonic Metamorphosis of a Theme of Carl Maria von Weber (Hindemith), 188
Symphonie fantastique (Berlioz), 20, 190
Symphony of Psalms (Stravinsky), 145
Szell, George, 106
Szymanowski, Karol, 108

Taillefer (Strauss), 30
Tansman, Alexandre, 189
Tasso: Lamento e trionfo (Liszt), 20
Tchaikovsky, Pyotr Ilyich, 128
Theme and Variations for full orchestra in B-flat major, Op. 43b (Schoenberg), 187–88
Theme and Variations for Wind Band, in B-flat major, Op. 43a (Schoenberg), 187
Third String Quartet, Op. 30 (Schoenberg), 145–46
Third Symphony (Mahler), 40–41, 55
Three Folksongs, Op. 49 (Schoenberg), 194
Three Piano Pieces, Op. 11 (Schoenberg), 67, 73
Three Pieces for Chamber Orchestra (unfinished) (Schoenberg), 81
Three Satires for Mixed Chorus, Op. 28 (Schoenberg), 141, 142
Three Songs for low voice and piano, Op. 48 (Schoenberg), 158
Three Times Seven Poems from Albert Giraud's Pierrot Lunaire. See Pierrot Lunaire, Op. 21
Till Eulenspiegel (Strauss), 20, 29

Toch, Ernst, 189
Tod und Verklärung (Strauss), 29
Toscanini, Arturo, 82n
Tristan und Isolde (Wagner), 15, 32, 79, 155
Tudor, Antony, 187
Twain, Mark, 66
Two Ballads for voice and piano, Op. 12 (Schoenberg), 55
Two Songs for baritone, Op. 1 (Schoenberg), 13, 14, 21, 42
Two Songs for voice and piano, Op. 14 (Schoenberg), 57n

Überbrettl (Berlin), 22–23, 26–29
Uchida, Mitsuko, 186n
Ullmann, Viktor, 104
University of California at Los Angeles (UCLA), 170–71, 186
University of Southern California (USC), 168–70
unvoiced stories, 19–20

Varèse, Edgard, 165
Variations for Orchestra, Op. 31 (Schoenberg), 146–48
Variations (for organ) on a Recitative in D Minor, Op. 40 (Schoenberg), 182
Verdi, Giuseppe, 122, 128
Verein für Musikalische Privataufführungen (Vienna), 106–9, 111
Vereinigung schaffender Tonkünstler (Union of Creative Musicians), 44–45, 107
Verklärte Nacht, Op. 4, A Sextet for two violins, two violas, and two cellos (Schoenberg), 19–22, 40, 122, 187

248 | INDEX

Verlaine, Paul, 55
Vienna
 anti-Semitism, 1, 2, 3,
 17, 194
 conservatism of, 44, 45
 Gurrelieder premiere
 (1913), 95–96
 honorary citizenship, 194
 Jewish community, 1, 2–3
 Schoenberg's burial in, 198
 Schoenberg's memories
 of, 179
 Skandalkonzert, 97–98
 See also Schoenberg,
 Arnold; VIENNA
 SOJOURN (1903–11)
Viertel, Salka, 89–90, 177
Violin Concerto (Berg), 172
Violin Concerto, Op. 36
 (Schoenberg), xiv, xvi,
 135, 172–74
Von heute auf morgen, Op.
 32 (Schoenberg), 39n,
 148–50
Vrchlický, Jaroslav, 12

Wackernagel, Wilhelm, 12
Wagner, Cosima Liszt von
 Bülow, 94n
Wagner, Richard
 anti-Semitism and, 26, 35
 vs. Brahms, 8–9, 13–14
 early influence on
 Schoenberg, 10
 Die glückliche Hand
 and, 79
 Gurrelieder and, 32, 33–35
 Kalbeck on, 60
 Kammersymphonie and, 50
 libretti of, 155
 quality of, 66
 as representative of
 German music, 128
 Schoenberg's early musical
 environment and, 7
 Schoenberg's lieder and,
 14, 15
 Verklärte Nacht and, 21, 22
 Western musical evolution
 and, 204

Waidhofen Manifesto, 3–4
"Waldsonne" (Schoenberg),
 15, 16n
Wally, Josepha (Seffi), 53
Walter, Bruno, 159
Webern, Anton von
 atonality and, 64
 Coolidge and, 145
 death of, 180
 difficulty of music, 212
 Gerstl affair and, 52
 Hauptstimme/Nebenstimme
 notations and, 138n
 Pierrot Lunaire and, 86
 Schoenberg's influence
 on, 44
 on Schoenberg's Stern
 Conservatory position,
 94–95
 Skandalkonzert and, 97
 Steinakirchen vacation
 and, 71
 Variations for Orchestra
 and, 147
 Verein für Musikalische
 Privataufführungen
 and, 107
Wedekind, Frank, 28
*Weib und Welt: Gedichte
 und Märchen*
 (Dehmel), 16–17,
 19–20, 21–22
Weill, Kurt, 28, 104–5,
 149–50
Wellesz, Egon, 43, 44, 52,
 97–98, 103
Werefkin, Marianne von, 75
Werfel, Franz, 93n, 177, 186
Western musical evolution
 Black American musicians
 and, 208
 cycles and, 216
 Schoenberg's belief in
 German musical
 dominance, 93, 125,
 127–28, 199
 Stravinsky and, 59, 93,
 128–29
 World War I and, 129,
 203–4

Whistler, James McNeill, 69
"Wie Georg von Frundsberg
 von sich selber sang"
 (Schoenberg), 18
Wilhelm I (emperor of
 Germany), 25
Wind Quintet, Op. 26
 (Schoenberg), 141
Winternitz-Dorda, Martha,
 95
Wolf, Hugo, 8, 9, 10, 12–13,
 60
Wolzogen, Ernst von, 26–27,
 29
Wolzogen, Hans Paul
 von, 26
Wood, Henry, 98, 99
World War I, 84, 93, 101–4,
 108, 129, 203–4
World War II, 182
 See also Nazi regime
Wozzeck (Berg), 80

Zehme, Albertine, 85, 86,
 89–90, 91, 92, 93
Zeitopern, 149–50
Zemlinsky, Alexander
 early influence on
 Schoenberg, 8–9, 11
 Erwartung and, 139, 140
 Gurrelieder and, 30
 Mahler and, 40, 41
 Pappenheim and, 72
 Pelleas und Melisande
 and, 109
 Schoenberg's lieder and,
 14
 Schoenberg's Viennese
 residence and, 42
 Skandalkonzert and, 97
 Steinakirchen vacation
 and, 71
 U.S. immigration, 178
 Verein für Musikalische
 Privataufführungen
 and, 108
 Vereinigung schaffender
 Tonkünstler and, 44
Zillig, Winfried, 120, 120n,
 121, 122, 143

About the Author

Harvey Sachs's many previous books include, among others, *Ten Masterpieces of Music* (2021), *Toscanini: Musician of Conscience* (2017), *The Ninth: Beethoven and the World in 1824* (2010), *The Letters of Arturo Toscanini* (which he selected, edited, and translated; 2002), *Rubinstein: A Life* (1995), *Music in Fascist Italy* (1987), *Virtuoso* (1982), and, as coauthor, Sir Georg Solti's *Memoirs* (1997) and Plácido Domingo's *My First Forty Years* (1983). Sachs is a native of Cleveland, Ohio, but has lived most of his life elsewhere: Toronto, Milan, London, Tuscany, Lugano, and, currently, New York City. He is on the faculty of the Curtis Institute of Music in Philadelphia.